4/07

Inconvenient Stories : Vietnam War Veterans

Inconvenient Stories

Vietnam War Veterans

FOREWORD BY
Rod Slemmons
Director, Museum of Contemporary Photography,
Chicago

AFTERWORD BY
Senator Richard G. Lugar
United States Senator for Indiana

UMBRAGE EDITIONS

An Umbrage Editions book
Publisher: Nan Richardson
Design: Erin Harney
Copyediting: Rebecca Bengal

Umbrage Editions, Inc.
515 Canal Street #4
New York, New York 10013
www.umbragebooks.com

This book was designed by
Paul Carlos and Urshula Barbour of
Pure+Applied, New York
www.pureandapplied.com

Printed in Italy

Umbrage Editions
is distributed by Consortium in North America
www.cbsd.com
and worldwide by Turnaround
www.turnaround-uk.com

: Foreword

No THINKING AMERICAN ALIVE during the Vietnam War era survived unscathed. And those memories are now being resurrected, or at least revisited, as we are embroiled in another war with less than clear goals, mounting casualties, and returning combat veterans. But the personal memories of those who actually fought in Vietnam have never needed resurrection—combat shifts the mind into the eternally present and eliminates the concept of memory. This book is about those veterans and how their lives today are perpetually informed by their lives then. We can all talk about war in the abstract, and about how it advances or distorts American interests, but we only occasionally get to see the faces and hear the voices of the people who actually do the fighting. These people know things that those of us who weren't there have no words to describe or experiences to relate to. We can look at them and hear their stories, and even think about the whole issue profoundly, but we can never know what they know.

Jeff Wolin began interviewing and making portraits of Vietnam War veterans in 1992, at the same time that he began a similar project with Holocaust survivors. The latter project took precedence because the subjects were dying and there was some urgency. It eventually became a traveling exhibition and book, *Written in Memory* (Chronicle Books, 1997). In early 2003, Wolin resumed his work on the Vietnam veteran project by re-contacting those he had worked with earlier and building a network that gained him access to veterans beyond the Midwest. Senator Richard Lugar of Indiana, then spearheading the Veterans History Project, wrote a letter on Wolin's behalf to Vietnam veterans in Indiana, which ultimately allowed him to expand his network nationwide. As an official partner of the Veterans History Project, Wolin's videotaped interviews will be archived at the Library of Congress.

In Wolin's own words: "From the *Iliad* onward, war has been a major theme in art and literature. I hope that my photographs and interviews will make a contribution to our understanding of how the trauma of war affects combatants, and civilians caught in literal and philosophical crossfire. Many important issues of war and peace emerge in the stories of these veterans and in the portraits themselves. Many veterans suffer from post-traumatic stress disorder. Some still wear their Vietnam War medals. Some fight for veterans' medical issues or make art or write books about their experiences. Others have found ways to put their experiences behind them, often with significant struggle, and to successfully return to civilian life. All were deeply and permanently affected by the war, but the majority are proud of their service."

Imagine an expanded version of Wolin's project—a series of photographic portraits and written interviews of men and women who fought in and survived the Civil War, the Spanish-American War, the First and Second World Wars, the Korean conflict, and so on—normal-looking people in their familiar surroundings, occasionally on the margins of society, with horrific stories to tell that we believe because this person in front of us was there and most of us weren't. In a significant way, this is a book about the inability of photography to record life completely, and especially to record the human consequences of war. We have a pathological confidence in information coming in through photographic media, until we hear the words of an eyewitness, reminding us of the first sentence of Herman Melville's novel, *Moby Dick*, spoken by the only survivor of Ahab's ill-fated mission: "Call me Ishmael."

Rod Slemmons, Director, Museum of Contemporary Photography, Chicago

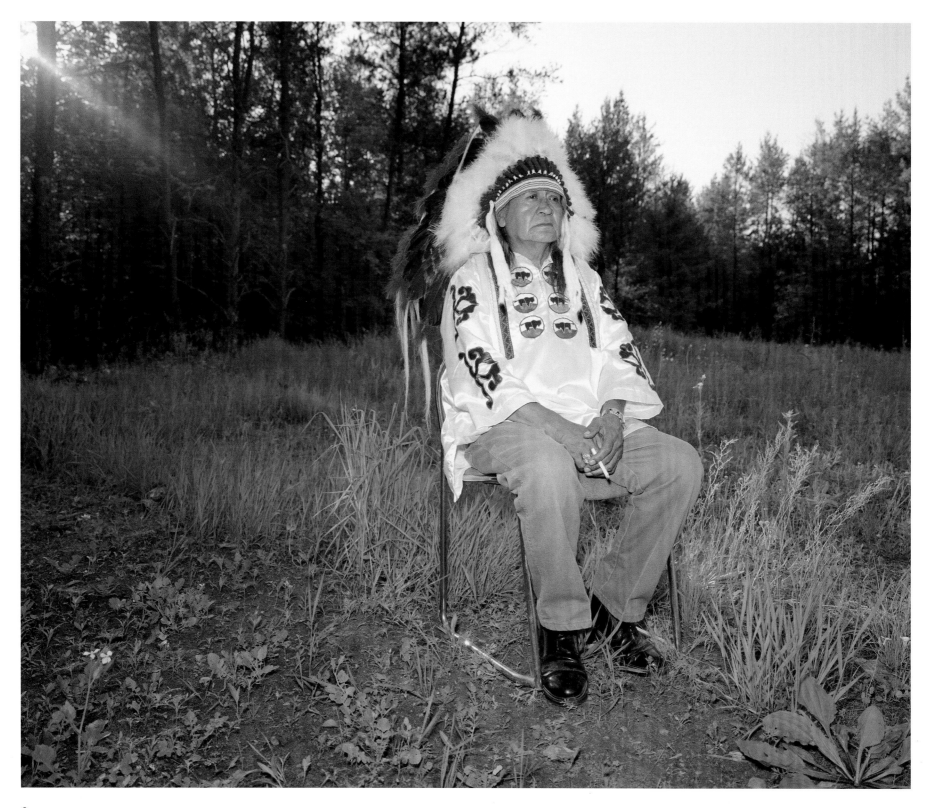

: Owen Mike

[**U.S. Marine Corps Lance Corporal** | **Summer 1968–March 1970**]

"**I**'M A NATIVE AMERICAN, Ho Chunk Nation, from Wisconsin. Above everything I accept my own death as destiny. It's a great honor to die as a warrior on the battlegrounds. Summer of 1968, I got in-country. I was assigned to the 3rd Marine Division, which was located by Quang Tri city up in the northern I Corps. My first assignment was with the H/S Company 3/9 in communication. I talked to my CO, told him, 'I'm an American Indian. I came here to fight a war. I want to be with an infantry company.' I was then transferred to I Company, 3/9.

On or about Christmastime 1968, I experienced my very first firefight—it was terrifying. Before the Dewey Canyon operation in A Shau Valley, one of my closest friends was killed while walking point; I volunteered to take over his job. It's nerve-racking and tiresome to walk alone far up in front of my platoon and my company. Walking point, life expectancy is very short; you are usually the first contact with the enemy you were killed or wounded. I was good and became a deadly killer and hunted for the enemy and did my job well. I was never scared. The only fear I had was the fear of being captured.

One operation that I didn't walk point we got hit. The enemy was shooting at us from the top of this mountain. As we all started to run up, a sergeant from another platoon was hit! He was screaming for help. I ran up towards where he was lying. He was hit in the arm; his bone was sticking out.

I cut up his flak jacket and his jungle shirt and used the shirt and his first-aid kit to stop the bleeding. Carefully I pulled his arm bone back then tied it with the cloths that I had cut up, using the flak jacket armor to keep the bone in place to prevent further injury. I stayed and protected him until a corpsman came. I left them to find my squad; probably saved his life.

There was an Army unit in Laos; they were getting hit bad. We were not supposed to be there when we flew in. Early in the morning, it was still dark. I was on guard duty when a blue flare exploded above us. Suddenly the enemy attacked us in waves. We held our positions and fought them off until the sun came up when it was over.

We captured an enemy soldier. I wanted to kill him but I chose not to because he was not on equal terms with me. We went out on patrols to look for more. With my platoon I came upon an enemy soldier, shot a whole clip of rounds in him and killed him.

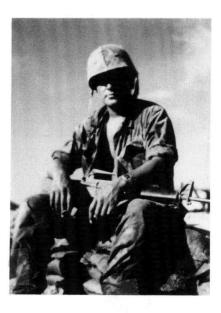

In fall 1969 they started pulling some of the 3rd Marines Division out of Vietnam—my tour had ended. I left Vietnam and flew to Okinawa. I left there and landed at Travis Air Force Base in California. March of 1970 it was cold; the snow was flying when I finally made it home to Wisconsin where my journey had all started.

I was discharged from the U.S. Marine Corps in September 1971. Memories still haunt me of when I was a young Ho Chunk Marine that went to war and survived through many firefights on the battlegrounds from A Shau Valley, to Laos, the DMZ, and the jungles of Vietnam.

To all my Marines who gave their ultimate sacrifice for me, thank you! To be where I am today, I have never forgotten you. Your sacrifice was not in vain but with VALOR AND HONOR, *Semper Fidelis*."

: Dennis "Denny" Brown

[**U.S. Marine Corps Private First Class** | **February 1966–March 1966**]

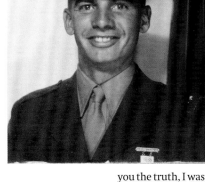

"WE BOARDED HELICOPTERS on March 20, 1966. We were in the lead helicopter. There were only five of us, plus the pilot and machine gunner. There was Lt. McMahon, Cpl. Floyd, L/Cpl. Groover, the head of our fire team, PFC Dale and I. We flew about seventeen miles north of Phu Bai, our base. The choppers went down real fast when we got to our destination. We got within two feet of the rice paddies and someone yelled, 'Get out fast!' They weren't going to land because they didn't know if there were North Vietnamese around.

So we jumped out of the helicopters, went down into the water and mud, took off running to the nearest dike. All around the rice paddies were trees. We got down behind these rice paddy dikes and waited until all the choppers had unloaded. It took quite a few minutes—there were 180 of us Marines in Bravo Company. I could hear the last helicopters go, 'Whoop, whoop, whoop,' going out of sight. And then there was absolute silence. I remember how lonely we felt. And you knew there was only going to be one way out.

After Bravo Company landed, Capt. Alexander formed us up. We took off walking down this trail past rice paddies and parallel to the paddies were tree lines. Somebody said, 'I saw a North Vietnamese soldier over there.' So we left the path and walked to the dike and looked across the rice paddy to the other dikes. The tree line was only about fifteen feet behind the other dikes where the NVA [North Vietnamese Army] was dug in. We got down behind our dikes. The NVA was concealed by the tree line.

We were ordered, 'Groover, get your fire team out there and search out the tree line.' At that time I knew that was it. We checked our rifles to make sure we had a round in the chamber. We made sure our safeties were off. To tell you the truth, I was just resigned to dying. I found out in that instant that if your fate is out of your hands, a calmness comes over you.

Groover, Dale, and I got up and left the dike and started walking across the rice paddy and when we got about halfway across—we were only about forty feet from them—I was thinking, 'I wish they'd go ahead and do something.' All the time we were walking I just figured this was my last day in combat and we were all going home in body bags because we were too close to them and the rice was only waist deep—there was no place to hide.

We got halfway across that rice paddy and there was a little bush about six feet tall. A North Vietnamese soldier stood up and threw a grenade at me. I started to hit the ground and they shot me three times with a machine gun. When that happened both sides opened up. There were thousands of bullets flying through the rice—a wall of fire coming from both directions and I was right in the middle of it. I had been shot three times plus I had shrapnel from the grenade.

I lay there for a while—I couldn't move. Groover cradled his rifle in his arms and low-crawled to me through the rice. He got me by my right hand and pulled me a few feet. But you have to remember, it was mud and water and all the time the battle is going on. Groover was exhausted by then. He looked back at me and released my hand and at the same time he got hit by four bullets from a machine gun.

Later that day Cpl. Floyd, our squad leader, and a Navy corpsman crawled out to Groover and me. Cpl. Floyd said, 'Groover's dead. We'll take Brown first.' They dragged me back to the dike and left me because they couldn't hoist me over; there was too much fire. I laid up against the dike on my belly; the NVA could see me. They went back to get Groover because no matter if you're dead or wounded, the Marine Corps will come and get you. I lay by that dike a while and later on that day a Marine I didn't know crawled up to me and he must have been awfully strong because he got his hands under my body and threw me over the dike to safety.

It was an honor to have served beside heroes when I was young. Each day I recall their loyalty and courage in combat. My wife, Diana, is proud of my service in the Marine Corps and in Vietnam. Her love and understanding has had a calming effect on me through the years.

After the war I phoned Marjorie Groover in Pensacola, Florida, the mother of Lt. Cpl. Groover, the boy who came after me that day and lost his life. When I talked to her, she never did cry. She told me this story: 'Denny, they sent my son's body home in a sealed casket with orders not to open it. But when I got his body home I just had to have them open the casket because if I hadn't, I would always be expecting him to walk through the front door. And when I looked upon his face, he was beautiful.'"

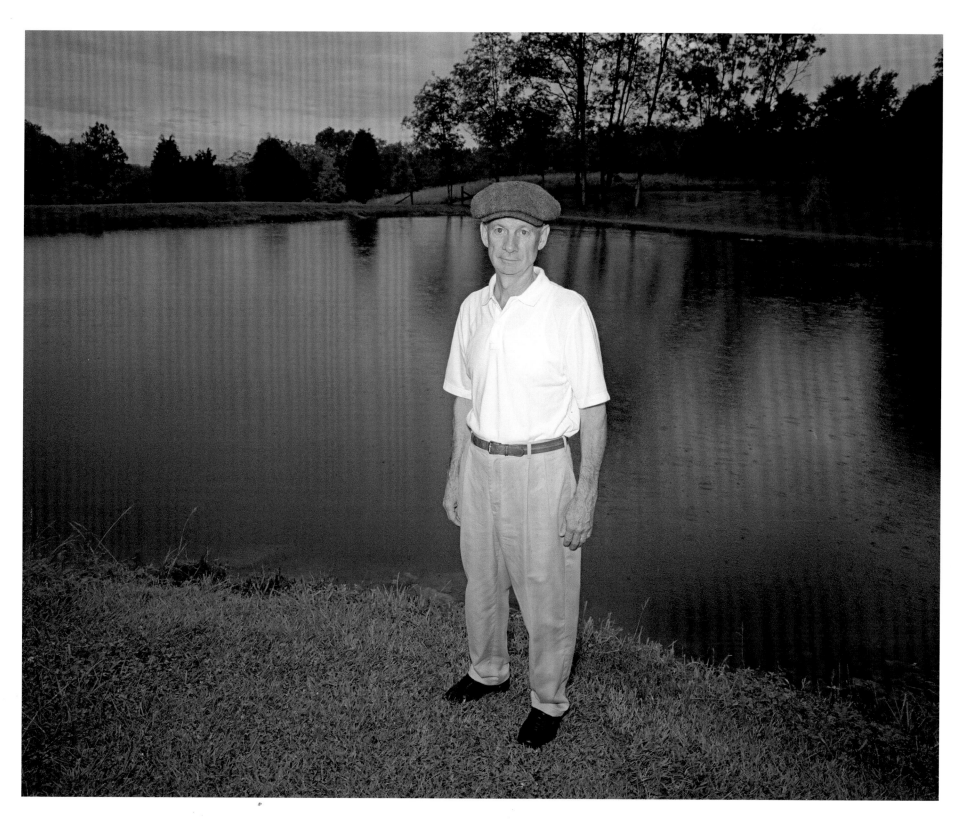

: Greg "Blue" Miller

[U.S. Army Specialist E-5 | February 1970–April 1971]

"**O**N THAT MOUNTAINTOP one of the first things the captain said to me was, 'You're walking the point.' And I said, 'You know, I'm not transferring in from another company. I'm brand-new.' And he goes, 'That's why you're walking the point. We don't want to do it. Don't worry. We'll teach you.' So I walked point for seven months. I was lucky. Very, very lucky. So many things happened. We were mostly in the jungles, a lot in the mountains. We were doing search and destroy; ambushes at night. We worked the river a lot.

When I walked point, I looked for booby traps. Our area was so booby-trapped it was crazy. The first booby trap I found was a 500-pound bomb. We were on a three- or four-man patrol trying to get back to our fire support base, pick up something and come back out. We were near My Lai—our brigade had Lt. Calley. I just happened to glance over as we were crossing a trail, because you could never walk on them, and I saw a hole in the sand. What they had done was put thatching and covered it with sand on this big trail. What they were doing, we figured, was trying to get a tank. But it was 500 pounds and we came back to blow it up and we didn't bother digging it up. We just put a Claymore mine on it and crawled back a certain range and boom! It lifted in the air—stuff falling all over us. We were laughing; we were cussing. Had no idea how big it was. We started digging stuff up after that.

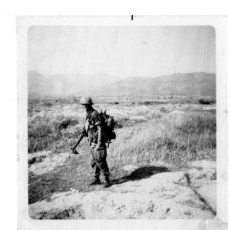

But that was luck. They actually took me off the point for a little while because, you know, you go through periods of depression. You think, 'If only I'd hit that little bitty booby trap they'd be sending me home in a body bag.'

The very first time we were out, the guy that took my place came into a tunnel complex. So they called me up to check it out and as I came up he's got the end of his rifle under a big rice shaker and he's getting ready to flip it over which you don't ever do—you got to check it for booby traps. So I just start backing up. I'm going, 'No, no,' and I stepped right on a booby trap, a hole the size of a shoe box they'd strung a wire across—staked it. It was hooked up to an RPG round, rocket-propelled grenade, which if it went off, we wouldn't be having this conversation—I'd be dead. And I hit it so hard that it snapped the wire instead of pulling the wire. It was down on this riverbed so it could have been rusty. It was just pure luck, pure luck. We dug that one up—we were kind of amazed. But after that happened, I decided, you know, put me back on point. I'd rather die from something I did wrong, my own mistake, and you're out far enough so no one else gets involved. I was lucky and I could tell it, so I didn't mind walking the point, until I got hit.

We were on this real big push. The area I was in was strictly VC [Viet Cong]—unless we'd go outside our area of operation, then we'd start running into NVA, like up in the mountains. So the first time there was a big push of NVA coming in, they brought our whole brigade—company after company coming in all night long. We were sitting on the side of this hill watching all these choppers coming into this big valley.

I was walking point for our company at the time. We were kind of pinned down. My squad was hanging out and they sent a new squad up this trench line where you have bamboo and trees growing. Their point man got pinned down and I went up to take his spot and one of our helicopters almost shot me—they mistook me for NVA. I looked up and here's this machine gunner in a Huey and I heard the rounds hit in the dirt around me, but he missed me. We got on the radio and they called in jets, called in gun ships. We had tracks coming in because we had trapped a big NVA force.

I'd blown an ambush the day or two before where they were setting us up with .51 caliber machine guns, which you didn't run into with the VC—it was all small arms. It was a daylong firefight with things hitting all day here and there. I wound up trading grenades with this guy and I ran out. I turned to my friend behind me and right then I heard 'pop,' but I just thought someone was taking a shot. I saw my friend's eyes get big and he started to yell, 'Chi Com,' and I already knew it. The thing fell between my legs and I looked down and I saw it and I remember vividly the weed I grabbed onto by the side of this trench to yank myself up to get away from this blast—and the thing went off, and I just sailed out in the middle of this rice paddy.

I'm lying there and the first thing I remember is, 'Can I move my toes?' Because I knew I shouldn't have legs, and I said, 'OK. I can move my toes.' But then I remembered the syndrome where you still feel the limb you lost. I didn't want to look down. I thought, 'Oh shit! No one is coming to get me at all.' All the hair stood up on the back of my neck. I realized I didn't have my M-16 any more. I didn't have any weapons on me at all. I thought the NVA would come up and grab me so I started crawling back to the trench line and I see my friend. Well, he'd taken the explosion up his leg. I said, 'Can you walk?' He goes, 'I think so.' So I got up and realized I could see the blood and stuff but I was OK. And I actually walked out of there.

They put me on the first dust-off—it's a special chopper with the red cross on it. I've still got four chunks of metal in my legs that they just left. I had *Love Story* in my pocket. When I was in the first hospital they came up to me and they said, 'Do you want this?' The book was shredded in half, but also had my blood and body pieces. I'm going, 'No. I don't want that. Jeez!' I don't think it protected me but it was in my pants pocket just out from my leg and that's where the big part of the blast went. It was pure luck the way it went off; the way it landed. But then it was severe enough that I never had to go back out to the bush."

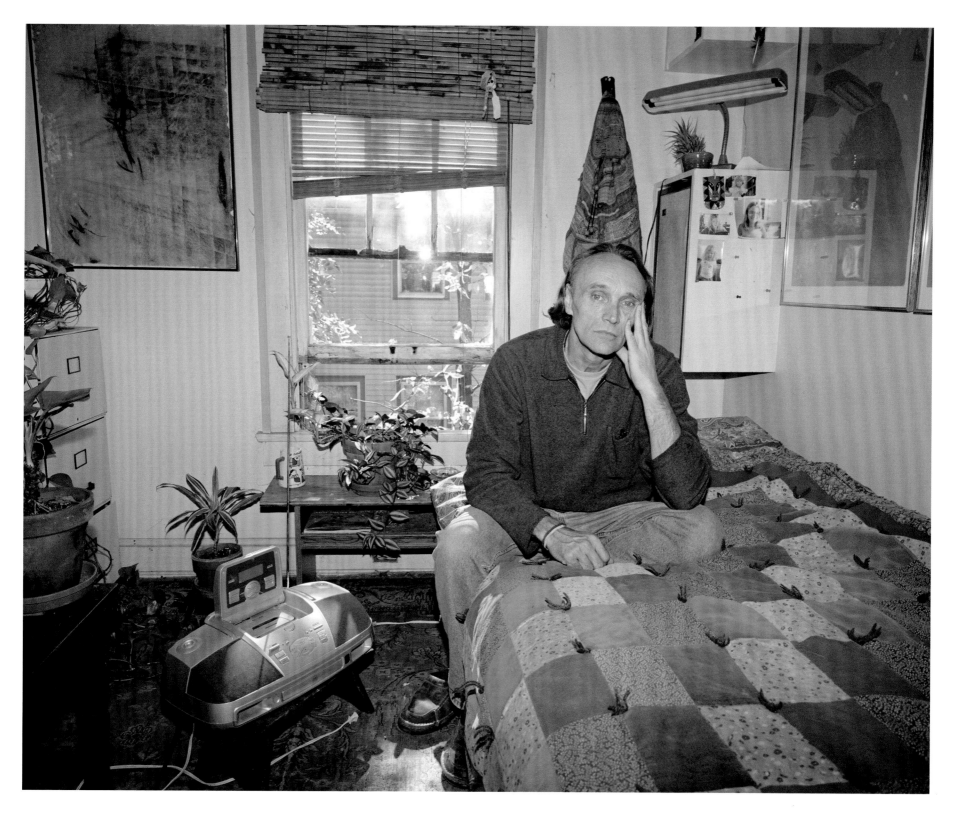

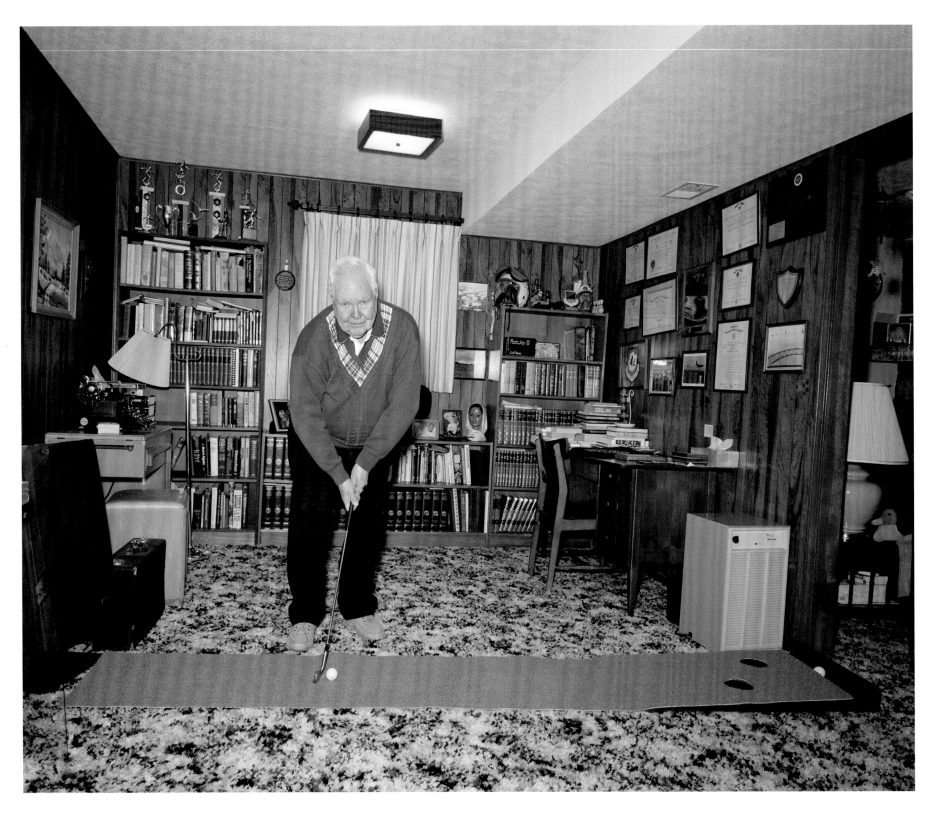

"**I**WAS SENT TO VIETNAM IN 1965. My initial assignment was a Blue Ribbon project to go to MACV (Military Assistance Command, Vietnam) as an air advisor, but the escalation in spring 1965 changed all that. They started pouring troops in and I was on the second aircraft that started bringing troops in. When I arrived there were somewhere between 18–20,000 troops. They started pouring in and it was a real fiasco. They didn't have places for us to live. They filled the available military quarters in downtown Saigon with troops. I finally got a room in a commercial hotel. I was stationed in Tan Son Nhut, one of the main bases just outside Saigon. I was the Admin Officer for the Deputy Commander of Operations for the first six months. I was involved mainly in processing top-security messages, administrative-type work for General Simmler, the D.O.

After six months I was put into the airlift division of the deputate and I was the Seventh Air Force representative to the herbicide program, Agent Orange. The herbicide program was very interesting and has a lot of bad publicity now, but they couldn't fill all the requests from the Army, Air Force—everybody requested it. And that was processed through the South Vietnamese Army and the embassy. Along the highways, like Highway One, and along the Saigon River where they had to bring almost all the supplies, there were choke points, heavy jungle, and there were many places where ambushes would take place. We defoliated these areas. And the Army and Marines and so forth would have bases where they encamped in the jungle and they'd have a perimeter. We'd defoliate around there.

They'd fly in formations of three or four in C-123's, spray planes. They'd go in at very low altitudes and gunfire was a danger. People could stand up and see a little airplane coming at 100 feet and take a potshot at it. In places where they suspected there would be problems, they would have the A1's come in and they would strafe and bomb. They did those missions at very low altitudes.

First mission I flew in Vietnam—I'd never been in combat before—I could hear this *pop, pop, pop, pop*. I thought it was an engine backfiring. I was sitting jump seat. So I mentioned to the pilot, 'Is that the engine backfiring?' He said, 'No. That's gunfire. They're shooting at us.' Now the humorous side of this is that we all had flak vests and I, a newbie, put the vest on like you're supposed to and the rest of the guys put their flak vests on their seats and sat on them. And I couldn't understand that and didn't want to say anything. If they didn't want to wear their flak vests that's their damn business. Just about that time, 'ping', a bullet goes up through the cabin and I took my flak jacket off real quick and sat on it. And while I was there I think the only time anyone got wounded—see, the Vietnamese were poor shots—someone caught a bullet in his butt. The planes got a lot of bullet holes.

But that was my job, to coordinate the operation. We'd get the requests; they'd go up through the Vietnamese Army and eventually get over to MACV and the diplomatic representative. There was a Department of Agriculture aide over there and they'd have a coordination meeting and decide whether we should or should not grant the request. Then if we approved the request we went out to the province chief and there we coordinated with him and got his approval to do that and there would be representatives of the Vietnamese Army and there would be representatives of the U.S. civilian-type, and military, the crew of Ranch Hand Squadron. I was in on that. And then when we had the dates and permission all worked out, usually two or three days before, psychological Air Cav with loudspeakers would fly over the area and advise any Vietnamese and Americans who might be in the area, that defoliation would be taking place.

Later on they graduated to a more sophisticated and more extensive operation. Reinforcements from North Vietnam coming down the Ho Chi Minh Trail would go into the jungle and they'd be lost—you couldn't find them. We wanted to interdict so we decided we'd take this particular area where we knew that they were somewhere and we criss-crossed the area and defoliated it and then you could see the trail. That was pretty effective.

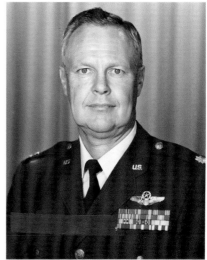

Then we found that the Vietnamese would grow rice and the Viet Cong would wait until harvest time and go in and take the rice away from the villagers. So somebody got the idea that we wouldn't let them grow rice in those areas. We defoliated the rice fields and I suppose rice was brought in to feed the village, but it was an effective means of denying guerrilla-type Viet Cong their food supply. Those were the principle uses while I was there. The Agent Orange itself—I don't know the medical ramifications of it at all, but at that particular time people were damn glad to get it and they were crying for it. We probably didn't know, or didn't think about it, or it was of minor importance as to the effects on the human body in later years.

Well that was my basic job. As a pilot I also flew resupply. I was still flying the old C-47 and I flew both administrative hops and resupply in the C-47."

: R. Michael Rosensweig

[**U.S. Army Rangers Specialist E-4** | **January 1969– February 1971**]

"**A**FTER MY FIRST TOUR OF DUTY in Vietnam I had orders for Fort Bragg. I got back to the States and at that time my family was in Baltimore. I was walking up Howard Street in downtown Baltimore—I was still in uniform. A truck backfired about two blocks behind me. I just yelled, 'Incoming!', and hit the pavement. It just freaked everybody out. I said, 'To hell with this.' Next day I took the bus, went down to the Pentagon and had orders changed to go back to 'Nam—just wasn't ready to come back to what we like to call 'civilization.' I wasn't done fighting my war—there was still a cause to be fought for.

I enjoyed the combat—the adrenaline. Don't mistake that. Don't mistake the love of combat for the lack of fear. We were all scared—just some of us got off on the adrenaline.

As far as getting orders changed, it was no problem. I just went down there, told them I wanted a change to go back to 'Nam. Eighteen days later I was back in country. I went through Rangers school—we had our own school in Vietnam. It was ten days of sheer hell. Our training was geared to guerilla fighting. I was stationed in the same area as my first tour, Central Highlands. The company was based in An Khe.

I loved being with the Rangers. We were a six-man hunter-killer team. Our mission was to go out and kill. Go in, strike, get out—covert. Sometimes, if there were too many NVA, we had to call in air strikes. Sometimes we had to call them in a lot closer than was allowed by military regs. In some cases it was do that or die anyway.

War just leaves scars that will never heal up in your head because of the overall trauma. The first person I ever had to kill was an eight-year-old boy. We were escorting the 101st Airborne in the A Shau Valley. A little boy ran out of the village with a grenade in his hand heading straight for a truckload of GI's—kind of hard to balance that one out. The grenade was in his hand. We tried to get him to stop—'Dong Lai!' 'Stop!' He just kept running with that Chi Com in his hand—it's a Chinese Communist grenade with a string fuse. We didn't have a choice. If we hadn't killed him he would have ended up throwing it in a truckload of GI's. He was about twenty-five yards away. There are too many other instances like this to list—and I say that in all sincerity. I just can't talk about them.

They deactivated my company just a few months after I left, when they started the withdrawal. A lot of guys who stayed went to either Special Forces or went to work for the CIA as black ops in Cambodia. The time I served with the Rangers was the pinnacle of everything I'd ever wanted to be. And when I lost that, I couldn't see past the war.

They sent me to Germany to an artillery unit as a mechanic and four months later I was out. A couple of Puerto Rican guys from New York were having some kind of big war among themselves and they made the mistake of coming through my room in the middle of the night. You don't just take somebody fresh out of combat and startle him in the middle of the night, because he ain't going to hide his head under the covers—he's coming out attacking. And that's what I did. The first I threw out the window; the other I pinned up against a locker and stuck a bayonet right up against his throat. I almost killed two of our guys—four months later I was out. There's a lot of stuff, especially with the Rangers, that's still classified and I can't talk about.

I have plenty of firepower. I stay pretty heavily armed at home and everybody that knows me knows better than just to drop in—I'm in my bunker. The woman I was married to for fourteen years was scared to death of me the whole time we were married because of the nightmares—wake up in the middle of the night crying, screaming, roaming around.

You know, because of our background in Vietnam, we had to watch our tempers more than anyone else. Society did not give us the right to get angry and shout. If we did that, we were considered lethal. I got fired more than once just for doing nothing more than anybody else would have done—got mad at somebody for doing something really stupid. Yelled at him. The reason I was given was because when I get mad, all people see in my eyes is death."

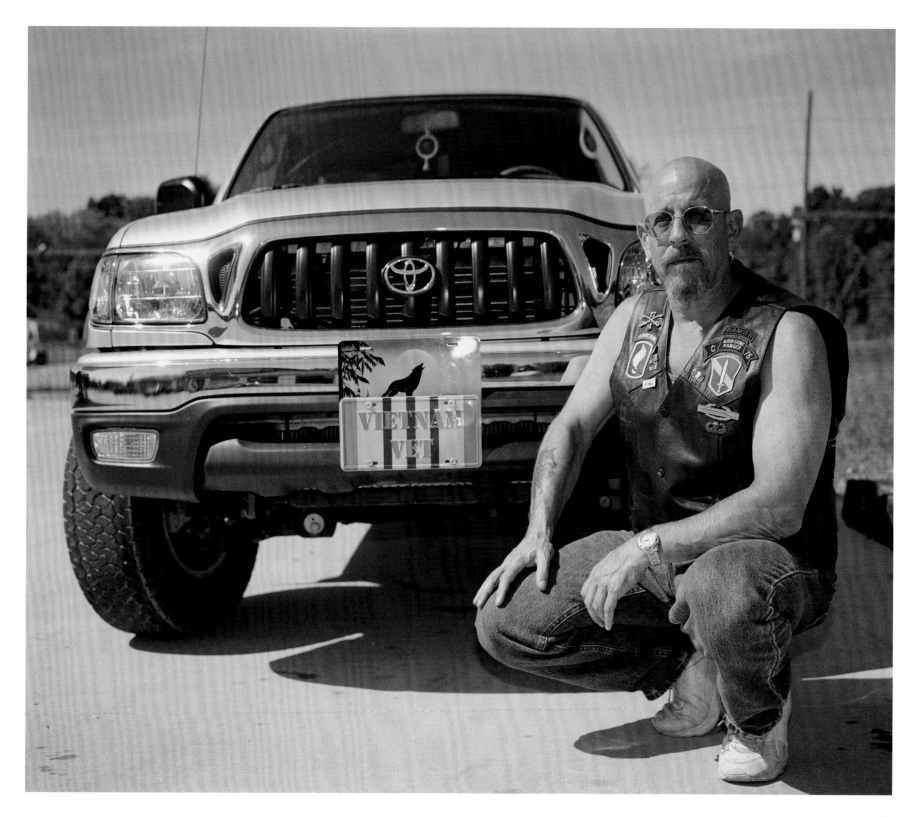

: Odell Newton

[**U.S. Army Specialist E-5** | **April 1970–February 1971**]

"**W**E KNEW THEY WERE OUT THERE. They hit us around 1:30 a.m. The sappers cut our barbed wire. They cut the wires for the Claymore mines we had out front. They came in by the bunker that was right next to mine, about forty feet away, and were on top of it, trying to set up a .51 caliber machine gun.

Of the five people in that bunker, four were dead. It was Patch, a guy from Texas, and we lost two more. We fought for half the night. We called in helicopters. We called in artillery left and right. By 4, 5 o'clock we knew there were no more NVA coming in and it was just a matter of finding those that were behind our lines.

When the NVA came in, they were high. They had to be on drugs judging from the

way they came in. I forget their preferred drugs but they were throwing grenades and not pulling the pins. I found three or four grenades outside my bunker they threw that they forgot to pull the pins. And some of them had tied their arms and legs off so if they got shot they wouldn't bleed to death. They had the tourniquets already applied.

The most disturbing thing was the next morning, there were all these bodies lying there. A plow dug a big hole; we dragged all the bodies, put them in the hole, put lime on top and covered the hole up. One of the sad things was remembering how the American soldiers messed with the bodies. We had lost soldiers so there was a revenge factor. In my mind the North Vietnamese were soldiers, just like I was. As a matter of fact they were defending more than I was at that time—it was their homeland. We stopped the soldiers that wanted to cut off ears and other body parts. We put a fast end to that. I ordered them not to mutilate the bodies. They did pretty much what I said.

Probably my worst experience was having one of our own platoons walk into one of our ambushes. It was our second platoon. There's an army expression that means messed up beyond belief. That platoon was messed up beyond belief. That platoon got almost wiped out three or four times while I was there and no one wanted to be in it.

We had set our automatic ambushes up on the trails we came in, any path we came in on, after everybody stopped moving. We had four platoons. We were in constant radio contact. So I radioed up to the command that we had stopped; everyone else had stopped. I sent a soldier out to set up the ambush—it was a six Claymore ambush. He didn't set it up far, maybe 100 feet away.

About twenty minutes later, the world shook—the automatic went off. At the same time, the second platoon called in that they'd been ambushed. I could hear them screaming without the radio. I put two and two together. They were not in the location they claimed to be; they were off by about two klicks and they were still moving—they were supposed to be stopped. We went out to police and I think we had killed three U.S. soldiers, and there were two or three more who were seriously wounded. I had buried that memory pretty deep. Without a doubt that had to be the low spot of my Vietnam experience. You are talking about eighteen and nineteen-year-olds. Due to poor leadership they got killed.

On my very first day in the field, our old platoon Sergeant, Gary Johnson, got killed. I was a 'shake and bake,' a ninety-day wonder just out of Fort Benning, Georgia. They picked me up off the LZ pretty late in the evening and wanted to make it back to a safe place away from the LZ. Johnson took me over to introduce me to the platoon I was going to be in. He gave me my ammo, my C rations. He said, 'We're going to go back out there. We're going to take a main trail. Don't ever take a trail, but right now we have to get there quickly.'

So we went down the trail. I was walking in the middle with Patch, the gentleman who later got killed in Operation Ranch in Cambodia. I heard a *ping*. I couldn't figure out what it was but everyone else was on the ground. I looked down the trail and saw these two little people with a great big gun, a .51 caliber. They were running down the trail. Gary had been walking point and I looked to where he was lying.

I walked up to Gary who was on his stomach. I rolled him over and my hand went all the way through his chest. The .51 caliber bullet went through his chest and took almost his entire back out. I put one of his dog tags in the body bag with him when the medevac arrived and I kept the other. As a matter of fact, just last year I gave Sgt. Johnson's dog tags to his brother. I carried Johnson's dog tags since April 1970 right after I came in-country. That was my first field day."

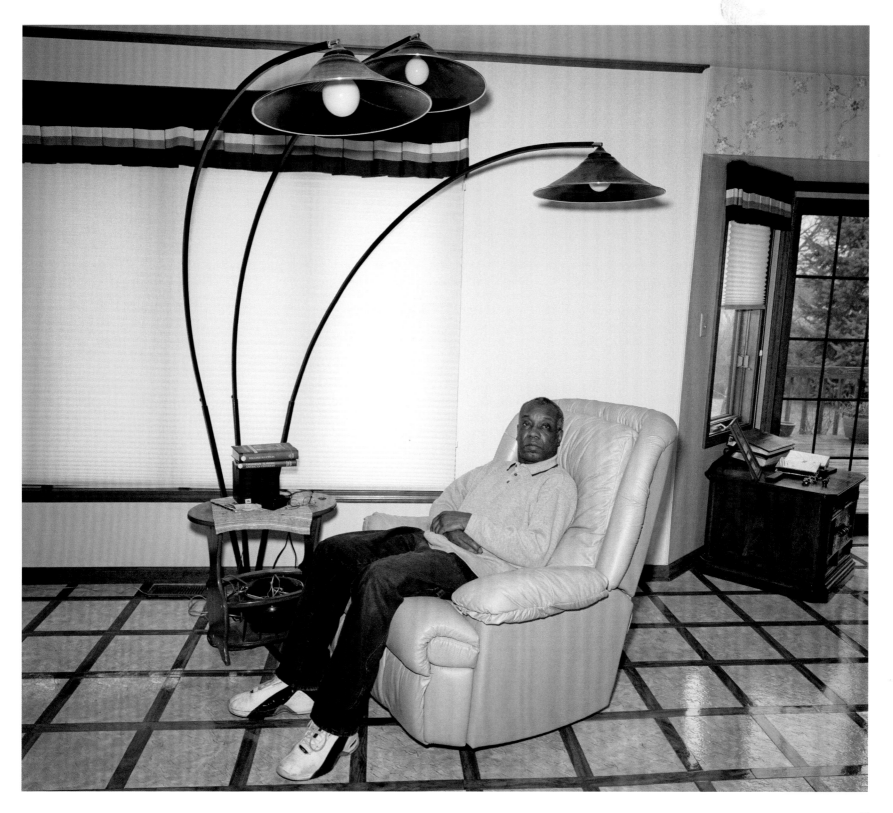

: Dale W. Jones

[U.S. Army Chaplain's Assistant Specialist E-5 | February 1968–February 1969]

"WE GOT UP AT SIX O'CLOCK. We had breakfast. We started work at seven. Usually what we would do is go over to the chapel, do a little paperwork, and then maybe the priest and I would go out and take a helicopter—the helicopter pad was right next to the chapel. We'd jump on a helicopter, fly out to a firebase, and we'd have services. This would take a couple of hours. Then we'd come back and there'd usually be a row of guys sitting on a bench waiting to see the chaplain—you *knew* what that was all about. They were anxious because they got a letter from their girlfriend or their wife—Dear John letters. So many times it was their best friend. A lot of them would be very distraught and determined that they needed to get back to the States. Of course, that was an impossibility—it was never going to happen. Sometimes that led to a bad end. The guy would go off the deep end, do something crazy and wind up in the stockade or some kind of military punishment. That was a sad thing.

Then we'd have lunch and come back in the afternoon and we'd usually get in a jeep and drive around to the different sectors and visit with the troops and then come back in the evening and have dinner. Then we might go back to the chapel—there might be a Bible study. I usually had something to do after that. As a matter of fact, when I was stationed at An Khe, we were so understaffed that I had guard duty. I averaged guard duty twenty-eight days out of thirty every month. So you get up at six, do your job, eat, and if you weren't at the chapel that evening for some activity, you were on guard duty. You'd have two hours on, four hours off, two hours on. Say for instance, you got off at six p.m.: You had your first tour at eight o'clock, so you went from eight to ten, then go sleep from ten to two, and go to four. And you were doing this every day. I was delirious at times. There was an old saying that there's two ways of doing things: the right way and the Army way.

We would visit a French leprosarium on a regular basis. It was on the ocean but to get to it we'd go over a series of mountains and down. This one particular day we were going down the mountain and coming around the curve was a little three-wheel Lambretta, and on the back was a Viet Cong. We didn't realize this until we started to pass each other. He had an AK-47 strapped to his back. I had my rifle right next to me but the funny part is, as we approached each other, we're looking at him and he's looking at us and we just passed each other. He went up and we went down. My rifle was right there—I could have just picked it up and popped him. It's just one of those things. Our jeep had 'GLORY' printed across the front and had two crosses on each side. We proceeded to the leprosarium and the nuns prepared us a seven-course meal—French bread, paté. It had a beautiful beach. We'd give them money, clothing, food. This place was the antithesis of every place else in Vietnam. It was quiet. It was beautiful—right on the ocean with the mountains behind it, tile floors.

Many times I would be in bed and the Charge of Quarters would say, 'Hey, the priest needs you—there's some casualties at the hospital.' So I'd get dressed; go get the jeep; go get the chaplain; go down to the hospital at the base or one of the field hospitals. You'd go in there and the doctors would be with their pliers pulling shrapnel out of these guys. Or some guy would be dead. I can remember in one case they pulled the sheet back—there was a piece of skull left, so the priest administered the last rites and used that piece of skull to apply the holy water with his thumb.

This was so long ago. I cannot remember the liturgy anymore—that was second nature to me. In a lot of cases when we'd go out in the field to have these services, people were more likely to show up than back at the base camp. It would be a little funny because the priest would make his statement and I'd make the response. That's normally done by the whole congregation but it would mostly be a private service between the priest and myself. I would represent the congregation. The rest of the guys honestly didn't even know the liturgy. But back in base camp you'd have a Sunday mass and only ten guys would show up. The others would rather go drink—they didn't feel that insecure back at the base camp.

I became an agnostic by the time I left. It just didn't make sense to me anymore. I couldn't imagine that there was some creator-type guy who was wanting to kind of torture us all a little bit and then if you didn't do everything just right, he was going to make me suffer for eternity. It just didn't make sense. Going in I was a dyed-in-the-wool altar-boy Catholic.

Father Gunning, the priest I worked for, went off and got married after we left. As a matter of fact, when I went to Australia for R&R, I developed a relationship with a lady there and I fixed him up on a date. He later went back to Connecticut and married a lady. He let me know that he had plans to leave the priesthood right before he left Vietnam.

Once we were talking about all the different kinds of sin: there's the venal sin; there's original sin—all the different kinds. And one of the guys, Nick, said, 'Father, what about masturbation?' And the priest kind of was quiet for a moment and then he said, 'You know what, there's only two kind of liars in this world. There's those who say they've never masturbated and those that say they quit.'

So you know we were irreverent. These people are people like you and me. They have all the foibles that you and I have. As a matter of fact, I can say this because I am an agnostic, but I really believe that the priests were the cream of the Chaplains Corps."

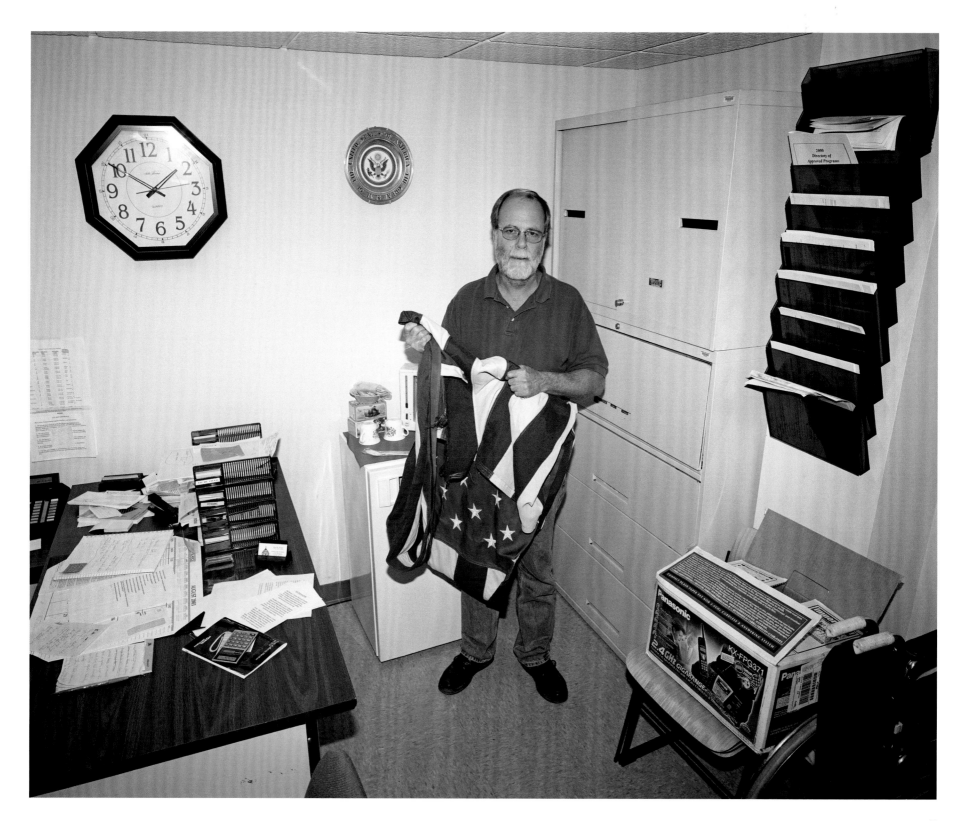

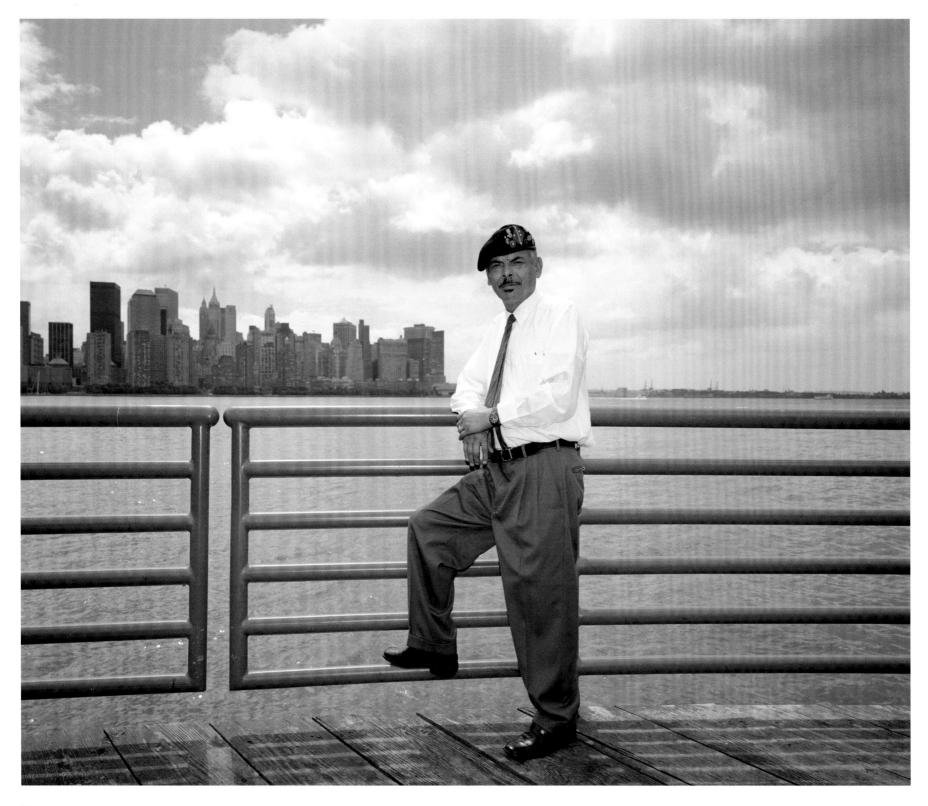

: Jaime Vazquez

[U.S. Marine Corps Corporal | October 1967–December 1968]

"VIETNAM WAS UNLIKE WORLD WAR II where the Nazis were invading Europe, and the Japanese attacked Pearl Harbor, and the enemy was readily identifiable. The Vietnamese had not attacked us so we didn't have this innate hatred for them to go out there and kill them. We had to have a reason to go there and kill. So the day before we left for Vietnam, they took 250 of us Marines and brought us to this training site—a big aluminum building with a stage—and they sat us down. A sergeant jumped on the stage and there were a lot of military police around.

The sergeant started talking about what was going to happen to us. Tomorrow we would be going into the combat zone. Look at the guy on your left: look at his face. Look at the guy on your right and look at his face. Three weeks from now one of them will be dead with his throat slit and his balls cut off and stuck in his mouth and that's because of the Vietnamese. And you know 'Jody'—the imaginary person who would stay behind and screw your girlfriend when you went to Vietnam, thanks to the Vietnamese. And your mother is going to be crying whether you're from Philadelphia or Indiana or Idaho or wherever. Your mother will shed tears for you, all of this because of the Vietnamese.

As he kept on talking he kept on riling up our anger, and riling up our anger to the point where we got so angry we would have killed any Oriental that would have been around us. At that point we Marines almost went out of control and we wanted to get this guy on the stage because of what he was saying and the way he was saying it. Out of nowhere about twenty military police appeared from the left and the right, and formed a cordon around the sergeant, and they took him out a side door into a black car and sped off.

The next day we were on an airplane to Vietnam with this hatred for the Vietnamese. It was because of these people that we were going to die there and our friends were going to die there and it was because of these people that our girlfriends would be screwing somebody else; it was because of them that our mothers would be suffering. I didn't know until years later that this was a psychological operation that was used against us. After a few weeks in Vietnam you learned the truth, and it wasn't like the sergeant had said, so the anger towards the Vietnamese left most of us. It just dissipated because the Vietnamese had never done anything to us. We were the ones who traveled 10,000 miles to attack their country…

I have two sons. One is twenty-three; the other is twenty. My twenty-year-old called me last night and said, 'Dad, I'm going to join.' I said, 'You're going to join what?' He said, 'Well, I've been to the Coast Guard and Navy recruiters and I'm going to join.' I never said to my sons, 'You will do this or you will not do this,' because they are men already. I was taken aback. I thought he'd gotten any desires to go into the military out of his system. His father went to Vietnam as a Marine, his grandfather fought in World War II and his uncles fought with the Sixty-Fifth Infantry during the Korean War. So we have a military history in my family.

So he called me last night, and I was just trying to guide him. 'If you're going to go, don't join now. You'll be in Iraq within a year.' He said, 'Yeah, dad, but I'll be in the Navy or the Coast Guard.' There's Navy people getting killed there and Coast Guard people putting their lives on the line but I can't order him not to do this. The only thing I can do is to teach him by example. I just hope he learns the lesson that I have learned, if he has to go to Iraq or some place like that. The lesson is that we have to try to do as much as we can to avoid going to war to avoid killing people.

Almost 2,000 Americans have died by this date in June 2005; 15,000 wounded. That's only the tip of the iceberg if we continue to stay in Iraq. Unfortunately, the people who die in Iraq, and the people who are permanently scarred mentally and physically, ten years after the war is over, nobody is going to care about them. Only their families will care. Only fellow veterans will care.

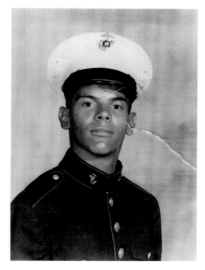

Even though I was opposed to Saddam Hussein, there's a difference between Saddam, and Osama bin Laden, who actually attacked us on the other side of the river here. I was here the day the World Trade Center was attacked. I went down to the waterfront and saw those buildings come down. There is a difference between Saddam Hussein, even though he was a dictator and a murderer, and what Osama bin Laden did in attacking the World Trade Center. I would have gone to war myself against the people who attacked us.

Since I came back from the Vietnam War, I have spoken to students and told them, 'The Vietnamese never attacked Grove Street—the street in front of the City Hall here in Jersey City—so why did I go to Vietnam to attack them?' Al Qaeda and Osama bin Laden did attack Grove Street, because a lot of people from Jersey City died in the World Trade Center.

I would guess that the one thing that really bothered me, that has always bothered me, is the cheapness of life in a combat zone. Think of the picture of the little Vietnamese girl running with no clothes on, burned by napalm. We bombed those villages and we really didn't care what happened to the people in them. It's something that we're paying for. We lost 60,000 Americans in Vietnam, but we killed more than 2,000,000 Vietnamese. Martin Luther King said that the moral arc of the universe is long but it bends towards justice. And when you compare 60,000 to 2,000,000, there is no comparison. I think we are paying for those human errors that we made."

: Phillip Zook

[**U.S. Army Lieutenant** | **December 1969–May 1970**]

"**W**E WERE MOVING INTO THE NVA BUNKER COMPLEX in Cambodia. There were a lot of B-52 bomb craters. My point man, Ruben Less, a Jamaican from New York, was very good; many times in the past he alerted us to danger. He saw something and stopped the company but he was shot and went down and that's how the engagement started. Of course we tried to move in to see if he was still alive. He was killed outright so we tried to get his body back. We pushed in and took a few more casualties. We couldn't get to his body. We pulled back.

On the twenty-fourth of May we expended three full loads of ammunition, meaning we were re-supplied three times. You can imagine that was a lot of fire that was going on. We took a few more casualties but we were actually in a pretty good situation.

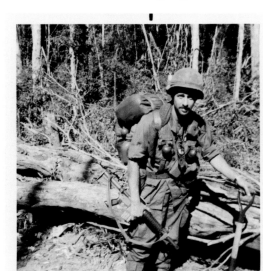

I'd already been hit with small arms fire—it had gone through my leg and there wasn't much blood, no bone damage. It ended up there was a little arterial and nerve damage but it wasn't a life-threatening wound. I was still up there fighting when we were mortared. We took so many casualties. Sam Morrison, my Radio Telephone Operator, who was right behind me, was killed. We took five killed and between thirty to forty wounded.

When the round hit we were trying to disengage. My platoon Sergeant was up and we were pulling people back from the fighting positions. The round went off—it was an airburst in the tree behind us. The shrapnel came down on us. I was knocked forward in a somersault. I took a piece of shrapnel in the back of my neck and my head and my face and down my arm and back and down my leg. I'm pretty sure some shrapnel hit my helmet. I spun forward and the helmet disappeared. When we got ourselves back up I was ambulatory, but I wasn't that ambulatory, so I slung an arm around Sgt. Edens, my platoon Sergeant, and he slung an arm around me and we went back.

We found Sammy and he was not dead yet, but he was obviously hurt pretty badly and people moved forward trying to help us get back from there. We checked the men, the bodies, to see if there was anyone that could be helped. We tried to get all the wounded back. When something like that happens, you go from a situation where you feel relatively in control to a situation where you lose all control.

The idea was to pull back as quickly as possible to some sort of defensive position where we could set up a medevac of the men who were most seriously hurt, and that's what we did. We were very vulnerable. The company could have been wiped out by a substantial ground attack, but we were fortunate because of what they call 'the fog of war.' It wasn't clear to the enemy what was happening in our defensive position—that we were medevacing and had people who were wounded and not capable of continuing to fight. But they didn't realize it.

I was medevaced out the next morning. The helicopter came and took six or so of us out. The rest of the wounded were ambulatory and walked out. My wounds weren't considered life-threatening to me. I was attended to, first by one of my riflemen. I was bleeding profusely from the back and from the leg, from the earlier gunshot wound, and then I'd taken shrapnel in both my legs. I had one leg that was bleeding. He cut the pants leg off and bandaged the wound. What ended up being the most serious injury: I had taken a piece of shrapnel in the ankle and it broke a small bone. You're pumped up on adrenaline. I was pretty sure I could do most things the first couple of hours but after the adrenaline goes down, the pain starts increasing. Plus I was hit in the face and my eye was swollen shut. You start feeling the pain.

Waking up after the surgery and finding a cast on your leg and your eye bandaged shut gives you a good dose of reality. But I never forgot that I was fortunate compared to a lot of the other men and a lot of my friends. There were men who were hurt a lot worse than I was, and there were men who were killed.

I got to Japan after being medevaced out of Vietnam. I was in a fifty-man ward at Camp Drake. The adrenaline is all gone and you've been operated on three times and you start feeling that nothing worse could happen to a person than what you've gone through, and you look over and the guy next to you has lost a leg, and the guy on the other side has been burned, and you realize that the Lord's been good to you, and what you're having to deal with is not as much as it might be and not as much as many of the people around you are having to deal with.

There's the misconception about what motivates guys in combat. You may get into it for a number of reasons: You may feel patriotism or you may feel compelled to go because your family has done it, or you don't have the courage to stand up and do something else. You may get in that situation for a lot of different reasons. But the reason people stay and that people fight is for their comrades. It's love, really, more so than anything else that motivates men in combat on the battlefield. There's no amount of fear or anger that could make a person run against an open field under fire to go to the aid of a friend. There's no amount of fear or anger to motivate somebody to throw his body over a comrade to protect him from shrapnel or small arms fire. That doesn't come from anything except love. Love of your comrades is the motivating factor on the battlefield."

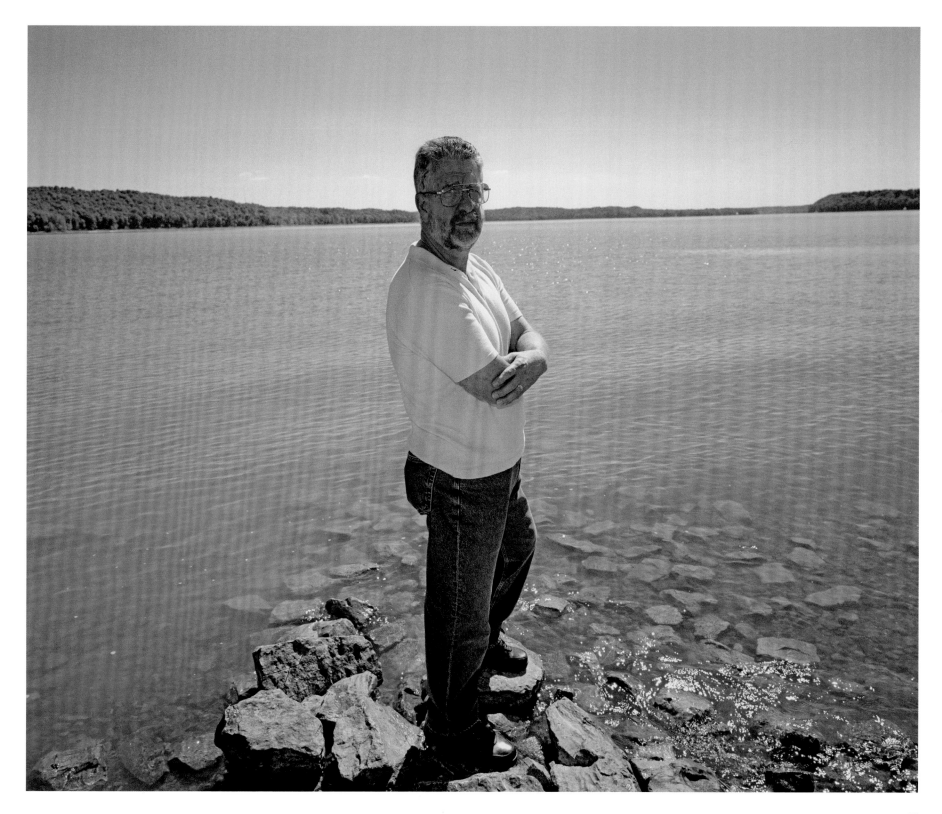

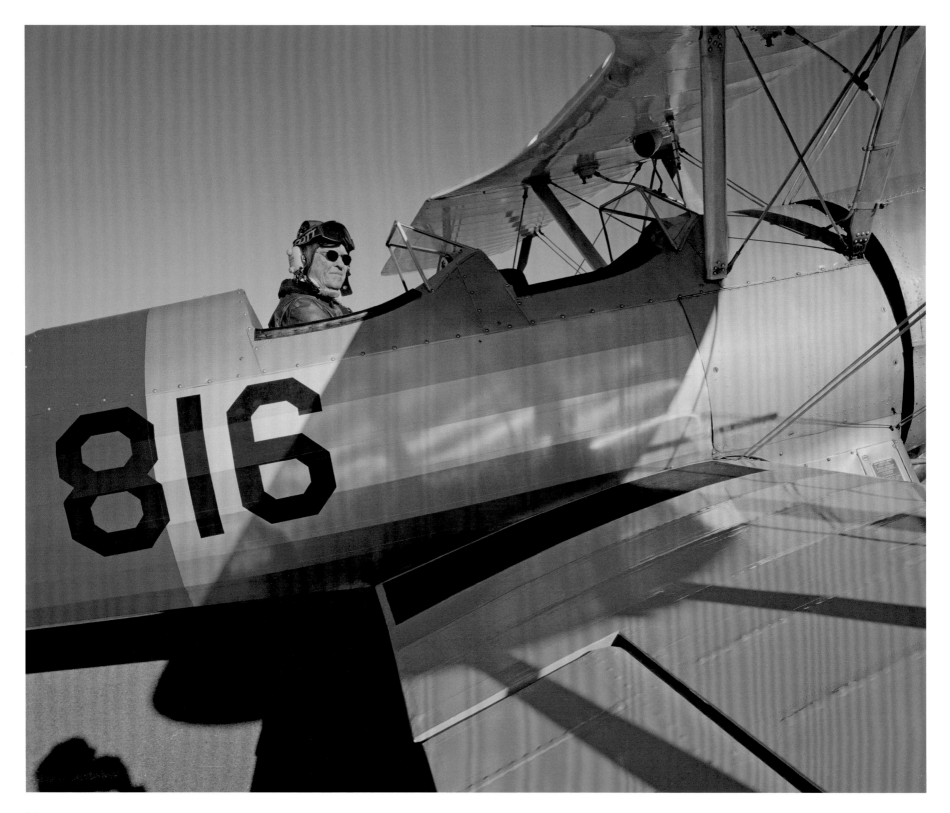

: George "Tom" Boone

[U.S. Air Force Major | January 1968–January 1969]

"**I** WAS A PILOT FOR OPERATION RANCH HAND, the twelfth Air Commando Squadron, stationed at Bien Hoa. We did the defoliation work spraying Agent Orange with C-123's. The C-123 was a great airplane for the job because the fuel tanks were right behind the engines and you could salvo them. You could eliminate a burning tank in a second, and there were very few fuel lines. This wouldn't always save you, but it surely helped.

We would typically fly two sorties per day. We would get up in the wee hours of the morning, have a quick breakfast, and go to our preflight briefing. We would then take off in formation and hit the first target exactly at daylight. The theory was that the enemy would still be sleeping and we would get through the first target without any shooting. It was a great theory; however, it just didn't seem to work. We would fly to the target area at 5,000 feet, and contact a Forward Air Controller who would 'smoke' the start of the target run. Then we would make a really steep descent and start the target run. We were supposed to spray at 100 feet off the tree-tops in order to get maximum coverage; but, when the shooting started you had a tendency to really get down on the deck because the lower you were, the safer you were. We expended our 1,000 gallons of defoliant during a four-minute run, and then tried to get to a safe area to climb out. That was the longest, most exciting four minutes in the world. Then we would return to base and do it all over again; we would usually be done for the day before noon.

They were always saying that we were the most shot at, and hit, operation in the history of air war. I don't know how true that was, but it seemed pretty accurate to me. Nobody ever got through an assignment without their plane taking hits, and at least half the guys had Purple Hearts and not from scratches. We couldn't bail out because we were too low while the shooting was going on and the plane had spray booms across the back that you would hit if you did jump. As a result, we didn't even carry parachutes. You just had to fly whatever was left of the plane as long as it would fly. My plane got hit on thirty-five missions and a few of them were pretty bad.

Most of the fire was from small arms; we wore body armor and our seats were armored to protect us. When the enemy would open up with the .50 caliber and other big stuff, it would get real serious. The heavy caliber bullets would go right through anything. They would even shoot rocket-propelled grenades, and one guy came back with a Montagnard arrow out of a crossbow stuck in his airplane. We might be the last military outfit that took hits from a crossbow. You took a lot of hits—that's all there was to it. I took my first hit on my first mission, and got my last hit on my last mission.

When the shooting started you would really get low because they would have less time to fire at you. I'm sure I was frequently only twenty-five feet off the tree-tops. Some of the airplanes had marks where guys hit the top of trees. We were low enough that you could get a real good look at the enemy and see if they were shooting at you or someone else—you would even see kids and women shooting. All of them seemed to be pretty bad shots. We would drop smoke grenades when we took fire and then the fighter escorts would hose down the area with some really bad stuff. It would sometimes look like the Fourth of July with everything going off. You could sometimes see the concussion when the ordnance would go off. If the women and kids were shooting, they usually got it too. That bothered me at first. Should you shoot at kids? No. If the kids are shooting at you, should you shoot at them? Yeah, I think so.

The day my flight commander got shot down you could see the gun emplacement that fired at him—it looked like a doughnut. They dug a round hole with a quad-mounted .50 caliber in the middle so they could shoot in any direction while standing in the hole. I was on Emmett's wing when they got him. They hosed him down really good and then turned on me, but the gun must have jammed because they started fiddling with it. Emmett's plane was burning like crazy—his right wing tank was on fire. I was screaming at him over the radio, 'Do this and do that' and finally his tank dropped off. We were making an escape over the South China Sea and that tank dropped like a huge ball of fire. Then his airplane slowly rolled over and went straight down into the sea.

I was never wounded, but I surely got scared occasionally. I know a couple of guys who said they were never scared and acted pretty casual about things, but it's awfully hard for me to believe that there was no fear in anyone. I would get extremely scared. I felt really bad about the fact that I might not get back to see my kids, and not watch them grow up, and not get back to my wife and parents.

I don't know of anybody who was having a great time over there. We would all have rather been somewhere else. I didn't want to go to Vietnam, didn't like it when I got there, and was happy to leave. But I was a career officer, and it was our job and our duty, so I went and I made the best of it."

: James LaFollette

[U.S. Navy Physician Lieutenant | August 1967–August 1968]

"**I** ARRIVED AT KHE SANH ON A C-123 AIRPLANE and was the only passenger. The plane was loaded with ammunition that the crew was going to drop off there. When we got to the plateau where the runway at Khe Sanh was located, the pilot says, 'Are you ready?' I asked, 'What do you mean by ready?' He replied, 'The enemy's got the end of the runway and they're going to try to get us when we land.'

The enemy shot at us as we were landing, so we landed quickly. The crew pushed the ammunition out the back of the plane—a parachute was attached, and they never did stop the plane. The plane slowed and I was told, 'Now jump!' And I jumped while they were shooting at us. That was the last plane to land that did not get hit. The next five planes to come in there were hit so the runway was closed. Everything after that was brought in by helicopter or dropped by parachute.

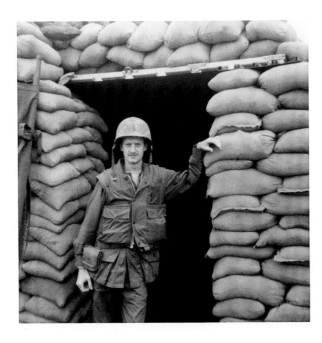

We had casualties every day. The first Battalion ninth Marines were sent out on a hill about a quarter of a mile west of Khe Sanh and the enemy had to come through that hill to get to Khe Sanh and we saw a lot of action. When we first went there, everyone was in foxholes, including myself. Eventually they made a bunker for me to treat casualties in, maybe thirty feet by ten feet. We sandbagged it so that it got to be fairly secure, but if you went outside the door, you were exposed to everything everyone else was. When we went out we'd put our flak jackets and helmets on and carried our guns. When I was outside the bunker, I had to check with the corpsmen around the hill where we had 1,000 men, most in foxholes and trenches. I also was required to walk to the command post for daily briefings.

Every day we had casualties and about seventy percent of the men in our group were killed or wounded. One company on patrol was totally wiped out in one night, either killed or wounded. They were just outside our perimeter.

I saw just about any injury a person could have and I had friends who were killed. The chaplain's assistant came around quite often and we spent a lot of time together. He knew the doctors were supplied with two-ounce bottles of whiskey. On his birthday he asked, 'Would you give me one of those bottles for my twenty-first birthday?' I said, 'You talked me into it,' and gave him one. He put his arms around me and gave me a hug. He took the bottle back to an area where there were ten of his friends. While they passed this two-ounce bottle of whiskey, the North Vietnamese dropped a mortar round in the middle of his group and we had eleven deaths within ten minutes of giving him that bottle. Although I was devastated, I had to check him over. When I saw his body, he did not appear to have any injuries but when I investigated further, he'd had a puncture wound that was about a quarter-inch long that went through the aorta, and he bled to death.

One man was brought to me by helicopter. The corpsman told me that this man had just died and we placed him on a stretcher. I looked at him and his pupils were still pinpoint, but there was no pulse. There was another doctor with me and we started CPR and got nowhere. The other doctor said, 'We're going to lose this guy unless you do cardiac massage.' I took a knife, opened his chest, and stuck my arm inside the chest and squeezed the heart. The man sat up, looked at me and said, 'What are you doing?' I told him to lay down. I sewed him up, inserted a chest tube so he could breathe, we medevaced him out, and he did just fine. He was dead when he arrived but we were able to save him.

With battle wounds, there are people with their legs and arms ripped off. People sometimes arrived with raw meat and bones exposed. It took a while to get used to this. The first day I was stationed in Vietnam we had twenty-seven amputees brought in at one time with anywhere from one to four of their limbs blown off. With such gruesome injuries, I was overwhelmed and thought, 'This is unreal.'

The one thing at Khe Sanh, though, along with the overwhelming needs of the wounded, I had a real fear that I would be killed. There were many times when our commanding officer would announce, 'We are going to be overrun tonight—there are ten times as many of them out there as there are of us.' That's a horrible fear to deal with and often I could not sleep. There were so many incoming mortars, rockets and artillery that it was very stressful. One end of our perimeter was overrun, but the enemy never got to the area where I was.

The siege of Khe Sanh lasted seventy-seven days. It was all part of the Tet Offensive. One day the enemy withdrew and suddenly there was no more action—we waited for something to happen. We went looking for the enemy and did not find them. I don't know where they went or what they did with their dead or wounded. Suddenly, there was nothing there except total devastation. It was defoliated with huge bomb craters everywhere."

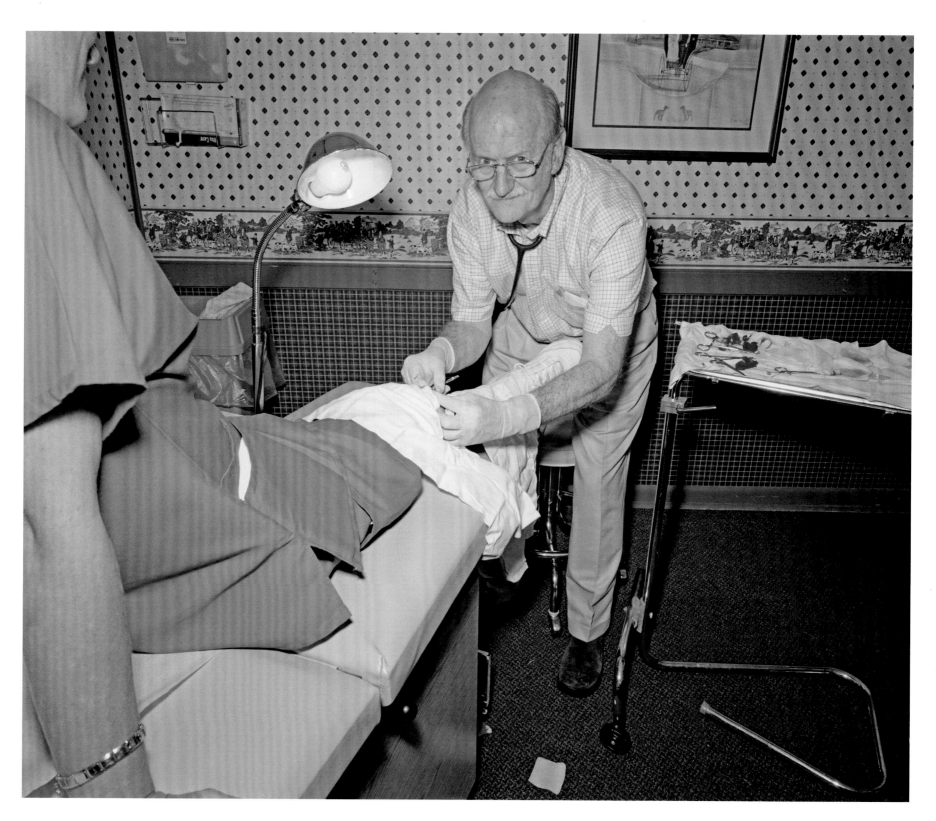

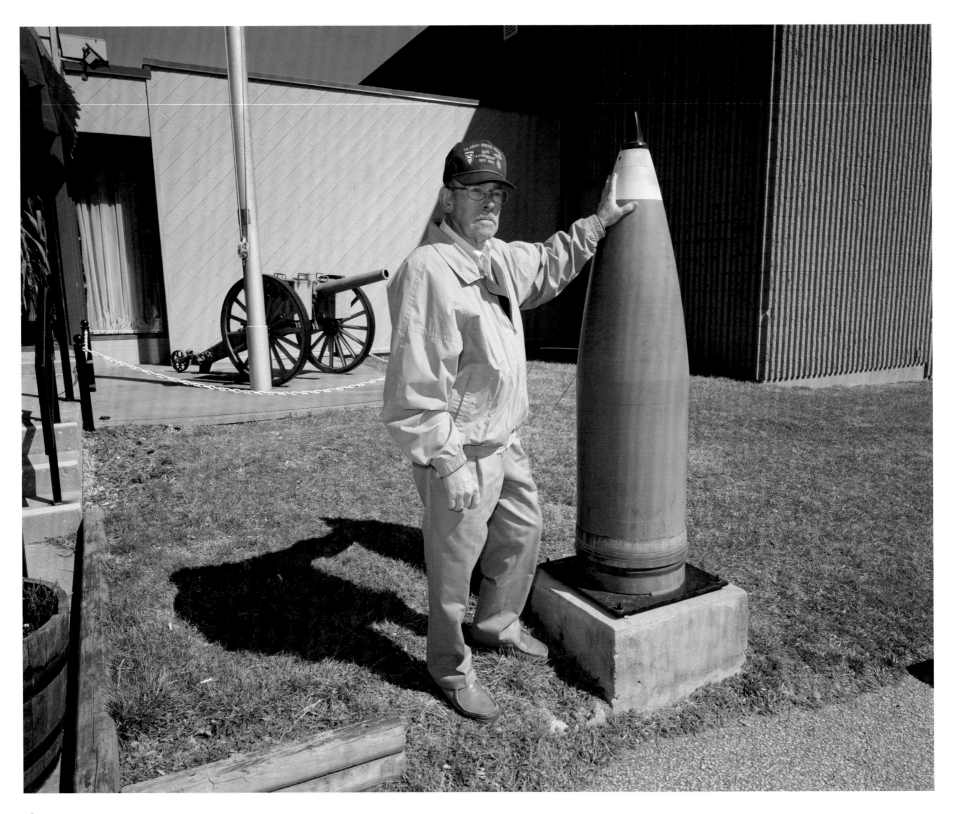

: Homer "Bud" Lynch

[U.S. Army Special Forces Lt. Colonel | September 1969–October 1970]

"I WAS THE COMMANDER OF DETACHMENT B-33 located at An Loc in the III Corps area from April to October 1970. B-33 was comprised of four border camps located at Minh Ton, Tong Le Chon, Loc Ninh, and Bu Dop along the Cambodian border. At each camp was a U.S. Special Forces A-Team comprised of a captain and lieutenant and ten enlisted men who advised and directed the operations of a company of Montagnards of 110–130 men and their dependents.

We were moving the force from the operation in the jungle near Bu Dop. We had about twenty Huey helicopters. We called them 'slicks.' They had a pilot, copilot, two door gunners, and a troop compartment. Then there was my command ship that I was in and two gun ships, and they had a pilot, copilot, two door gunners, and a rocket pod on each side. I think it held twelve rockets—pretty good size. Each rocket was the equivalent of a 105 mm artillery shell. They precede the slicks in to clear the zone and they'd suppress enemy fire against the helicopters coming in. The command ship stayed up high above all this to see what was developing.

One of our gun ships got shot down—it had taken rounds from the ground through the belly of the chopper. It knocked out the engine and they auto-rotated in. You don't have any power, but a helicopter pilot can change the pitch in the last few seconds before hitting the ground to cushion the fall. And they hit pretty hard and it broke the tail off the chopper. It was on fire—it looked like the sun on the ground. We landed close by in a rice paddy and jumped out and ran over. I got one door gunner out. We knocked out the fire first—we had fire extinguishers on board. My executive officer, Capt. Bill Walker, got the other door gunner out the other side. We got the copilot out—a warrant officer, Jimmy Graham. The pilot was still pinned in the wreckage. The rotor blade was broken off, and my door gunner and I tried to use it like a crow bar to lift the wreckage off his back.

At that point in time the rocket pod on our side, where I had just been standing a few moments before, exploded and flipped the helicopter up in the air and it came down on its top—killed the pilot. Killed Capt. Walker, although he didn't die immediately. My door gunner was hit in the face. Fortunately the chopper blade saved our bodies because we had it under our arms—the blade protected us from the shrapnel that came out of the rocket pod. And it flipped us up in the air like bugs. Before, when we went through the flames to get that door gunner out, I hadn't noticed the heat, but now I did, flying through the air—the heat. And I came down in the water, waist-deep water. And I thought I ought to stay under the water and get away from this flame that's on top. I crawled dog-fashion through the mud, underwater, until I had to come up for air. When I came up I saw a wound on my arm—the blood shot out like a fountain. I thought my arm was broken, so I grabbed it and held on, and my Seiko watch had flipped loose. I thought I'd lose my watch but if I grabbed my arm, I could stop the bleeding and wouldn't lose my watch. So that's what I did. My tail gunner got hit in the face. He was blinded. I didn't see him again, so I don't know if it was a permanent thing or not.

They got us on board the chopper but Capt. Walker was missing so I told them to find him, and they located him and brought him and put him in the chopper with all of us who were wounded. Flew us back to Quan Loi, which was maybe thirty to thirty-five minutes away to an aid station there at the airbase. They put an air splint on my arm and whatever other patches they put on. I was hit in the forearm, shoulder, and face with shrapnel. They got us back on another chopper for a flight to Saigon, the Twenty-Sixth Medevac Hospital. And I had them radio over to my camp at An Loc to tell them what had happened and that we were headed to Saigon to a hospital. And we landed—they were waiting on the ground and they got us in the first treatment room, and they said Bill Walker didn't make it.

My boss, Lt. Colonel Sidney Hinds, Commanding Officer of Company A, located at Bien Hoa in the III Corps area, was down there by that time. I was supposed to be medevaced home but I asked him not to medevac me. I said I didn't figure I was hurt bad enough for that. I wasn't ready to go home and see anybody. My attitude at that point was that I just wasn't ready to see family or friends back here. I still had work to do.

I lost use of my right thumb—there was nerve damage. In fact, there's some shrapnel in my arm and in my shoulder, and a couple of pieces in my forehead still. And some five years after I retired, a piece of shrapnel came out of my ear in the middle of the night.

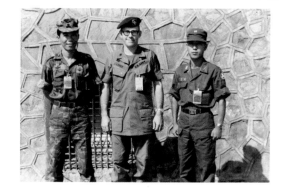

I feel very fortunate. A lot of guys weren't as lucky as me. The two door gunners from the chopper that got shot down died within three days. The warrant officer, Jimmy Graham—I went to see him. He was in some sort of metal frame, but he looked like a spider in a web. He had broken so many bones in his body when the chopper hit the ground. He was being medevaced back to the States. The pilot, Lt. Smith, was killed outright when the chopper blew up. That was a bad day. They were good people. I can't say enough about Special Forces. They were top notch."

[Bud Lynch was awarded a Purple Heart and Silver Star for his actions on that day.]

: Robert S. Dotson

[**U.S. Air Force Captain** | November 1969–June 1971]

"I FLEW F-4S OUT OF UBON ROYAL THAI AIR FORCE BASE. I flew over 300 combat missions—about fifteen in North Vietnam, the same number in Cambodia with the remainder in Laos. I was shot down twice. The first time was the eighteenth of February, 1970. It was far and away the most stressful.

I ejected after being hit in a valley in northern Laos near the North Vietnamese border. The only time you eject is when you are more afraid of the airplane than you are of the ejection seat. And you are rightfully very afraid of the ejection seat—it's very dangerous. They were shooting at me the whole time in the parachute. I thought, 'You're really going to die this time.'

I landed on my back on a medium-sized hill. I buried my parachute under a tree. I pulled out the antenna, which turned the radio on. I said, 'Banyan 03 Bravo's up.' Almost immediately I was contacted by the Forward Air Control. He flew by and saw my parachute. I looked at my watch—it was ten o'clock in the morning.

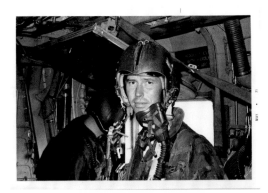

I moved to the north side of the hill to facilitate any rescue attempt and found a dead tree with a log underneath. I crawled down next to it and said to myself, 'I'm a log.' I had taken out my gun at this point. I had the radio in one hand, the gun in the other, until the radio started making too much noise, so I attached the acoustical coupler—a little tube you put one end into your ear and the other over the mike on the radio. I'm leaning against a log and I'm thinking to myself, 'I'm a log.' But I'm a log with a gun and a radio.

About 2:20, after I contacted 'Sandy,' the search and rescue plane that had flown in to knock out enemy defenses and lead the pick-up helicopter to me, I started hearing noises. I look straight uphill and pretty soon I can make out a person. He's got a big round, yellow face; his gun is slung over his right shoulder, pointing forward. He's looking at the ground and he's obviously coming down the same route I did.

So I get on the radio, 'Sandy 01, this is Banyan 03. I've got some bad guys uphill from my position.' And he says, 'Banyan 03, you're coming in very weak. Say again.' And I said, 'Sandy 01, that's because I'm whispering. There are bad guys very close to me. I want you to put in ordnance uphill from my position.' Sandy says, 'Roger 03. Ordnance is inbound.' I could hear the aircraft propellers off in the distance getting louder. I heard the bombs going off and they were way west of me. I said, 'No, Sandy. You're short. You need to put that stuff on me. I've got bad guys very close to my position.' And he says, 'Banyan 03, Bravo. I've started the Jolly Green (rescue helicopter) inbound. We've sanitized the area. Get set for pick up.'

By this time the guy must have heard something because he stopped about fifteen feet away and he looks at me. His eyes grew wider and his mouth drops open and he starts moving his hand toward the trigger. The Air Force taught me to concentrate on the blade, put the blurred image behind it and squeeze. My gun went off—made a hell of a racket. The guy straightened up, shouted 'Nong hai,' made a half turn, and fell back uphill.

Somebody on the right shouted 'Oi!' Somebody on the left shouted 'Oi!' The guy on the right started shooting full automatic. The guy on the left hesitated a little and started shooting full automatic. By this time I start hearing the helicopter blades. Sandy comes on and says, 'Take out your flare and locate the day end.' It puts out a fluorescent orange smoke. I reached into my vest and took out a flare but didn't pop it. I knew if I put even a hand up, it would get shot off.

Sandy vectored the helicopter right to the dead tree I was under and stopped. The guys on the right and left stopped shooting at me and began shooting at the helicopter. I got on the radio, 'Jolly Green. Shoot uphill from my position.' I could see bullet holes down his external fuel tanks and he's streaming fuel. I got on the radio and said, 'Jolly Green, you need to break it off.'

At this time he makes a pivot turn, and the tail gunner sprays the area, and away he goes up the valley. Things get very quiet. About fifteen minutes later Sandy comes back: 'Banyan, we're going to have to pull back and form a new SAR effort (Search and Rescue). We'll be contacting you.' This was about 2:45. I was thinking I was not going to make it.

About 4:30, a new Sandy, 03, arrived and I worked him to my position. Clouds started moving in and I knew I had a maximum of two hours more light. Sandy sanitizes the area once more. Both of the enemies had moved off to the west sometime earlier, taking the gun from the guy I'd shot.

So Sandy 03 began a second SAR effort. It went very smoothly up to a point. I could hear the wop-wop-wop of helicopter blades. He stopped about 150 yards from my position. About that time there was a loud 'whoosh' off to my left and an explosion underneath the helicopter. It looked like a boxer who'd taken a hard hit. It staggered back and reeled a bit. I maneuvered him closer to my position and he started dropping a jungle penetrator, which landed thirty to forty feet down the hill from me.

I duck-walked out; the downwash of the rotors made it hard to see and it was getting dark. I could see the two feet of the guy I shot—he had tire-tread sandals. I grabbed the jungle penetrator and said to myself, 'Wherever this thing goes, I am going.' About a year and a half later they finally started lifting me out of there. As soon as he got me up clear of the jungle canopy, he immediately went into motion and reeled me in as they were going up the valley."

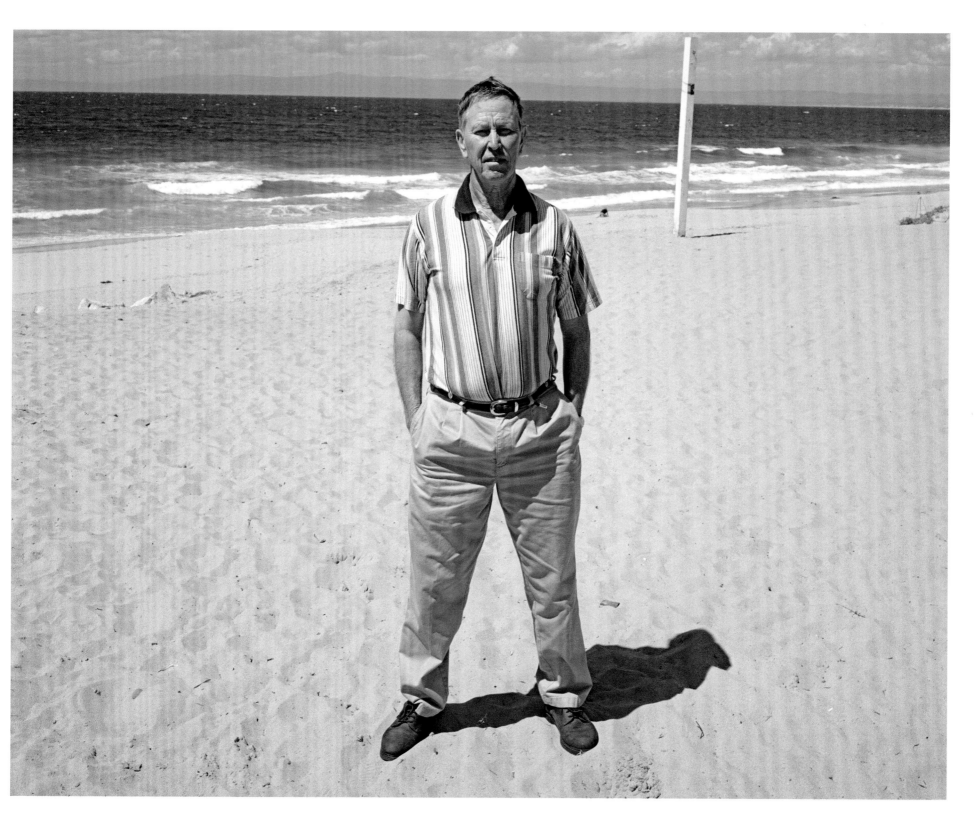

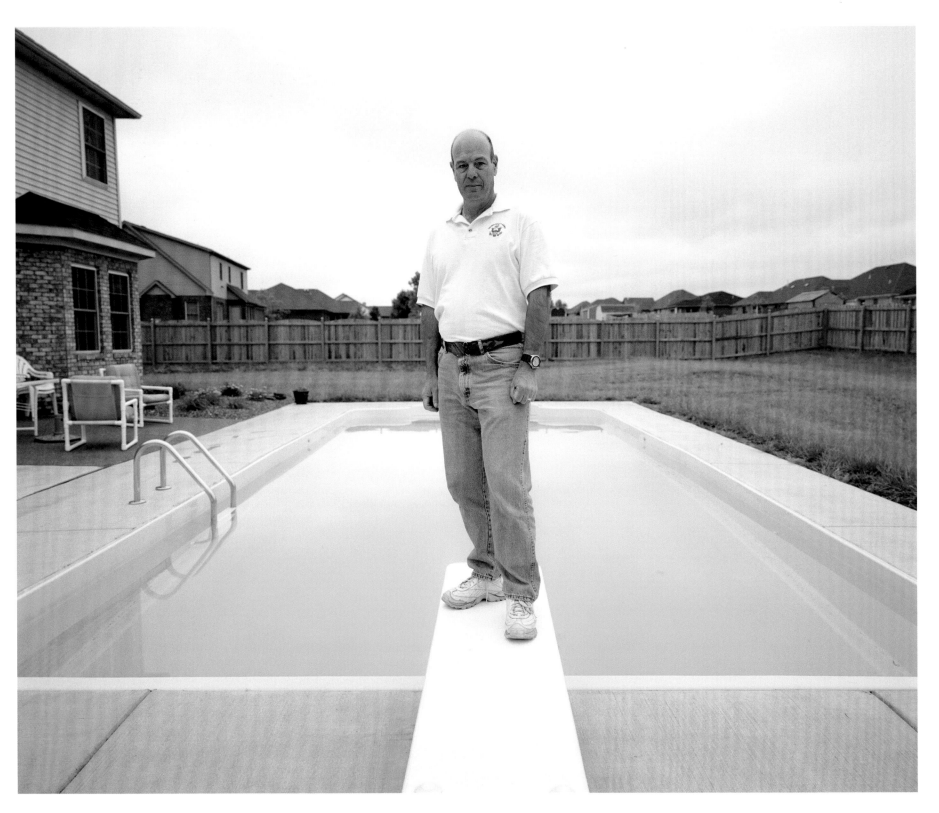

: Michael LaBarbera

[U.S. Army Chief Warrant Officer 2 | May 1970–May 1971]

"**D**URING MY TOUR OF DUTY in Vietnam, I was a helicopter pilot assigned to two different units, the 9th Infantry Division and the 1st Aviation Brigade, both in the southern area of the country. I was flying an OH-6 Loach, a Light Observation Helicopter. It was a Hughes 500, a small round aircraft with just myself and an observer/gunner—we didn't carry any troops. Our job was to fly right on top of the trees and look for enemy activity. We had advisors that would fly in a UH-1 utility helicopter 500 feet above us giving us directions on where to look. We'd report back to them what we'd see and if they advised us, we could use munitions to either shoot things up, or we had hand grenades we could throw. The AH-1 Cobras would fly 1200 feet above us. They were armed with rockets, a grenade launcher, and mini-guns to suppress any hostile fire we might receive to allow us to clear the area.

We worked in teams of two at treetop level. We had a lead and a trail aircraft. If we had to work an area, we used a mini-gun mounted on the left side of the aircraft or hand grenades. We worked in a racetrack pattern, and each aircraft would cover the other as they were engaging a target. It wasn't until I got home and tried to tell my friends in layman's terms what I did: my job was to piss the enemy off enough to have him shoot at me so we could locate his position. When I'd tell people that, they'd say, 'You didn't mind doing that?' But at the time I didn't look at it as something I would or wouldn't do—that was my job…

As far as I can tell, I think I only killed one person. We were flying back to the home base and one of the Cobra pilots said he saw some activity and he started circling this area. As he was circling he called out on the radio he was receiving fire and he turned his aircraft and started shooting rockets. We got over to his location and as I was searching the area I saw someone along a narrow canal, three to four feet wide, jump out of the water. That's when I started using my mini-gun. I'm sure I must have killed him. They sent in troops later to see what they could find and they found a cache of weapons, so evidently what we did, based upon what the Cobra pilot saw, was justified. I don't reflect back on it like, 'Oh, I killed someone.' It was either him or me.

The advisors on the Hueys would tell us before we'd go in, 'It's a free-fire zone. If you see anything, you're clear to open fire.' Otherwise if we saw something we'd have to tell them and they would have to give us the OK to open fire. If we saw activity, like footprints in the mud, something concealed on the ground, or a small shelter, we could throw hand grenades or use the mini-gun to draw fire to try and flush the enemy out of hiding. Depending upon the amount of activity, the Cobras would attack after we would mark the location with colored smoke or the advisors would decide to insert troops into the area.

I feel strongly towards my country. I spent twenty years in the military and retired from the Army in 1994. I realize people have a right to their own opinion and they have the right to protest, although I don't agree with a lot of them. But to have someone move to Canada during the war to escape military duty and then want to come back to the United States after it was over—I mean, they lived up there during the war, they need to stay in Canada and let the Americans who are proud of their country live here.

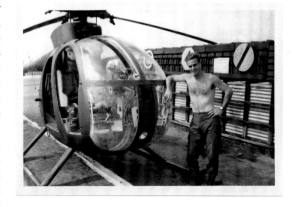

I consider myself very patriotic. I still wear my uniform to the high school where I teach Junior ROTC. I wear it proudly. I feel I'm more patriotic than a lot of Americans based on conversations I've had and the number of people not willing to serve in the military. People are impressed when they see me in uniform and tell me they wish they would have served or stayed longer in the military.

There are people that don't want to join the military, even the National Guard, because they are afraid they might get called up and have to go to the Persian Gulf. I think that's their opinion, but there are still guys like Pat Tillman, the Arizona Cardinals football player. He gave up a lucrative career in the NFL to carry a weapon and was killed in Afghanistan. There aren't that many people that have those beliefs anymore, that want to stand up for America and defend it. I heard this saying while I was serving in Vietnam and it holds true for anyone who has defended our country: 'You have never lived until you almost die. For those who fight for it, freedom has a flavor the protected will never know.'"

: Michael "Mick" Mitchell

[**U.S. Army Specialist E-4** | **May 1968–August 1969**]

"I WAS OUT IN THE FIELD until I was shot October 21, 1968. On that particular day we strolled into a bunker complex up in the mountains. The VC and NVA had bunkers with underground hospitals and so forth and we accidentally strolled into this bunker complex at 3 or 4 in the afternoon. We encountered two VC—we killed one and one got away. The sarge wanted to stay there all night and that was a big mistake—we argued with him that we got to get the hell out of here; he's gonna bring back some of his buddies. There were a lot of holes in the ground and a pretty nice hooch up there. It was complex enough that it would take some time to search, so the sarge said, 'We're staying.'

That day we had eleven men. We put out three O.P.'s with three men each and the sarge and the medic stayed at the hooch on top of the mountain. Right at dark they hit us and they shot one of our guys. They hit us pretty good. The bad weather was setting in—you could see the fog coming in. It was monsoon season. So we was stuck. They couldn't get helicopters in, and the guy that got shot, got shot pretty bad—he died in the night. We had to call in 105 and 155 mm artillery from the firebases to keep them off our backs. And they walked those shells around us all night long but we knew that when daybreak came, they would try to hit us and overrun us. Of course, they had no idea how many of us there was.

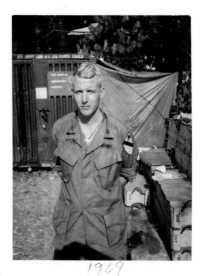

1969

So they come full strong the next morning. And we was able to fight them off. The only trouble was we called in artillery too close to us and we had a couple gun ships and a couple loaches—glass bubble helicopters with mini-guns underneath—working out for us, too, and at daybreak evidently one of the pilots mistook us and hit us hard.

To my knowledge, myself and Sarge was the only survivors, maybe the medic. I was medevaced out—they put a sling around me, dropped it between the trees. The shrapnel went in below my right ear and took a chunk the size of a half-dollar out of my skull. They medevaced me out because I was bleeding pretty good from my head. They dropped the sling down and you had to put your arms together and hold on tight because if you let go you'll fall right down through the trees. They don't have time when you're under fire to strap you into anything.

The medevac was taking rounds as they was hoisting me up through the trees. I was bouncing off the trees. I did see the sergeant once after I got back and he was still alive. He was the only one I saw from that unit. I was gone for about 45 days on the USS Repose hospital ship before they sent me back. The shrapnel I had taken was probably from one of our own gun ships. It was an airburst.

I was surprised they sent me back in-country. I thought they'd send me home because I couldn't hear. I thought, 'Jesus Christ. Surely they're not going to send me back out to the field.' I seen the paperwork about not being able to hear out of one ear, and I got a high-pitch ringing which I still have to this day."

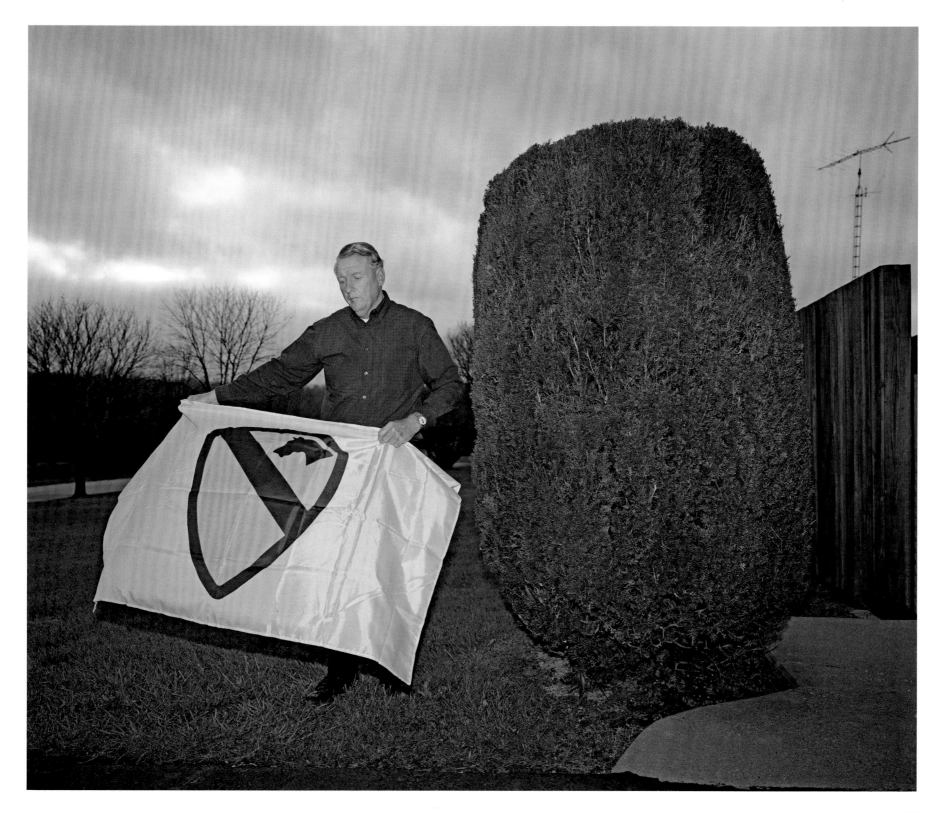

: Ned B. Ricks

[U.S. Army Captain | July 1970–July 1971]

"THE FIRST CAVALRY DIVISION was going to stand down and go back stateside. An in-country standard tour is twelve months. If you had been in-country nine months or less, you had to stay. If you were with a unit that was being stood down and you'd been nine months or greater, you got to go home with the colors. At this point I was there six months.

At about that time, somebody with whom I'd made acquaintance in the personnel system got a TWX, military initials for a telegram, sort of an 'all points bulletin,' saying they were looking for a non-rated armor captain to command an armored cavalry unit. He called me on the telephone and said, 'Would you like the job?' I said, 'Well, yeah.' As a career officer, combat command is a résumé builder. He said, 'It's a good thing you want the job, because I've already accepted it for you. Pack your bags. Be at the airstrip tomorrow morning.'

So I went and picked up the paperwork and traveled two days and arrived at the new unit in An Khe. I reported to my new Colonel. He said, 'Welcome. I have a chopper outside waiting to take you to your troop.' It wasn't until I got to Troop C that I found out they currently had no commander because the soldiers had murdered the man who had the job before me. His name was William Francis Reichert.

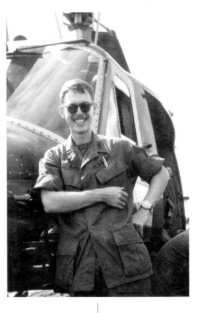

I was sitting in the orderly room, the company-level office, signing the assumption of command order, which gives you the legal authority and responsibility for being in charge. The young man who was the armorer, the mechanic for guns, brought me my .45 pistol and a full magazine of bullets and said, 'Here—you'll probably want this.' I said, 'What's the rush?' And he said, 'Don't you know about Capt. Reichert? He was shot right there,' pointing not far from where I was sitting. I said, 'Who did it? A sniper? Sappers who'd come through the wires?' He said, 'No. It was them fucking niggers. They killed him right there.'

So I looked at the first sergeant who had met me and prepared the assumption of command order and I said, 'Why didn't you tell me about this?' And he said, 'I just got here myself.' They had fired the other first sergeant, relieved him of his duties and shipped him out. So here I was in command of about 200 armed guys who'd just voted the last guy out of office very severely."

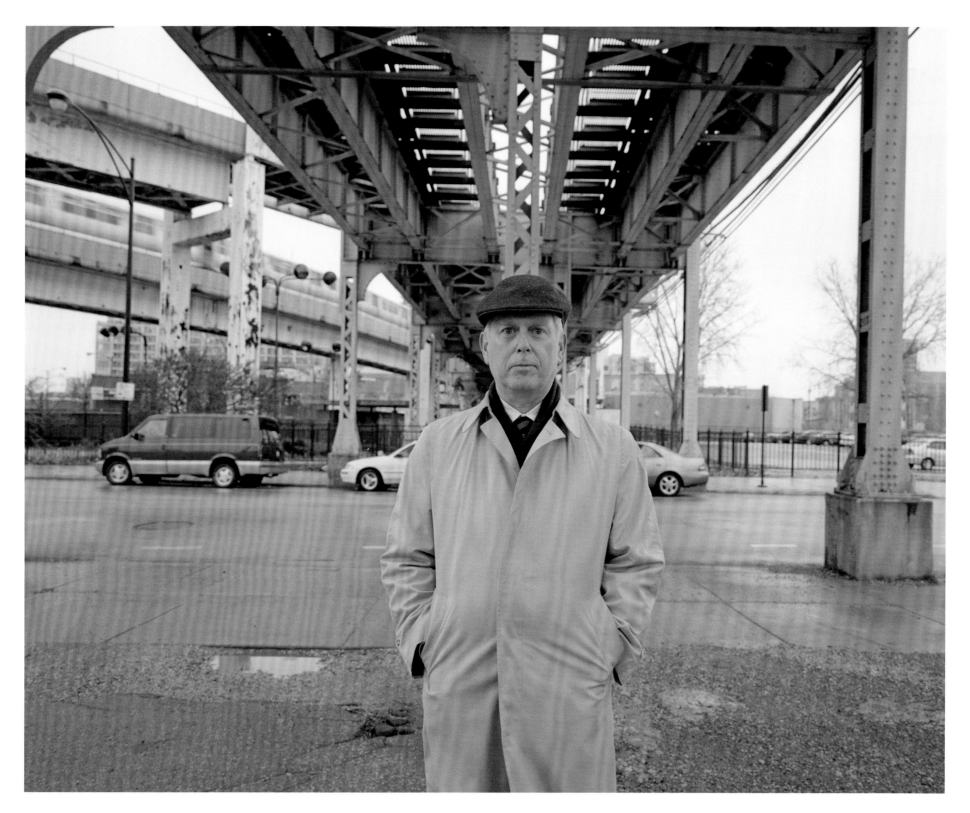

: Don Simon

[**U.S. Marine Corps Sergeant** | **February 1968–November 1969**]

"MY FAMILY TRADITION IS YOU ENLISTED in the service. You did your time. I went away to college. I thought I was going to be a big football star—I was high school All-State. I thought I was big stuff. But I was an undersized lineman at Iowa State. I thought I was going to be a big-time star and I wasn't a big-time star. In the Simon family, you did your turn in the service, and that was the progression in life. My grandfather was a colonel in the Air Force. My dad and my uncles were in the Navy. And it was just my turn. I left college after one year. I was going to join anyway, so I said, 'Now is the time to do it.'

I was wounded several times. The third time I was hit was pretty nasty. We went out on a Monday. There was a lieutenant, a radio operator, and me out of Vandergrift

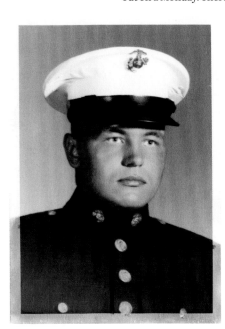

base. There was a rice paddy; it was a field with more than one hole. There were about 200 rice paddies. This lieutenant was from Oklahoma. It was the first time I operated under him. He wanted to cut right across the rice paddy and I said, 'No—we don't want to do that. We want to go around.' He informed me he was a lieutenant and this was what we were going to do. I said, 'Yes, sir,' and we started to cross the field. We were running a recon for the whole platoon, so we were out of sight.

Halfway across this field they opened up on us and they killed the lieutenant—he was the first in line. They killed the radio operator—he was some guy from Texas I'd never met before. Then there was me. So the first guy, the lieutenant was killed; the second guy, the radio operator was killed, and I remember I got hit in the face with the back of this guy's skull. The round caused his head to explode—he got hit in the face. I remember spinning around and then I got hit in the leg. Me and the radio operator fell into a rice paddy on one side and the lieutenant fell into a rice paddy on the other.

I faded in and out of consciousness for the next two days. My platoon looked for me and eventually saw the vultures circling over the rice paddies. This guy spotted the birds feasting on the other bodies and they found us. They hauled me out—my leg was swollen like a balloon. The first thing they did in the field was slice me open from my hip to my ankle, packed me full of sponges and I went back to the rear to 'Charlie Med' where I was treated and then they sent me to an army hospital in Japan.

I got hit in the back of my right knee—I didn't get hit with a full round; I got hit with part of a round that splintered off from the guy from Texas in front of me. He got hit a couple of times and one of the rounds splintered off and hit me. That was really a slight injury because I got a concussion—I broke my orbit, my eye socket. The doctors back at Charlie Med reached in through my mouth and pushed it back out and stabilized me. So I could have been a lot worse. I could have looked like Quasimodo.

The injury to my leg was secondary to the injury to my face. I was lucky when I went into the rice paddy because a lot of me went into the water and so I was hydrated—I didn't shrivel up because it was probably 120 degrees. I lay there from Monday to Wednesday. I was not real conscious most of the time but I remember I'd come out of it once in a while. I can remember the rats: they were eating the other guys. I could feel them running over me, but I was breathing pretty hard so they knew I was alive. Only my head and part of my right shoulder were above the water. I remember I was so blistered from the sun. I remember the heat. My head was one big blister.

There's bad luck, and then there's bad luck. I could have been killed too, like the other two guys. In fact, I'm sure because the radio operator fell into the same rice paddy that I did, there was an alternative for the rats—it was easier to eat him. That sounds terrible and I hate to be that practical, but I think that's maybe the difference between my being alive and not being alive."

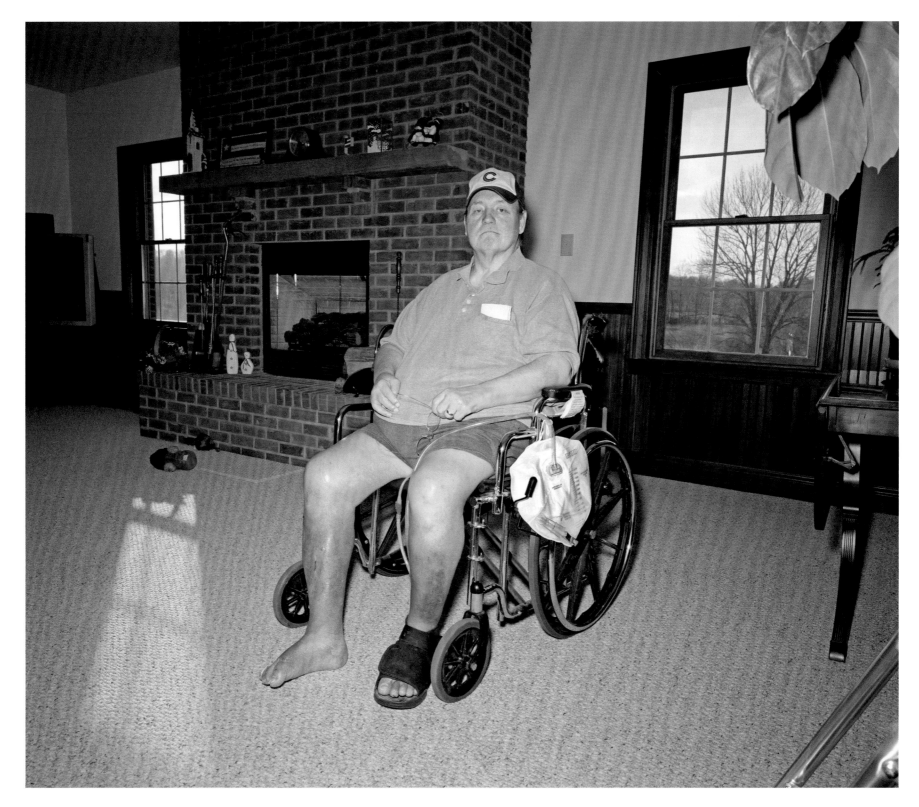

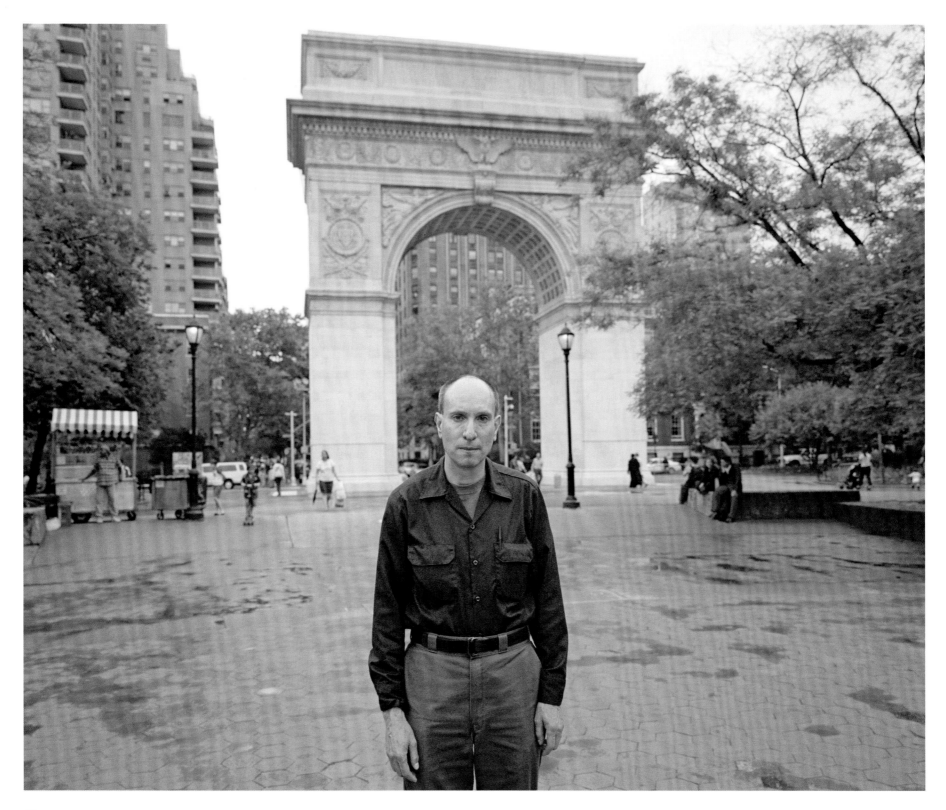

: Marc Levy

[**U.S. Army Specialist E-4** | **November 1969–November 1970**]

"AS A MEDIC, THE VERY FIRST GUY I PATCHED UP was a case of friendly fire. We had called in a Hunter/Killer team. Hunter's a Loach, a small helicopter, he scouts out the area, then he calls in Killer, the Cobra gun ship who's got rockets and mini-guns. Loach came in and we waved. We had a machine gun team up on a hill and Hunter opened up on the gun team from thiry to forty yards—he was right above, like a giant bumblebee. Hit my guy with an M-60, then walks the rounds down because he sees us waving. He was trigger-happy. It was understandable, but we'd thrown smoke to mark our position.

They were walking the rounds down the hill. Just missed me and Steve, my lieutenant; they missed all of us by ten or twenty feet. Steve said, 'Get up there, Doc!' This guy John, his leg was just blown open. I'm looking at his bones; I'm looking at his muscle; I'm looking at ligaments and there's blood spurting from his shoulder like a geyser. I straddled the guy—I just sat on him. Then the gun ship comes in and starts laying down rockets and mini-guns right over us. Like *Apocalypse Now*—you got smoke; you got rockets; you got mini-guns. It was wild.

I'm patching him up. He's writhing in pain. I don't know where it comes from, but this is the good part of the war story. From somewhere—bear in mind I'm Jewish—I say, 'John, you believe in Jesus?' And he's screaming and I say, 'We're gonna pray, John. We're gonna pray to fucking Jesus.' John says, 'Jesus Christ, Doc. Gimme a fucking cigarette!' His hands are shaking. I turned to the squad leader and said, 'Pete, give John a fucking cigarette!'

So John's got his cigarette, but he's shaking like crazy. I said, 'Pete, light the fucking cigarette!' and while John's smoking the cigarette, I jab him with morphine. I don't remember how we got him down to a bomb crater. When the medevac came in, I fucked up. We're at the lip of the crater and the medevac crew throws down a litter. We put him in, they start to winch him up. His arm is fucked. I'm not thinking, just acting. And the helicopter's winching him up. But before they get him up, I leaned over and put my hand to his ear. I said, 'John, it's Doc. You're gonna be all right. Everyone loves you.' So they start to hoist him up and once he's perpendicular but not off the ground I said, 'All right, John. You're gonna be OK.' And I slapped him right where he got shot. And he screamed bloody fucking murder. Then they hauled him in and the chopper was gone and all this dust and shit trickled back down. We gathered our gear and moved out…

We took wounded at this LZ and I brought a guy to the aid station and the battalion surgeon couldn't do his job because he was drunk. Later somebody tried to frag him. You take a hand grenade, wrap elastic bands around it and pull the pin. You put it in a bowl of diesel oil and put it in the person's hooch at the right time of day. The diesel oil will eat through the elastic bands and when the tension is right, 'Boom!' But whoever did it used a Coke can full of diesel, so when the diesel ate through the bands the can was too small, so the spoon, the handle of the grenade, didn't have anywhere to go—he found it.

At this LZ I was sleeping outside because it's hot, and somebody comes running past—we're getting hit. I run into a bunker. The rounds go right over us. They hit the bunker forty or fifty meters away. We hear the all-clear siren. We run out; people are screaming, 'Medic!' I run to that bunker and Gene Locklear's inside. There was no blast wall. A mortar hit and there should have been a sandbag wall that would have taken the blast, but it wasn't there.

So he's inside, big guy, 6'2". He's got shrap in the head, shrap in the hand trying to block the blast—reflex. He's in shock. The bunker's on fire and there's a case of frags on top; a case of Army frags, not WWII pineapple grenades. These were baseball grenades; killing radius about five yards—nasty. I'd say there were a dozen in the box. If that thing exploded everybody would have got fucked up. But you block that stuff out of your mind.

I said, 'Gene, you got to get out. Come on.' And he's in shock. I said, 'Gene there's a case of frags on top. Get out! This thing's gonna blow!' And he can't hear me. So I crawl in; drag him out—his arm over my shoulder. This guy's bigger than I am, but I drag him to the aid station and that's where the doctor's drunk. Then two guys drag in one of my best friends. The doctor finally starts working on Gene, or somebody did. I see my friend; he's hit bad, ghost-white. Calls my name. I call his and he just collapsed. I start crying. There's a couple more casualties so I ran out to deal with them, and then I start shaking. The other medics saw me shaking and I couldn't bandage up this guy. I said, 'Can you help me bandage him?'

Then two or three months later they have this award ceremony and someone says, 'Hey you got to get ready. They're having this ceremony for you.' I said, 'What for?' Everybody has to be in formation. They got banners and bugles and pillows and colonels and all this bullshit. And afterwards this medic who bandaged this other guy up cursed me out. He said, 'What the fuck did you do to get the Silver Star?' I lived with that for a long time. I still don't think I deserve that Silver Star. I did it without thinking, which is how most people act in those situations."

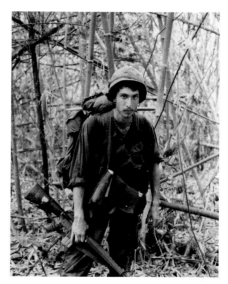

: John Hargesheimer

[U.S. Marines Corporal | November 1967–December 1968]

"**K**HE SANH BASE WAS SUPPOSEDLY GOING TO STOP THE NVA infiltration routes from the Ho Chi Minh Trail coming into I Corps in the north. We were five or six miles from the DMZ, right there on the Laotian border—you could see Laos from our base. We were used as bait, to draw the NVA into battle, but we didn't know it at the time.

Tet started around 4:30 in the morning. We could hear the rounds screaming in—there's nothing more frightening than incoming. They were trying to hit the center of our base where Col. Loundes was, where the hierarchy was, and they were trying to knock out the airstrip. They just pounded us and they hit the ammo bunkers. They weren't trying to get us guys on the perimeter.

You could hear the rounds coming in: rockets, artillery, and mortars. Their accuracy was very good—they already had us zeroed in by that time. The NVA were expert, excellent shots. And they blew the heck out of the center of the base. There wasn't a thing you could do but just sit there and you knew guys were dying right and left. You couldn't leave your position in case they did come in with the infantry…

During the siege you'd see guys get blown up; see arms and legs going up. It was constant. You never knew when it was going to be your time. Some guys developed a fatalistic attitude. You prayed a lot. Some guys couldn't take it—you either cried or you laughed. Some guys would get hysterical laughter. I remember being in a bunker with three or four other Marines, and the rounds were coming in pretty hard and heavy. You just hunker down and cover your head with your arms and hope for the best. And you hope if you do get hit, it's going to be quick. You don't want to get tore up—you want to either die outright or make it out in one piece.

There were two guys in there and they started giggling. It was hysterical; just their way of coping. And then they started laughing. Me and this other guy looked at each other like we can't stand this. We sat there for several minutes and we thought, 'Which is worse: taking a chance on running or staying with these two guys with their uncontrollable laughter?'

So we took off and we got caught out in the open. The bad thing about that is sometimes they'd throw in these rounds that would go off 100 feet above ground and it would rain shrapnel. There was a tank fifty feet away. I believe the tank sergeant's name was Soto, a Hispanic guy. He saw we were caught out in the open and Sgt. Soto backed his tank over us. There's an escape hatch in the bottom of the tank. All of a sudden this hatch opened and these arms grabbed us and took us up into the tank. The kid I was with got hit in the leg with shrapnel from the airburst before the tank got there, so Sgt. Soto saw we were in trouble and saved us.

One of the first places to get blown up when they hit us was the mess hall. We ate C rations from the end of January until I left Khe Sanh; nothing but C rations twice a day—I got so sick of them. The food hadn't been much better in the mess hall. We almost cheered when it blew up. They didn't evacuate the cooks—they put them on the line; they couldn't get them out. It took more courage to try to leave Khe Sanh than it did to stay there because they were always shooting the planes up.

Anytime a plane or helicopter would come in, it was like a magnet. The NVA had spotters up in the mountains above the airstrip and whenever a plane got near you could hear the rounds going off—they tried to shoot them out of the air. If the plane or helicopter landed, guys would come running out of them, rounds dropping all around. You'd see guys getting hit. Where I was positioned we were looking at the airstrip. Anytime a plane came in you stopped and watched because you knew something interesting was going to happen…

One time Ray Ferry and I had just dropped off a crate of 106 mm rounds, walked back to the truck and just as we turned around, we were almost touching each other, a round went off, and all this shrapnel and smoke came towards us. It was like in slow motion. It hit me and spun me around—I got hit by some shrapnel in my left arm—and then I lay on the ground. The first thing you worry about is: you don't want to lose your eyes and you don't want to lose your manhood. So you grab your area down there—it's OK. Then you start checking your eyes because you don't want to go blind. You can lose an arm or a leg, but you don't want to lose your eyes.

I was on the ground shaking my head trying to get the cobwebs out thinking, 'I'm blind!' when all of a sudden I see two feet racing by me, so I know I'm not blind. Ray is still lying there beside me. Dennis McTevia runs down and drags me out because we think the ammo dump is gonna blow. We count heads and realize we're missing people. We turn around and go back. Ray was one of my best friends in Vietnam—he was still lying there. One little piece of shrapnel had gone right through his heart. We all wore flak jackets but it was so hot that he didn't have it buttoned up or he probably would have been OK. But that stuff happened all the time, somebody dying…

Over the years pieces of shrapnel would come out of my arm. I'd kind of pick them out and throw them away—little slivers. I went to the dermatologist last year because I had a dark little bump that kept coming back. She dug it out and said, 'It's a piece of metal.' So I finally got my last piece of shrapnel from Vietnam out—it only took thirty-five years."

: Benito R. Garcia, Jr.

[U.S. Army Specialist E-2 | May 1965–April 1966;
September 1966–August 1967; February 1968–June 1968]

"THE FIRST TIME I SAW A DEAD AMERICAN, there were three of them—their heads were up on stakes. It was in 'D' zone, not too far from Bien Hoa. The enemy was doing that to scare us. Of course, it didn't scare us; it made us angry. By this time I was lost in the jungle. I was alone. I was AWOL—I weighed 112 pounds; they wanted me to hump a spare barrel of an M-60 machine gun. I had just gotten out of the hospital two weeks before with appendicitis. I'm thinking, 'I'm not in shape. I can't do this job. I'm leaving!'

I ran off and then I stopped. 'What in the hell are you doing? You've never been in the jungle before!' By this time it was too late. I was lost, separated from my unit. That's when I ran across the heads. I found the individuals that did it. I heard them down the hill by the river and there was one over where the heads were and he was masturbating. I was going to try to take him prisoner, but I stumbled and I stabbed him accidentally with the bayonet. Once I did that I had to kill him. And when the other two came up I shot them both and I cut off their heads. Some of the guys from the 101st Airborne used to call me 'headhunter.'

At first I did it because I was enraged but then it was a way to score points—that's how you were esteemed by your peers. It didn't bother me back then. But now I don't sleep more than fifteen to twenty minutes at a time and then I wake up with nightmares and chills and sweats. I walk the perimeter at night. But that's my cross to bear. I see children: When you've killed their parents, you hear them crying.

I proudly endured that I stood my post; I did what was expected of me. My fellow paratroopers respected me despite the fact that I was a fuck-up in the rear. In the boonies I did my job. Today I have to suffer with that. No big deal. Georgie-boy, when he came in as president, they started cutting our VA benefits. I'm at 150% disability: 100% for PTSD; 30% for diabetes; 10% for erectile dysfunction and 10% for organic brain damage. I'm in pain all the time, but you get used to it. They give me medication, but it doesn't work. What does help is marijuana—but the sons of bitches won't let me have it. They want to give me codeine, heavy narcotics, but that counteracts the Viagra and I'd rather have a hard-on and endure the pain than just be a fucking zombie…

Here we are in the middle of the night—it's drizzling—me, Doc Wheatfield, a guy we called Cherry, John Wekerly, and some others. There's a girl lying under a huge banyan tree—she's pregnant, about to deliver a baby. We break out our ponchos and Doc Wheatfield gets underneath and delivers the baby. We felt responsible for the baby. Doc asks one of the guys to get some fruit from the C-rations. I said, 'Doc, no one's going to give up their fruit.' Doc was a Christian man. He said, 'Oh, ye of little faith.'

The guys came back with a big sack full of canned fruit. We gave her whatever we had in money and fruit. And then a mama-san arrived and first she looked at us real mean like 'you murdering bastards.' But then she saw the food, money, the baby was fine, the little shelter we had built, and she came and stood in front of us and she bowed.

It was raining, like I said, but when the baby came out, there was a clap of thunder and it stopped raining and the baby cried out. You could hear it in the whole valley. We were so proud and so happy and some of us were crying. As soon as we started to leave, here comes the rain again. We were walking along a rice paddy. There was a herd of water buffalo and someone says, 'Look at that deformed cow!' It was a cow having a calf. People from ranches will tell you this: a bull knows its babies and will allow the mother to have a calf, but other bulls don't give a damn. So here we are in the middle of the rain holding hands in a circle around this cow while Doc Wheatfield is helping deliver that calf.

We went over there as regular kids doing a tough job. Some of us lost our way. We did bad things when we were required to, but at the same time when it came to helping the innocent, we helped. We were noble. Our hearts were good and those good hearts got wounded.

After the war we were treated disrespectfully. We were persecuted. In the '70s over thirty percent of federal prison inmates were Vietnam veterans. I was one of them. On Mother's Day, my father, Benito Garcia, a police officer, arrested me for robbing banks. In eighteen days I robbed six banks in Chicago. I'd go in with a .25 automatic pistol with .22 ammunition—I didn't even have a gun that shot. I was not very good at it. Then I hung up my guns and picked up the books while in prison. In sixteen months I received my associates degree in secondary education from Vincennes University. I earned enough credits for a bachelors degree from Indiana University in Sociology.

In prison I felt comfortable because I know how to be in a society of macho men. I was always alert, always tense. I could deal with that environment—it was the jungle with steel bars. I could function there; I couldn't function out here—it's still difficult. I served six years, one week active military service and six years, three months in prison. I got my degree; I was released and I was everybody's success story. Harry Porterfield did a thirty minute segment on me for the CBS Chicago affiliate.

I was successful for a while but then the nightmares about 'Nam started and I had to drink. The only way I can get through the night without getting up is when I'm passed-out drunk. But I haven't had a drink since '95 when I got in trouble again. An East Texas judge wouldn't believe that I was a thrifty shopper and that the 320 pounds of marijuana in the trunk were all for me. I wound up in a Texas prison. I served three years, three months. I am presently on parole for that offense—possession of marijuana, not distribution. When I got out I had eighty-nine months of parole—I've got fourteen months left. I successfully completed the parole for my bank robberies and I expect to successfully finish this one. I won't smoke now, but come December 27, 2005, I am going to roll a fucking joint the size of a bus and I'll kill it in one drag."

: Tom Price

[**U.S. Army Specialist E-5** | **July 1970–June 1971**]

"**P**RIOR TO GOING OVERSEAS, I was stationed at Fort Ord and for whatever reason, I had no orders; I was put on permanent burial detail. A group of us would have to go out and do funerals. None of us had ever done it before. We practiced and when we fired the salute, it was supposed to sound like one gun.

I was the pallbearer at this funeral of a soldier killed in Vietnam. I was on the dirt side of the grave. We were all nervous. I slipped and thought I was going to fall in. We finally got our composure and everyone was OK. When we fired the salvo at the end of the service, it sounded like a machine gun going off. The family freaked out. The sergeant went to give the widow the American flag—she wouldn't take the flag. It was a nightmare.

We were coming back to Fort Ord on a little bus and everyone was all bummed out. There was a hippie van going by; we waved at them and they gave us the finger. Then the bus broke down. We were off on the side of the road. It was just a horrible day. The sergeant walked to a gas station and came back with a couple of cases of beer and everybody just got wasted.

When I got to Vietnam, my thoughts were, 'I don't know these people. They didn't do anything to me. They have not hurt me.' I really didn't want to use my rifle and I didn't fire my rifle except for target practice. That was pretty much the way the men felt in the squad I led. In 1969, when I went in the Army that was the way it was. People were just fed up with the war by then...

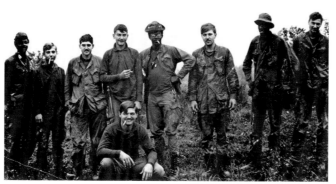

One time we were out in the field and we hadn't been re-supplied in a while. We came across these villagers and we did a big search of their huts and some weapons turned up—we found a couple of AK-47s. So everyone got really uptight and on edge. There was a lady and two or three girls, and another set of huts down the way. We went down and rounded those people up and put them all in one space. We had basically taken them hostage.

We set up Claymore mines for protection. Before dusk, one of those mines went off. My platoon sergeant said, 'Take some guys; go down and see what it is—probably a pig wandering around.' So we got down there and it wasn't a pig. It was a Vietnamese who, I assume, was going to visit his wife or daughter, but that thing just cut him in half. I'd never seen anything like that before in my life and never saw anything like it after—I was very fortunate in that. Well, that really got everybody freaked out.

We stayed there for the night and called in helicopters the next day to take those people away. Then we torched the place. It was one of those things that you felt, maybe I was romanticizing a bit, that those Vietnamese had lived there for generations and they would never see that place again—they would never come back. They would be taken to a relocation camp somewhere and that would be it. The life they knew was no more."

: Mark Scully

[U.S. Army 1st Lieutenant | June 1968–June 1969]

"I SPENT MY ENTIRE YEAR in Vietnam as the Assistant Battalion Advisor to the 4th Battalion, 48th Infantry regiment, 18th ARVN Division—Army of the Republic of Vietnam. I could have rotated back to a safer job at Xuan Loc after six or seven months, but chose to stay with 4/48th.

While with my unit I went on hundreds of company and battalion-sized operations. I was under sniper, small arms, machine gun, mortar and rocket fire from the enemy. I operated in booby-trap infested areas, leech-filled swamps, triple canopy mountain jungle and muddy rice fields. I called in supporting fire of artillery and helicopter gun ships. I coordinated evacuation of the wounded. I was getting supplies and ammunition to the unit while its battalion commander was selling them on the black market or worse. I found the job to be stressful and traumatic, especially the five months of Dai-uy Diew's command.

The Vietnamese commander of the 18th ARVN Division was corrupt. He had a core cadre of cohorts who went back together since the mid-1950s when they had all been in an elite airborne battalion together with him as commander. It was rumored that he ran a vast criminal enterprise.

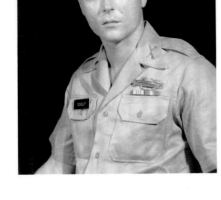

Tieu-ta Tan was not part of this clique. He was Battalion Commander of 4/48th when I first arrived in June 1968. He was a superb tactician and beloved leader who cherished his men. He had spent six months in Fort Benning, Georgia, attending the Infantry Officer's career course and spoke excellent English. He was a senior major in the division. In order to get rid of Tieu-ta Tan and put in their own guy, a new position was created. Tan was put in charge of getting the railroad running from Bien Hoa to Xuan Loc.

With a senior major out of the way, Dai-uy Diew was made Commander of the 4th Battalion, 48th Infantry. Diew was evil incarnate. As Captain Dexter C. Newman later said, 'I knew something was up when the guy showed up for war with his wife, driving in a 1937 Packard.' He did ghost payrolling, taking the pay of soldiers on the rolls who did not exist. He did double payrolling, having everyone paid twice, one of which he kept. He sold food, medical supplies, and gasoline on the black market. Even ammunition would be siphoned off and sold before it got down to his soldiers. He would keep the bonus money that was supposed to go to the men for capturing weapons or killing enemy. And, as commander, he had total life-and-death dictatorial power and control over the entire battalion. We were all afraid of him.

After being in combat with them five months, I had an excellent relationship with the Vietnamese junior officers of the battalion, especially the 1st Company commander. The Vietnamese soldiers knew I would risk my life for them. They trusted me with their lives.

About three weeks after Diew took over, the 1st Company commander came to me and laid it all out. He was requesting our intercession. The effectiveness of the battalion as a fighting force had already deteriorated and he foresaw it only getting worse.

Right at that time, we had a new senior battalion advisor, Captain William Stoner. I relayed the information I had received to him. Since he was so new to the battalion, whereas I was more familiar with the situation, he had me go to Xuan Loc, 18th Division headquarters and report to Col. Walter E. Coleman, Advisor Team 87 Commander and the counterpart to the Vietnamese commanding General.

Col. Coleman listened to all I had to report then questioned me as to my evaluation of the new battalion commander's 'competency in the field.' I replied that I could not tell. We had not gone on many battalion-size operations. They were mostly company-sized ones where he would stay behind. I asked the colonel why he brought up the issue of 'competency in the field.' He replied that it was U.S. policy to not interfere with the internal affairs of the Vietnamese unless they proved themselves 'incompetent in the field.' I asked him what 'incompetent in the field' meant. He replied that if the Vietnamese battalion commander were to have a platoon or company be 'wiped out,' that would constitute being 'incompetent in the field.' I asked him if that might mean a company or platoon I might be with. He said, 'That's right, Lieutenant.' There was nothing more to say. I said, 'Yes Sir,' saluted him, and left.

With regards to the duration of the event, my dialogue with Col. Coleman lasted about ten minutes. The duration of Dai'uy Diew's raping and looting of the battalion lasted until mid-May 1969, over five months. I was afraid of him the whole time. I often thought about killing him but could never come up with a feasible plan. He did more destruction to that battalion than any enemy could. If anyone's death would shorten the war, it would be his. To this day, I think I would have killed him, given the opportunity."

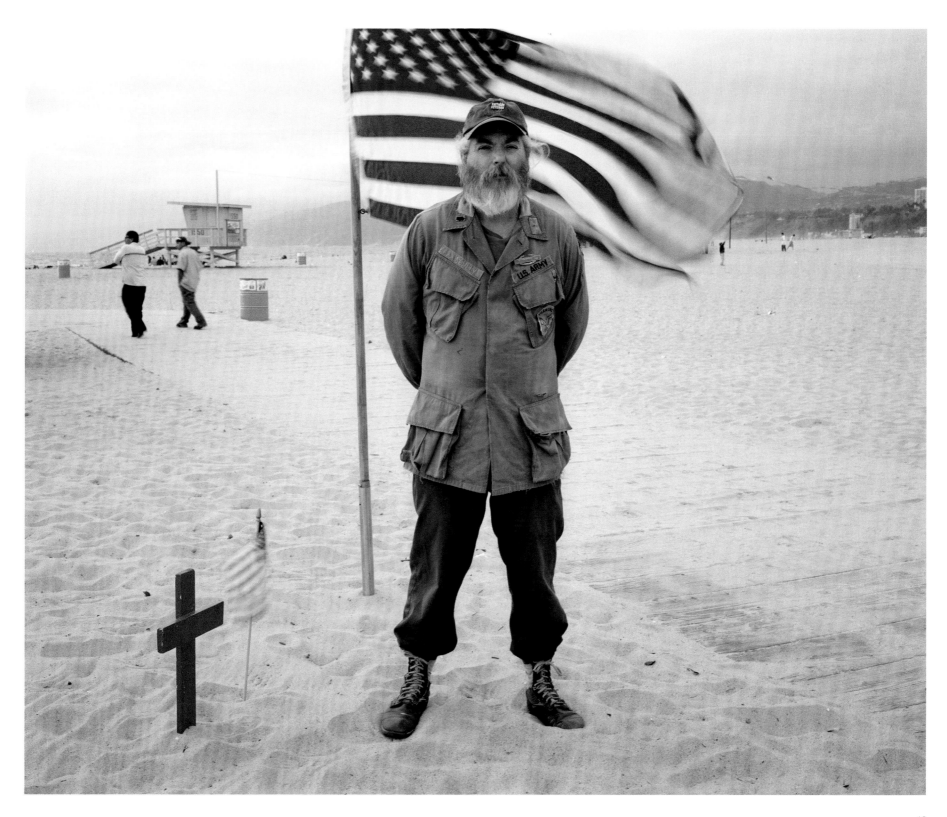

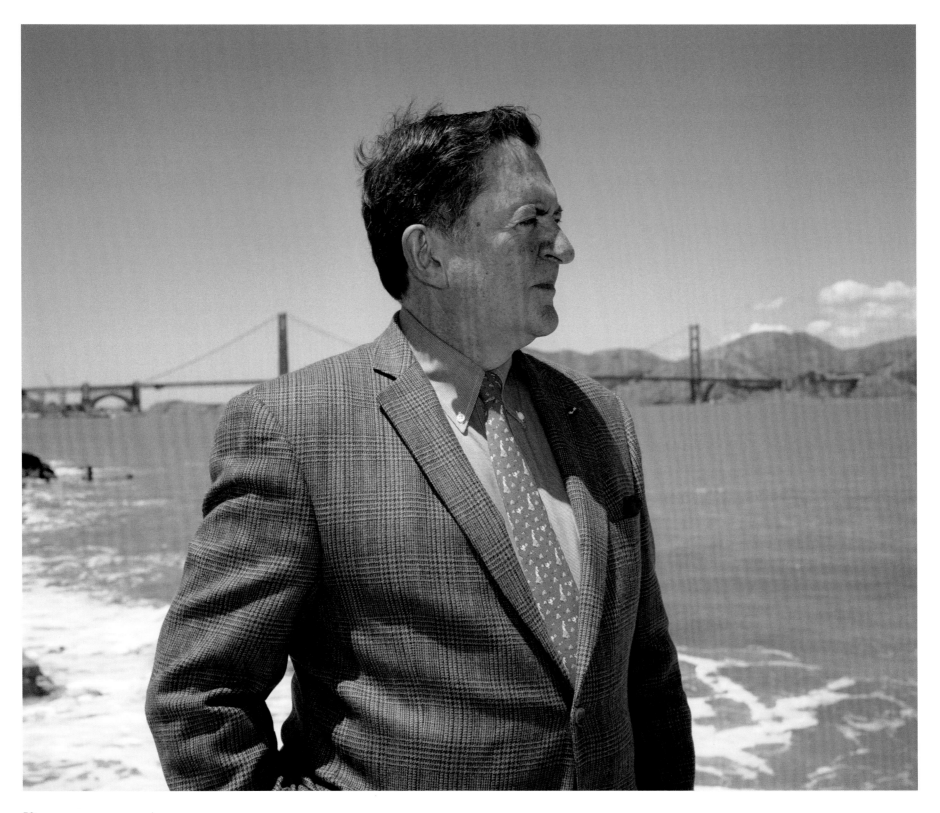

: Philip Gioia

[**U.S. Army Captain** | **January 1968–April 1968;**
April 1969–May 1970]

"**O**N MY FIRST TOUR, we deployed all the way from Fort Bragg, North Carolina, on almost no notice. We were a brigade of the 82nd Airborne that was called into action as a result of a request by General Westmoreland for additional troops during Tet. We were airlifted to Vietnam on about twelve hours notice. My battalion was the Initial Ready Force of the 82nd Airborne Division, so we were locked and cocked and ready to go anywhere in the world. That was our job, and it just so happened that on this one we went to Vietnam.

We were the lead element of our brigade and we were in-country and up into the Hue area so fast that there were no other Army combat units up there yet, so we were placed under the operational control of the 3rd Marine Division. When we arrived at Phu Bai, just south of Hue, the Marines were heavily engaged in downtown Hue trying to retake the Citadel, which was still occupied by the North Vietnamese. We began operating on the west side of the Perfume River, and looking for North Vietnamese units all along that sector and then westward, out toward the A Shau Valley. We developed a number of very brisk firefights there.

My platoon was the one that discovered the very first of the mass graves outside Hue. When the North Vietnamese entered the city in late January at the beginning of the Tet Offensive, they had lists prepared by their Viet Cong guides that enabled them to round up the entire civil infrastructure of the city, from the province chief and representatives on down to the district chief and his family; the entire university faculty; all the doctors, teachers, lawyers, police, firemen; everything that allowed the city to function. They herded them out to the flats along the Perfume River and made them dig these very long ditches, and then killed them all, hundreds of people.

We found the bodies. One of my sergeants, an E-5 named Reuben Torres from Arizona, had tripped over what he thought was a root sticking out of the ground. It turned out to be the elbow of a woman schoolteacher that had just popped loose. He said the look of the bone and smell reminded him of a sheep that had been hit by a mountain lion or coyotes, back on his uncle's ranch. He could smell the death, the decomposing smell, and he brought me over. I looked at it and I said, 'I think we need to get this up.'

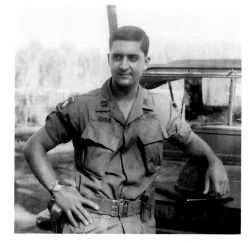

So we dug it up, and saw more bodies next to it, and radioed back to Battalion and got the word to start digging them up. We kept turning up more and more bodies, so we put our gas masks on. They didn't have any Graves Registration personnel there. We were the ones who got them all out. And over the course of that day, more and more senior officers would fly in, and then news teams came. It was hilarious, because they kept well clear of this stuff. They kept upwind, and they stayed away from us, but they all looked very concerned, very 'martial,' but it was my platoon that was digging these bodies out. It was a very unhappy experience. I've really hated Communists ever since then.

The irony is that people like Noam Chomsky, to this day, maintain that this was a trumped-up American atrocity. But I'll tell you when you stood hip-deep in one of these graves trying to pull bodies out that had been two or three weeks in this aqueous, sandy sub-soil starting to seriously decompose: children, women, men. There was a French medical team, a West German doctor, a number of priests and nuns, because South Vietnam still had a very strong Roman Catholic presence. You knew who did it. It wasn't done by the Americans, and it wasn't done by the South Vietnamese. It was done by the Viet Cong and the North Vietnamese—the Communists.

It was a horrifying experience. That was my first real look at what the enemy was capable of doing. This occurred before we had our first big action so I hadn't seen much combat yet, but then we had this incident, and after that I became very, very focused on my job."

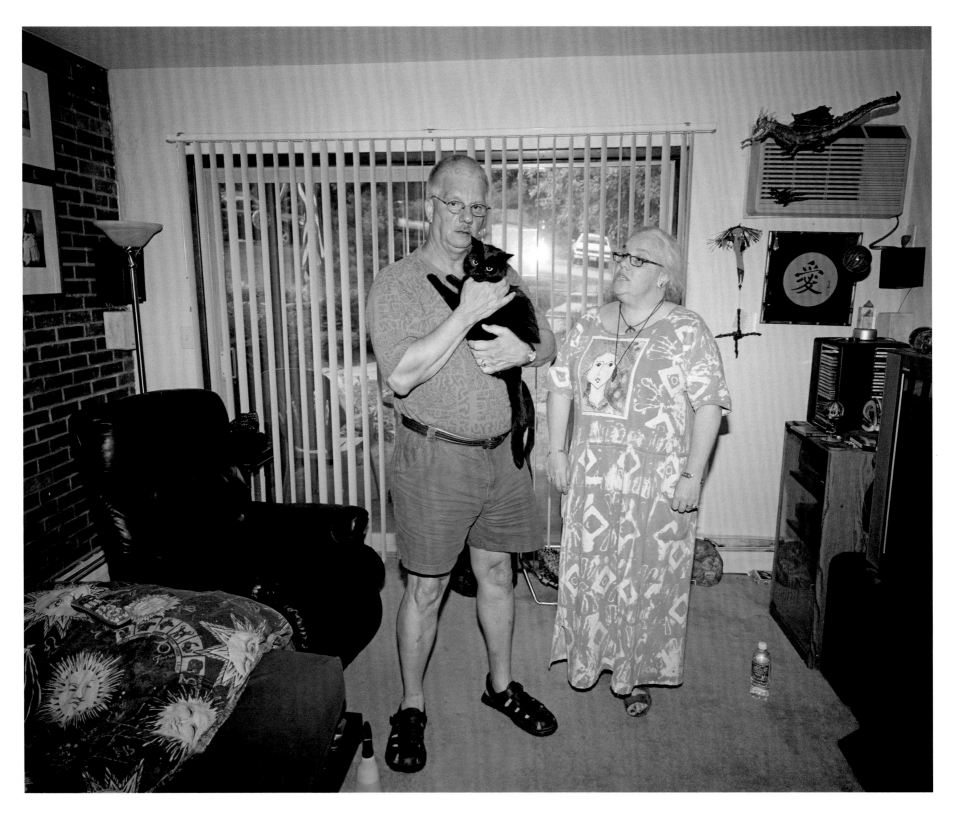

"**I** THINK IT WAS JULY 3RD. We just came in on a three-day stand down when they came to us about 8 o'clock at night. 'Get ready to go. We're going to send you out—there's movement in the area. We think they're building a base camp and we want you to check it out.'

So we went out that night and set out at the bottom of a hill and started up. Delta Company was on the other side and they walked into a horseshoe-shaped, battalion-size NVA base camp. It cut them to pieces. The NVA opened up with automatic weapons fire. I got behind a log. Every time I'd raise my head to look out, someone with an automatic would open up. I'm lying there thinking, 'They're going to walk up and shoot me in the head.'

You could hear guys hollering for the medics. The NVA had gotten in between my unit and had gotten people's dog tags and called out their names saying they'd surrendered. An NVA called, 'Medic, medic!' and when the medic got there, he got shot in the face.

Once we took the hill we found no NVA soldiers—not one dead body. There were GIs all over the place. They put us on a detail picking up the bodies—take a poncho, roll the guy in the poncho, drag him down the hill. I don't know how many of our guys we dragged down. I couldn't look at them any more. It really bothered me. I was thinking, 'I could be dead too.'…

I lost a friend named Ross. A week before he was killed, he and two other guys came across four or five NVA soldiers eating. Instead of shooting them, they got into hand-to-hand combat and killed the NVA. They were decorated. I thought he was really brave.

We were in a firebase and it was morning when I saw him approaching the base. I was standing on a bunker and I yelled out, 'Hey, Ross, come on; I'll buy you a beer.' He looked up and just then the guy in front of him who was walking point dropped to the ground and an NVA sniper shot Ross in the chest. I ran out and was holding him in my arms and I said, 'You're going to make it.' I stuck my thumb in his chest to try to stop the bleeding and I realized half his back was gone. He choked to death on his own blood. It was stupid of me to run to him because the sniper was still out there—the medic wouldn't go. I remember punching the medic for not going. I held Ross in my arms while he bled to death. I felt a little guilty and later I left a letter to him at the Wall in Washington because I'd lied when I told him he'd make it and that the helicopters were coming. I thought if I hadn't called out to him, he might have seen the sniper. It bothered me to watch the life run out of him.

We had a lieutenant who was a West Point graduate. He'd been out in the field for six months and typically they'd give them a job in a base camp for the remainder of their tour but he volunteered to come back out. One day he took his Radio Telephone Operator and said, 'I'm going to check out this trail.' We knew better than to walk the trails. This RTO came running back a few minutes later and said

they'd captured the lieutenant. We found him three days later. They had buried him up to his neck. They'd peeled all the skin off his face and shot him through the head. We thought, 'Man, these people are cruel!' We had to change all the call signs and maps because he'd had all that stuff on him…

I was in-country for three months and we hit this bunker complex. There was a ten, fifteen-minute firefight. After it was over, this woman came out of a hole in the back of a bunker. She stood on top of the bunker; she was pregnant. She said, 'Chieu hoi,' which means 'I surrender.' This guy with a machine gun said, 'Chieu hoi, my ass!' and hit her with a burst of M-16 fire. She fell backwards and the guy took a knife and cut her stomach open, took out the baby and drop-kicked it like a football. And he said, 'Well, I got two for the body count.' I couldn't believe it—I was shocked to see this.

This guy was in-country for eight or ten months and somebody was smoking dope in the rear and he reported him. It was at Blackhorse. The next day they found him hanging in the showers. He was beaten to death, I remember thinking, 'That's what he deserves for killing that woman…'.

I have nightmares every night. When I first came home I drank so much, trying to block everything out. It wasn't until I quit drinking that I started having flashbacks of incidents that happened to me in Vietnam. For a long time I'd have flashbacks every time I heard a helicopter. I remember when they dedicated the Vietnam Memorial in Cincinnati, three helicopters flew in and one came in really low. The next thing I know, I'm crawling on the ground.

I've been in group therapy for combat veterans since 1980. When I came back from Vietnam, I had jobs. My co-workers would do stuff to aggravate me. They'd

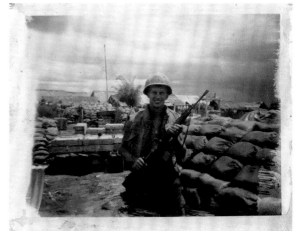

come up behind me and drop skids to watch me jump. I tried to kill a guy at work one day. My doctor told me, 'You can't work any more. You have to go on disability.'

I've learned with PTSD what you can do, and what you can't do. I was feeling depressed a few years ago. I sat on the toilet and put this SKS assault rifle under my chin, pulled the trigger and it went 'click.' My wife came in. I looked at her; she looked at me and I said, 'Shit! It didn't go off. It must not be my time.'"

: James May

[**U.S. Army Specialist E-5** | **September 1969–September 1970**]

"I WAS A PERSONNEL SERGEANT when I went over. I ended up being assigned out of the personnel records section at Chu Lai. When I got in-country, the first thirty days I compiled records for the Calley report, the My Lai massacre. Calley was with my unit—the Americal Division. I had to go make sure all the depositions were in the right order, working with the JAG section. I went out to the area around the village of My Lai and I had to make sure every evening when we got back that everything was compiled in case Calley came to trial. My job was to oversee that the text was put together and given to the Central Intelligence Division.

I was subpoenaed and had to go back and testify at Calley's trial at Fort Benning, Georgia. I was called in one day and was in there about twenty minutes. They asked me ten or fifteen questions. I told them I didn't think Lt. Calley should be the fall guy. It should have been Captain Medina. He told Calley to go ahead with the search and destroy mission and everybody else from Calley on down was just following orders. Calley was the lowest ranking officer and he was going to get convicted…

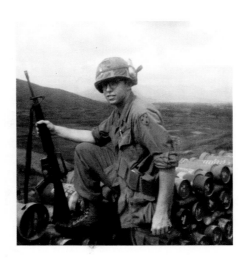

My opinion is that they went to My Lai on a search and destroy mission if they came under contact. There was a General flying over the day they went in who decided to change the mission. Captain Medina decided the mission was going to stay the same. He ordered that if the unit comes under any hostile fire then it would be a search and destroy. And that's what a search and destroy was—you go in there and round up insurgents and kill them.

They did come under some fire; they didn't know from exactly where. They did find a couple of tunnels. It's one of those tough situations in war. I guess when it got to the women and children getting killed is where a lot of groups get angry nowadays. They don't give the soldier the benefit of what they're going over there for. They're over there to defend this country besides themselves. Everybody would like to go over and win a war without firing a shot but that's not how it happens."

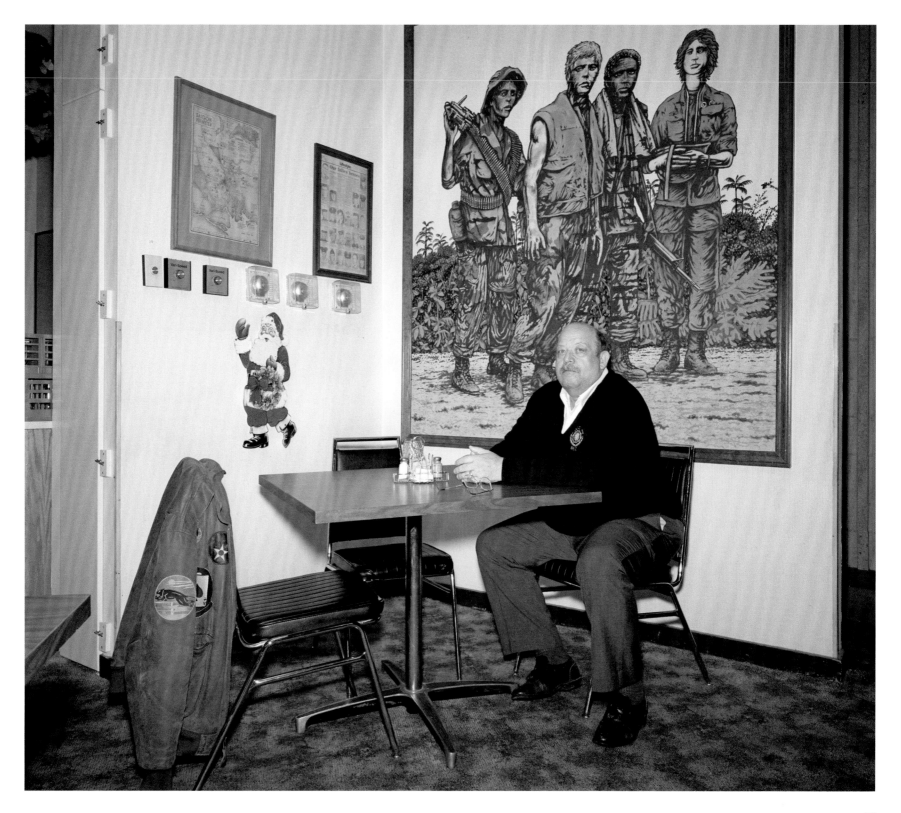

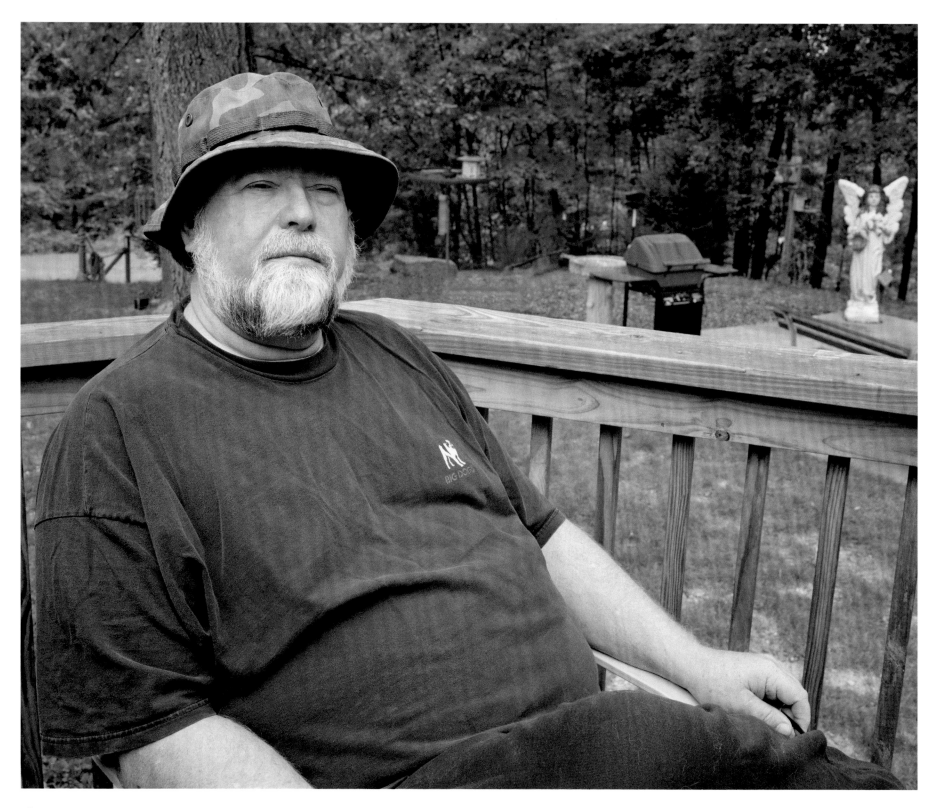

: Ronald Melvin

[U.S. Army Specialist E-5 | April 1968–May 1969]

"I BECAME A MEMBER OF THE 1ST AIR BRIGADE, 13th Aviation Battalion, 121st Assault Helicopter Company. My duties were to fly with the 121st and the 336th T-Birds—flew near every day and a lot of times at night. Intermixed with this were the duties I always performed which was being the avionics crew chief at night—it's multi-tasking at its finest…

Agent Orange was sprayed practically every two or three days. There were large fields on both sides of the compound. We didn't know what Agent Orange was. They started spraying by order of Admiral Zumwalt to destroy the enemy's ability to hide in the foliage along the rivers. It came to be used to cut down the foliage in and around the bases. We had Vietnamese who went around and sprayed between the hooches. We had fifty-five-gallon barrels filled with sand and weeds would grow up in them all the time. And these guys would spray them and 'poof!'—the weeds would be gone. And we're thinking, 'Man, this is a pretty good weed killer.' And we'd see planes and they'd spray, and many times I've sat on the bunker and been within yards of a plane that swooped down low, sprayed the field once or twice like crop dusting, and got that stuff on me. It was like a fine mist in the air.

Agent Orange is what I suffer from now. I've been awarded not only 100% service-connected disability for my eyes but an additional fifty percent service-connected disability which I just received two months ago for Agent Orange-related diabetes. I'm a severe diabetic with other problems besides that are all related to my experience in Vietnam. The VA will never admit that the Agent Orange caused my visual impairment but in my original paperwork—I've done two stints now at the Heinz VA Hospital for the Blind—at the bottom was a clause that three doctors who helped me get my service connection said it was most likely caused by exposure to chemicals, but there is no actual proof that the eyes were effected by the Agent Orange. I've been proven beyond a shadow of a doubt to be in the wrong place at the wrong time, which is the story of my life back in those days. It wasn't just the over-spraying at the bases. We would go out to these LZs where they would spray the night before and the foliage would be entirely down by the next day. This stuff was so strong that it would take a well-grown field of saw grass and bushes and turn it to nothing but a muddy field in less than twenty-four hours.

Another way I drew flight pay was through 'dust off,' the medical ambulance services the helicopters provided. We had a big medevac unit on the end of our compound at Soc Trang and at any given time, especially at night, we could be called and some of my most harrowing experiences were on those helicopters, because they flew 'patient protectors'. By the Geneva Convention they weren't allowed to have fixed weaponry on a Red Cross helicopter, but they had been shot at enough that

they decided long before I got there that patient protectors were ok. So they would give you a free .60 caliber machine gun, which was not mounted on a tripod, and you would sit in the gunner's door and wait and hopefully nothing would happen but sometimes things did happen. The enemy tended to shoot as much or more at that Red Cross as the ones loaded for bear.

I was extremely lucky. Many times those helicopters were shot up, and one of my most harrowing incidents was when I lost a good friend who was a medic on one of those missions. They were firing up the chopper and I was rolling up in a 3/4 ton truck we drove around the field and my buddy, Al, who was a medic, said, 'Hey, why don't you come along with us on this one? We need one more patient protector.'

Medics had fifty-foot cords on their helmets so they could walk away from the helicopter and help load people on. This ville had been attacked that night and we landed on a small dock area at the edge of the river and the village. Al was loading up wounded and I remember this little girl who had been gut-shot and she was screaming over the roar of the helicopter and the chatter on the radios between the pilots, the medic, Al, and us two gunners. Then from across the river they opened up on us with a machine gun. They were lying there waiting for us and less than six inches underneath my feet there's a rubber fuel bladder that you sit on top of. They probably put a hole every two, six inches under my feet. If they'd aimed higher they would have got me but it ripped open the belly of the helicopter.

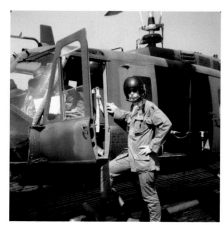

I was firing back as fast as I could—I literally made the barrel of the .60 caliber red. I just opened up and held on the trigger. As we were pulling off, I heard the pilot scream at Al, 'No time. Gotta go.' Al didn't want to be left behind. He jumped for the skid and held on as we took off, then dropped about 200 feet and fell to his death. So I lost a very good friend that night and it was distressing because we had these wounded on board, mostly children including this still-screaming ten, eleven-year-old girl who was horribly wounded. I have no idea if she ever made it. Once they got the morphine in her she quieted down, but we had to set the helicopter down in an open field some five, ten miles away. We were waiting for another helicopter to meet up with us to transfer the wounded, and we'd already lost a man. Our helicopter wasn't going anywhere because we were dumping fuel everywhere. That was a pretty hairy night that night."

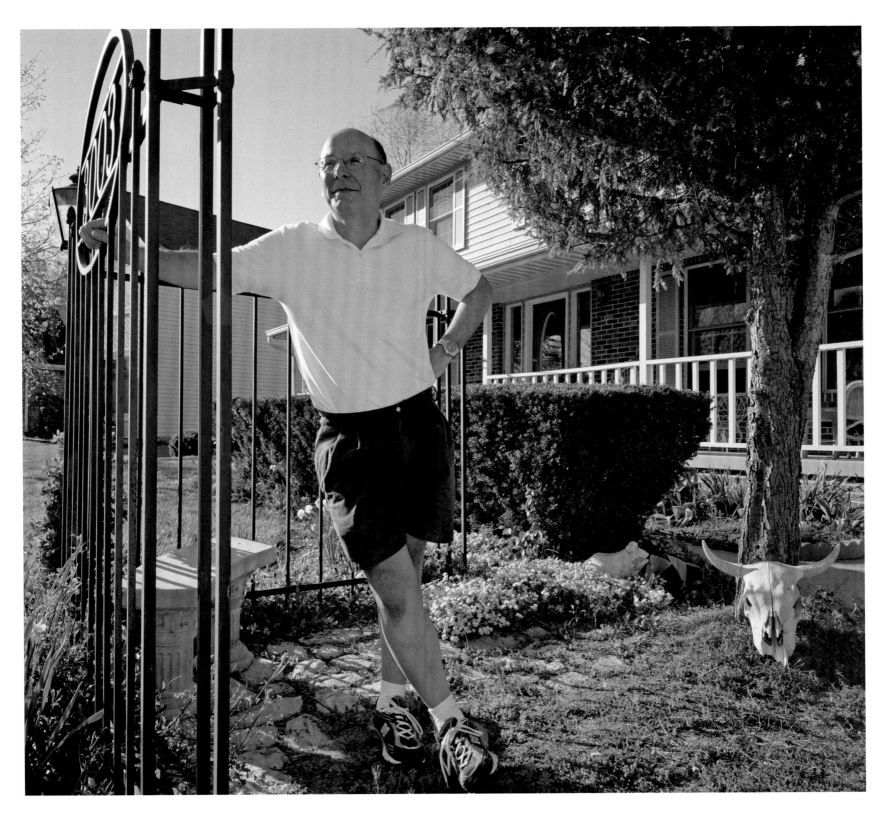

: James Kryway

[**U.S. Army Captain** | **February 1970–February 1971**]

"**Y**OU FLEW SO MUCH IN VIETNAM — you felt that when you got in the helicopter, it became part of you. It's what I did daily, so when I sat in the seat, it became an extension of my body. At times, we would fly the helicopter outside the safety envelope. I mean we'd take more load than it should have, fly it a little faster than we should and maybe take it outside the bank range. We knew each helicopter that we flew. We knew its good points and bad points, and knew how much it would lift based on the density altitude.

The Huey was a utility helicopter. We would do all types of missions and on occasion medevac wounded. The one mission I didn't care for was back-hauling soldiers who had been killed in action. That's very gruesome because sometimes the KIA would be wrapped up in a poncho instead of placed in a body bag. It's a sad mission. We'd back-haul them to a major operations base so they could get transported to a mortuary and go home from there.

Some days you'd spend all day hauling food, water, ammunition, mail, and other supplies. On Christmas Day, I hauled Santa Claus around with ice cream to the hot GIs located in remote areas. Santa got in and I said, 'We're going to this firebase, this firebase, this landing zone, and so on.' I spent all Christmas Day hauling this guy around in a Santa Claus suit giving the poor troops in the jungle ice cream, sundry packs, bubble gum, and other goodies. So I flew Santa around—we didn't get shot at on Christmas. It was a good mission because I was busy helping out and not feeling sorry for myself spending Christmas alone without my family.

During my year tour in Vietnam I had four helicopters rendered inoperable after taking ground-to-air fire. I have a round that went through my helmet. I didn't have my regular crew with me on that mission; I had a guy who was my maintenance chief and another enlisted soldier who just wanted to get some flying time. Some troops were operating near an LZ and they got into a firefight, and they had sustained some wounded soldiers. Well, we were in the area so I went to medevac the wounded. When we started our approach to the LZ, all of a sudden, we were taking ground-to-air fire. We landed, loaded the wounded on board, and I felt some hot stuff against my neck—I just brushed it off. With the couple wounded soldiers on board we proceeded to take them to a MASH unit, which wasn't too far away in Song Be.

I was monitoring my fuel gauge on the flight to Song Be, and it was really dropping pretty quickly. I said, 'Boy, this thing's eating a lot of gas.' So after we dropped off the wounded GIs we flew over to the fueling pods. We always fueled hot—we wouldn't shut the Hueys down. We'd have the crew chief jump off, reduce the throttle down to flight idle and pump in the JP4 fuel, and go on to the next mission.

All of a sudden I got a call from the tower, 'You better shut it down. You've got a leak.' So I had the crew chief look under the helicopter. We had several rounds hit our fuel cells. We were draining more fuel than we were pumping into the bird. We shut it down to keep from catching on fire. When the helicopter was finally shut down, I got to take my helmet off and that's when I saw that a round had gone through my helmet, through the greenhouse canopy which was above my head, and ended up lodged in the rotor blade. I still have it. I sent it home and my wife had it put in a plastic cube. I did not tell her the story of the round until I returned home safe and sound…

My experiences in Vietnam were on the whole positive. I had a different perspective on life when I came back. I came back a more mature person. I had been places I had not seen before. I had been in life-and-death situations, had to make decisions that put other men who depended on me in life-and-death situations. That had a pretty maturing effect—I was no longer a kid.

I did not anticipate, nor will I forget, the greeting I received once I returned to the U.S. The greatest day I experienced in 1971 was the day I boarded an airplane leaving Vietnam, going home to my wife and baby that I hadn't seen in a year. I landed in the U.S. wearing the uniform I had processed out of Vietnam in. I'm thinking, 'I'm back in the United States. It's wonderful—no one's going to shoot at me. I'm still alive, lucky me!' I got back in the good old USA and people are pseudo-spitting at me, and rendering me obscene hand gestures in the airport in San Francisco, calling me, 'Baby Killer.' I'm not a baby killer. There were places and times in Vietnam that I took fire and did not fire back because it wasn't a free fire zone and I didn't want to wound or kill innocent civilians. What started out as a great day ended as a very bitter day! I was pretty down in the dumps for a while as a result of the reception I received in the San Francisco airport."

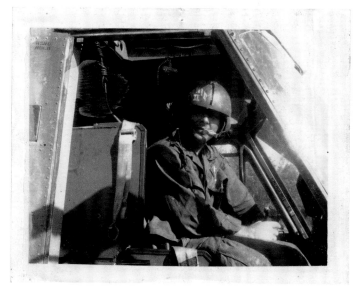

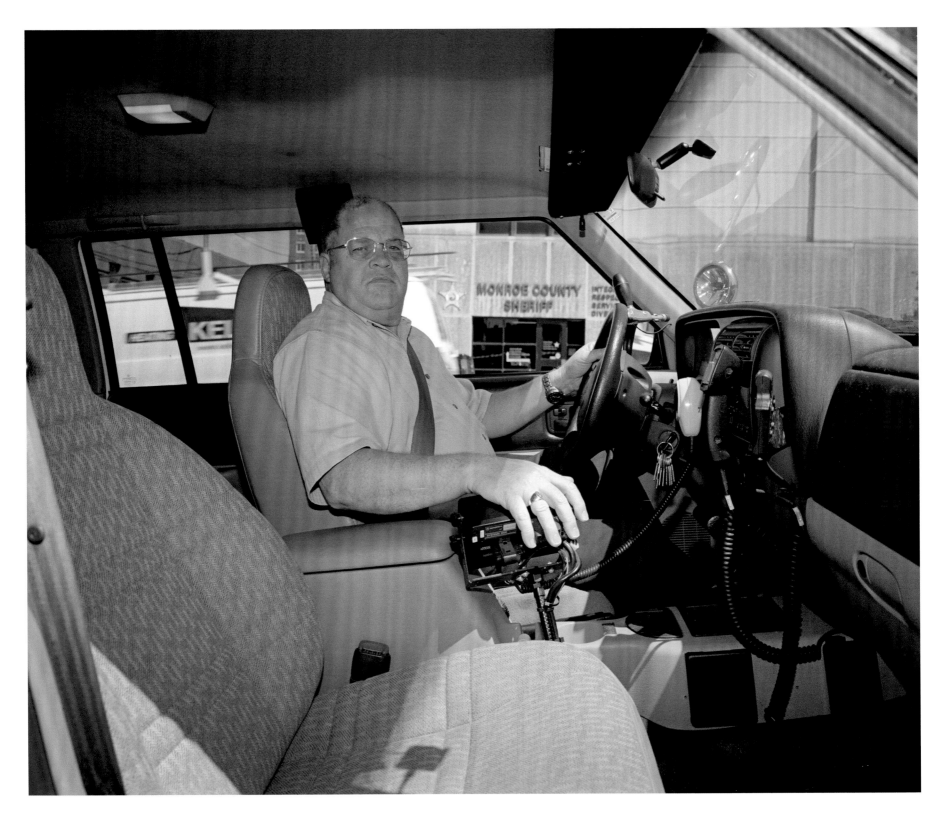

: Stephen P. Sharp

[U.S. Army Lieutenant | October 1969–October 1970]

"IN EARLY '70 they started demobilizing the 1st Division, and certain people who didn't meet the criteria were sent to our Cav division as replacements. I had a young sergeant come in who had been a teacher. He had two kids and a wife. I don't know how he got drafted, but he did. He had done six months with the 1st Division but because he didn't have nine months in, they reassigned him to us for an additional six months to complete his tour. He was from Washington state. The thing that affected me more than anything else, I sent him to Bien Hoa to talk with the division rear to get a teaching job to finish his tour doing GED work with soldiers out of the inner city who had quit school.

He came back and said, 'I got the job, but I won't be getting orders for a couple days.' But because we had just come back from Cambodia and were low on folks, the commander said, 'He's got to go out in the field.' We went out, and two days later he was killed. The same day he was killed I got orders reassigning him to Division rear as a teacher. I met the helicopter when he came back I and watched him die. That was a real trying experience for me because I did everything I could do to get him out. We're not positive but it might have been friendly fire. He got shot through the back of the head…

Our battalion was the first American unit to air assault into Cambodia. We left out of An Loc en masse; we went into Cambodia in company size. We landed in an open field. We were cutting down trees, digging foxholes; berms were pushed up. We were being ambushed or mortared almost every night because we were going into areas were the NVA was. We normally worked through the day and at night before the sun went down you'd find a place to go on an ambush or to hide.

At nights we'd do observations and see these lights moving and then we'd call in air strikes. I had the experience of being about three klicks from a B-52 strike when we first built our firebase. We're about 3,000 meters away. You don't see or hear anything; you're just bouncing off the ground—it would lift you off the ground.

We once had a young guy die of fright. We were in Cambodia; I was out re-supplying my company, which was out about 3,000 meters from the firebase. I was getting ready to go out and join them. Well, they came under fire. There were very high trees—250 to 300 feet tall—this was an area which was a major forest. It had been there for hundreds of years.

We were coming in with Chinooks and lowering supplies in a net rather than landing. We were attacked by an NVA unit. This was when Doc got his second Silver Star. He had been dragging people—the mortars were coming right in on them and he found one young man who wasn't responding. They found no wounds on him whatsoever. He was a new guy and he had been kind of nervous. The only thing they could figure was that he died of fright…

After the war, when I came back, I was a company commander at Fort Benning, Georgia; I was responsible for 300 men. You're held accountable for all their actions—good, bad, or indifferent. My company had a lot of returning Vietnam vets awaiting release from service with major drug problems—heroin, mostly.

We had one guy walk into a first sergeant's office and say, 'My wife's out in the car.' On the way home, she told him she'd had an affair while he was overseas. Well, he killed her. And he comes to his duty station and tells the first sergeant, 'My wife's in the trunk.'

We had significant racial problems. There was polarization within the units where this brigade was out of control. It was a support unit for the infantry school at Fort Benning. They were up at four in the morning and went to bed at midnight. That's all they did seven days a week with no breaks and they didn't want to be there. That was a real problem. There were drug problems and polarization with the black troops moving into their own areas. We had a young man come in; checked in with the CQ and went up to get a bite. Well, he was in the wrong area, which was a black area, and they just beat the hell out of him. So he wakes up, finds a fire ax and kills those guys. He went to jail.

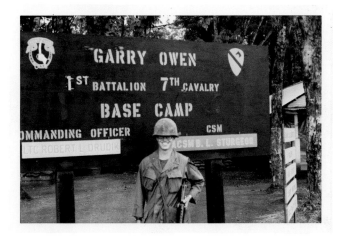

You have an unpopular war. Now you're coming back from fighting; you have to spit-shine your boots; you have inspections; you have to go out and play war games. These guys had four to six months left—they didn't want to do it. As an officer you do the best you can. You try to accomplish your mission with what you have."

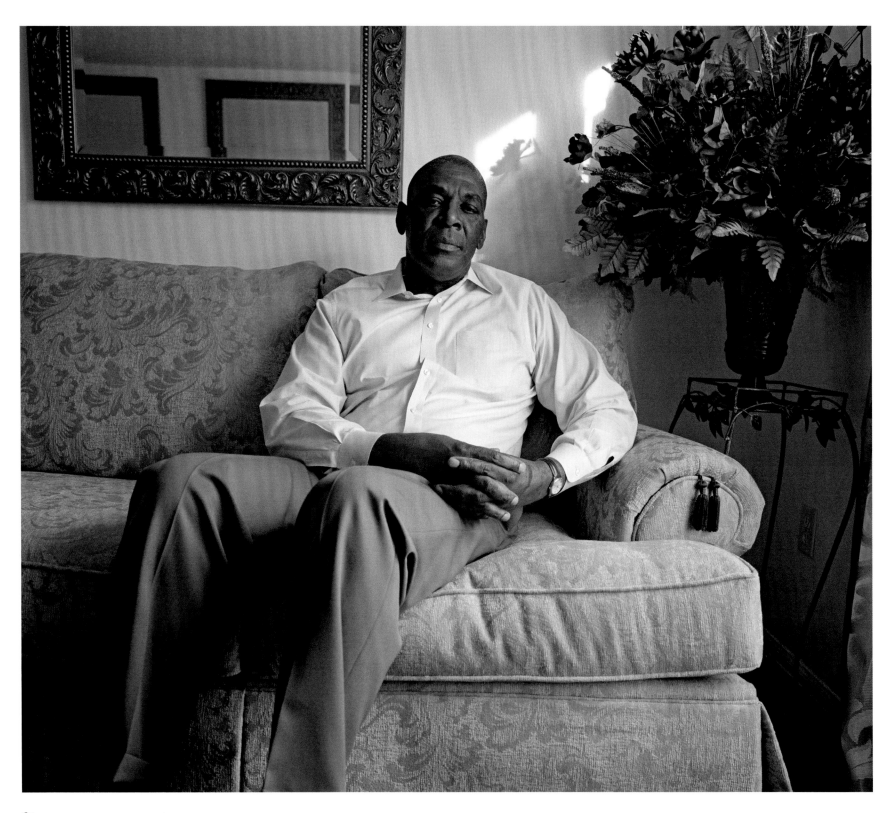

: Frank Ackles, Jr.

[**U.S. Marine Corps Sergeant** | **September 1969–August 1970**]

"WE HAD FREE ACCESS TO THE MEDIA and we had *Stars and Stripes* and we got newspapers from home so we were well aware of what was going on in the political world, and the feelings about the war, and the sense of how the war was being taken back home. It was right in the middle of the civil rights movement and there was a lot of controversy surrounding the war. Over time, by being there and seeing what was taking place, we gained an understanding of the war and the political will behind the war, that this was something that wasn't right.

For myself and many other soldiers, in a sense there was a dropping out—not being motivated. The level of morale started to wane. Marines are usually 'spit and polish' and you wear the uniform of the day properly. You noticed guys stopped caring about how they wore the uniform; they wouldn't blouse up their pants around their boots; wouldn't maintain clean, neat uniforms; they let their hair grow real long. Guys got involved in drugs, started wearing ornaments: peace signs, Black Power bracelets.

There were different ways soldiers would greet each other, especially African Americans. They exchanged Black Power greetings—we used to call it dap—it was a handshake ritual that would sometimes take four or five minutes to get through. There was violence too.

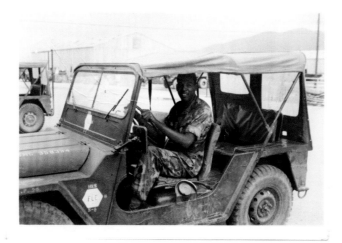

I guess the worst-case scenario was Marine-on-Marine violence. There was a lot of racial tension in Vietnam, more on the bases than out in the bush. Sometimes it was black-on-white violence. It was racial tension created by the civil rights movement as a whole. It was a way people lashed out, and many times it was inappropriate.

There was a lot of separation and isolation; whites would separate from blacks. In my company it wasn't that malicious. In my hooch there was an equal number of white guys and black, but we partied and congregated in separate groups. However, in the maintenance battalion across the rice paddy from us, they had a fragging incident. There was a show one night with no black Marines in the audience, and the black Marines fragged the floor show. If I'm not mistaken, four white Marines were seriously hurt. This was aimless—just lashing out inappropriately.

There were incidents on my base of guys shooting tear gas at staff NCOs and officers going back and forth to the showers. In certain ways and certain places, the morale had broken down."

: Greg McNamara

[U.S. Army Specialist E-4 | August 1967–August 1968]

"**I** WAS A COMBAT ENGINEER. Upon arrival in Vietnam, I was assigned to Company 'B' of the 27th Engineer Battalion. The 27th was headquartered at Blackhorse base camp off of Route One near the village of Xuan Loc. We were doing a lot of roadwork near there. We had an Army outfit running a rock crusher near a ville named Gia Ray. We had to run convoys to pick up loads of gravel and had to go through this little Third World town. Gia Ray was Third World to the 'T': thatched huts, dusty roads, palm fronds, banana trees, barefoot little kids—you never saw any adult males. Just little kids, old men and women, and even girls, but you never saw adult males. They hated us. This town was known to be full of VC sympathizers. We just drove right through there.

I can remember four convoys that, on the return trips through the ville, the VC had mined the road. One time an American dump truck ran over a mine. Three other times Vietnamese vehicles hit mines. Once it was a Vietnamese dump truck; another time a Vietnamese deuce and a half. Yet another time, it was a Lambretta crowded with people—that wasn't pretty. The VC waited until our convoy passed, dug a hole in the road, and laid down a mine, then split before we returned. And that's when I saw some really grizzly stuff. I saw bodies still smoldering. I saw a woman's torso minus her legs and arms. The Vietnamese bought it. The VC put mines out to kill us, and these hapless civilians ran over them and got blown to hell—big hole in the ground.

One day, we mine-swept the area inside a laterite pit where some heavy equipment was working, but we didn't mine-sweep a path where guys would take a break with their equipment still running and go off and have a little boom-boom with mama-san. So one of these heavy equipment operators got off his vehicle, walked hand in hand with mama-san down this path, and they stepped on an anti-tank

mine and it blew them to pieces. I was out there the next day mine-sweeping this pit, and a friend of mine calls me over, 'Hey, Mac. Come here, man,' he says, 'Look at this.' It was the prostitute's foot, like 200 feet from where she got killed. He said, 'What should we do with it?' I said, 'Do with it? Whaddaya mean? Jesus, she doesn't need it anymore. Leave it there!' So we did.

Our company got mortared several times. The one attack that really freaked me out was in the middle of the day. This occurred in a fire support base named Camp Bastogne in I Corps near the mouth of the A Shau Valley. We had been sent up there in April or May 1968. We lived in bulldozed slit trenches dug into a side of a hill over which we placed logs and several layers of sandbags. One day there were four of us filling sandbags—my friends Mark and Cass and this black guy named Kennedy. We got to the middle of the day and knocked off for chow.

Kennedy left his fatigue shirt up there—he just threw it over the shovels. And this was only ten feet from the top of our bunker. The mess hall truck was down in a ravine close by so we had our chow and we were kicking back on our cots in the bunker and all of a sudden, 'Boom! Boom! Boom!' But that first 'Boom' sent black smoke billowing into the bunker. And I'm thinking, 'Whoa! That was fucking close.' We hear a few more explosions outside. As quickly as it started, it ended. We're lying around, forty-five minutes go by and we're thinking, 'Shit man, this is great.' But Sarge appears in the opening to the bunker and says, 'OK, let's go.'

So we all file out and the four of us go back to where we'd been filling sandbags and that's exactly where one of the mortar rounds had landed. Kennedy's shirt was still there and it looked like a sieve. We'd been no more than ten minutes away from going back to our chickenshit detail. I was dazed for a couple of days. I remember walking around thinking, 'This is short-timers' jinx. I can't fucking believe this.' I had less than two months to go. I couldn't believe I could get this close to returning to the 'world' and have some random harassment attack kill me.

Vietnam was an eye-opening experience. Sometimes I wish it had been a more 'noble cause' that you could be proud of. I'm not proud of it. Yet, I'm glad I was there to see what was going on—just to bear witness, I guess. It could have been at the expense of my life, but it wasn't. I survived so I'm bearing witness now and I had hoped, up until Iraq, that the U.S. wouldn't do something so stupid and thoughtless again. But, here we go: Weapons of mass destruction? No! Imminent threat? No! Domino Theory? No! Are we ever going to learn? Apparently certain members of my generation now in power didn't learn a thing, because they didn't go to war—they lack historical perspective. So in a way it makes me want to recede from everything; go off to Colorado and just become a mountain man. Hunker down and live my life and try to be as capable a grandparent as I can.

That's my experience in Vietnam. I'm glad I went. I'm glad I survived. I'm glad I didn't kill anybody. I'm glad I'm here to bear witness."

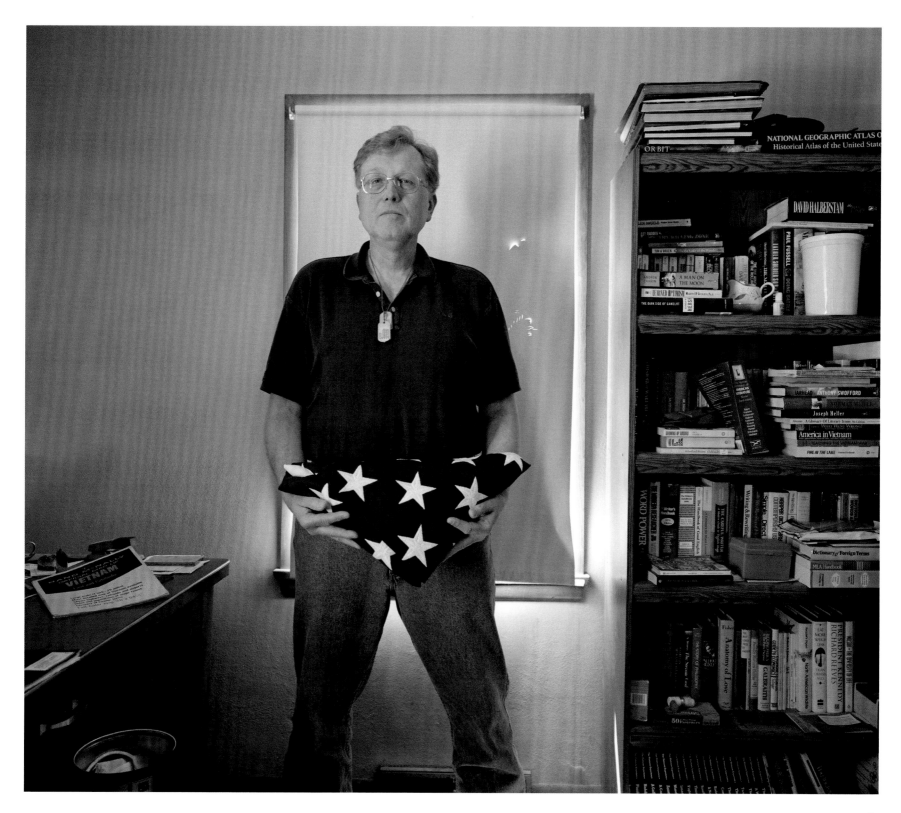

: Marc Leepson

[**U.S. Army Specialist E-5** | **December 1967–December 1968**]

"THE WHOLE WAR EFFORT BOTHERED ME. It was just so painfully obvious almost from the minute you got there what was wrong and why it was wrong. From my perspective, it was a palpable unwillingness of the South Vietnamese to fight their own war. They let us do the dirty work. I remember this distinctly—this is not romanticizing or filling in the blanks. We would sit around and say that if the Americans left, the Viet Cong would take over in a week. The feeling was so strong that the South Vietnamese people and army would fail. I was there during the peak of the American involvement. There were something like 560,000 American troops there. We

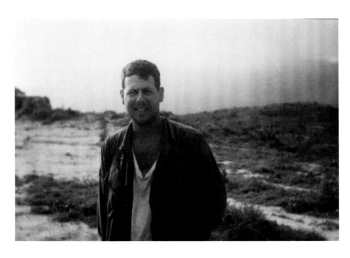

didn't see this burning desire to fight Communism among our allies. It meant to me that the war wasn't worth fighting. It wasn't a war worth shedding American blood or treasure. It was disheartening and embittering. I was bitter about the whole thing. I was bitter about being drafted and being there.

It is true that something like 2.8 million Americans fought in Vietnam and more of those enlisted than were drafted. But a lot of them enlisted because of the draft—the draft was breathing down their necks. If you were drafted, you didn't have a choice of what job you had—if you joined, you did. You had to do three years for the Army, four years for the Navy, Marines, and Air Force if you joined. If you were drafted, you'd go two years. When they say it wasn't a draftee Army, it was a draftee Army. There were 1.2 million of us drafted among the 2.8 million. Of those 1.6 million, God knows how many wouldn't have joined had there not been a draft.

The war was very different depending on where you were and when you were there. When I left at the end of '68, there wasn't a big morale problem. The widespread morale problems didn't really start happening until the war was winding down. Like John Kerry said, 'How do you ask a man to be the last man to die for a mistake?' That was more like late '69, and in '70, and in '71. We didn't have the best morale in the world when I was there, but it wasn't endemic.

I can only speak for myself, but I think the way I felt about the war was the general feeling of most of the guys I hung around with, my buddies. There wasn't one guy there that I knew who was there to fight Communism. We had one goal and one goal only and that was to come home in one piece. Everybody I knew was like that—every single guy. I knew maybe 300 guys over that year. There wasn't anybody with a burning desire to be there. Nobody. I've known a lot of Vietnam veterans over the years since then. Lots. And only a handful expressed the fact that they were over there to defend their country or fight Communism or whatever.

I got changed to 1-A from 2-S a month before I graduated from college. So we knew what was happening. I made a halfhearted attempt to get out of the draft but I just thought, 'What the hell? I'll let myself get drafted.' I got drafted on July 11, 1967. The reception center was worse than basic training. For two days while they are processing you, shaving your hair, getting you a uniform, giving you all these tests and shots, I thought, 'What did I get myself into? This is the biggest mistake I've made in my life.'

But in retrospect, minus the war, it turned out to be a positive thing in my life—a rite of passage that I don't know I could have gotten any other way. I turned twenty-three in Vietnam. I wasn't very mature when I went—I really grew up there; I made it through unscathed. I served my country. I didn't serve in a 'good' war, but I did serve. I did give two years of my life to the country, and I'm proud that I did it."

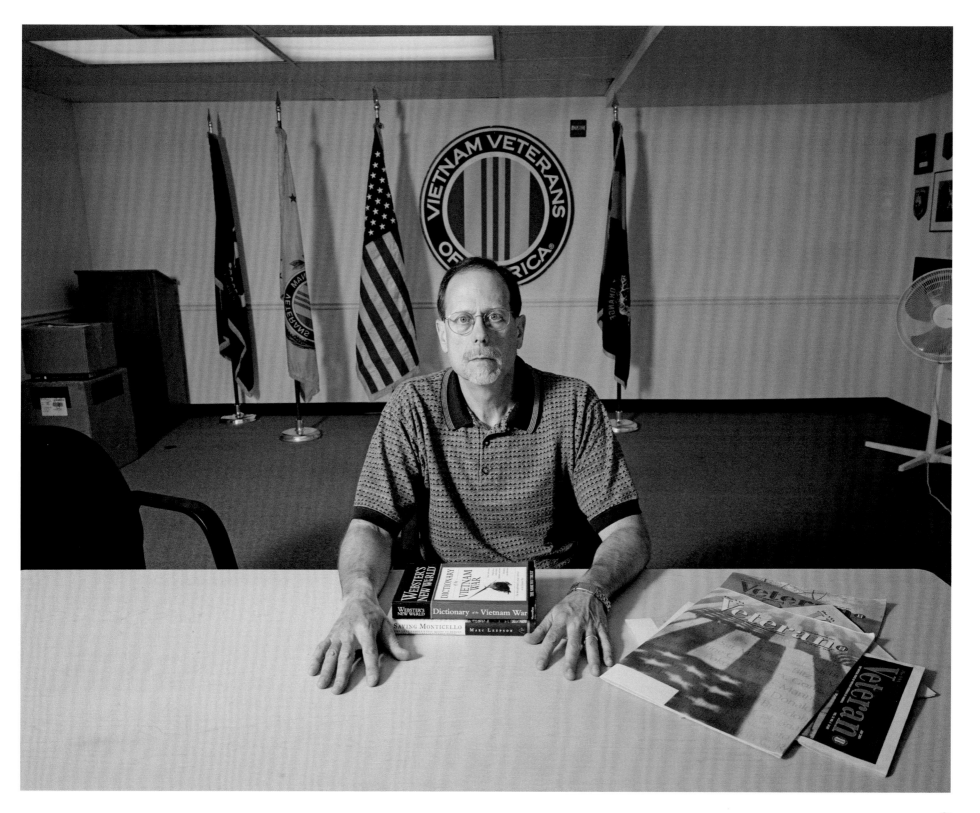

: Nigel "Buddy" Newlin

[U.S. Army Specialist E-4 | November 1967–December 1968]

"**T**HE FIRST TIME I WAS OUT IN THE FIELD, about the third night, I went on listening post duty. I was in NDP, Night Defensive Position, and we got a ground attack—VC. I don't know if it was a battalion or company or what it was, but anyway they were trying to overrun us, and we lost one guy that night from another company; this was at our battalion.

The next morning, my squad and a couple others went out on a body count. That was the first time I ever saw a dead soldier and that was an enemy soldier and I still see him—he was a young kid, probably fifteen years old, maybe a little more. Nice

looking kid. I walked up to him. He was lying there and I just looked at him and I thought, 'Man, I don't have anything against this kid. I probably would have liked him. You know, we'd have probably gotten along.' That's one thing that's always stayed with me. I thought if it had been me lying there how my family would have reacted. I thought, 'This guy's got a family, too.'

When I came home, I went back to Indiana University. I got back December 31 and second semester started the 16th of January—something like that. So I got back and registered. Three weeks out of Vietnam I was back on campus in school.

The first week of classes, I was crossing Seventh Street to the Union in Dunn Meadow and they were having a big protest rally there. I was coming down the steps to go to the Commons and this guy walks in front of me and he's carrying a North Vietnamese and VC flag and this guy was the head of SDS on campus. He's a state or federal judge now—I've seen him around town in a car with a star on the license plate. I see him once in a while and I'm going to go up and introduce myself some time and tell him how I felt that day. I just wanted to cry. I thought, 'Man, after what I'd seen in Vietnam, for him to put that flag right in my face'—it upset me.

To think I went so he had the freedom to do that, in that way, I felt good. But then I thought about my friend, Lt. Lula, who had been killed in an ambush, his parts splattered all over me, and I thought about the other people who didn't come back. And I'm sure if Lt. Lula's dad had been standing by me, it would have really affected him. Here his son is dead trying to give this man freedom, and he's carrying the enemy's flag. I wanted to sit down and cry because I was so mixed up about it.

After that, in spring 1970, there was a national moratorium against the war. The night before that on ABC they had a half-hour show and for the first fifteen minutes the Commander of the American Legion told you why you should not participate, why you should support the troops. The next fifteen minutes was someone from SDS or one of those groups and he said why you should be out there protesting and telling the government why this is a crap war. And I listened to both of them.

I was living over on the corner of Second and Washington and a couple of my roommates were sitting there, and one of them looked over at me and said, 'Well, what should I do? You've been there.' And I said, 'Bob, that's it right there exactly. I've been there and this one guy's telling me one thing and the other one is telling me another, and I've been there, and I still don't know which is right.'

And I was mad at both of those guys for trying to tell me what I should do. And neither one of them had been there. Neither one had seen the guys die. Neither one had seen Vietnam or its people. So the day of the moratorium I didn't do anything. It was my little protest against both of them.

War is terrible. I don't want my son to ever go to war. Now I don't have any control over that. I made a statement once that he would never go, that I'd bust his kneecap with a hammer. But I have no control over that because he might want to go. He might say, 'I need to go, or I have to, or I want to.' "

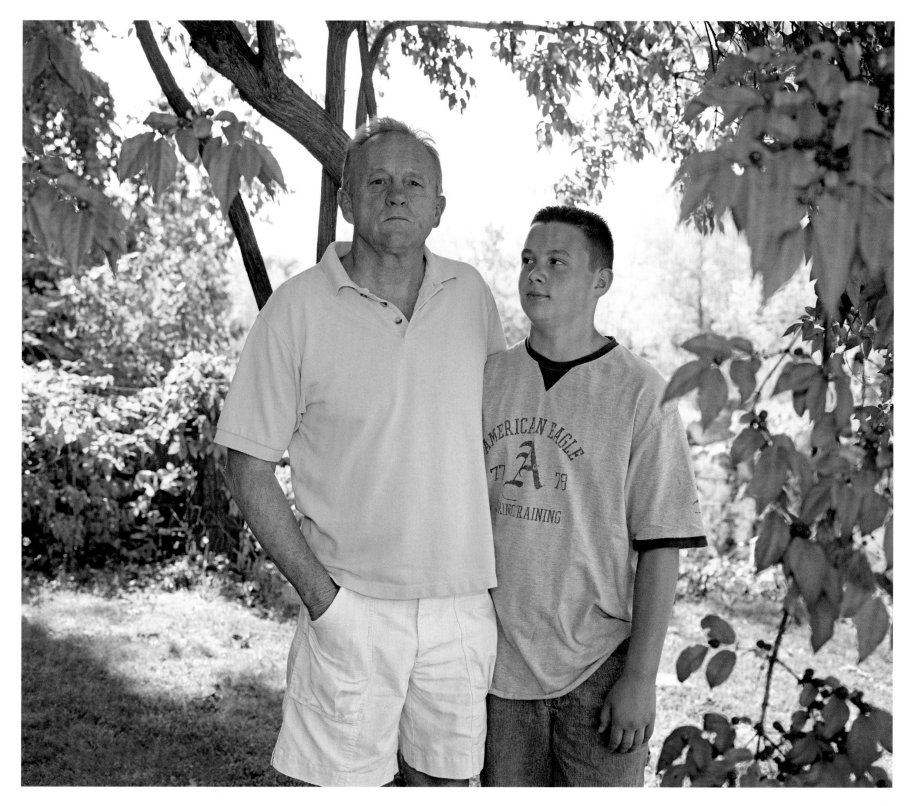

: Eugene Moncel

[16th Military Police Group Captain | July 1970–July 1971]

"**M**Y COMPANY PROVIDED THE MILITARY POLICE SUPPORT for everything outside the combat base, convoy escorts for the convoys coming in and out. We had Quan Tre province, which had about 350,000 people residing in it, and about ten miles or so of the province directly to the south. We had the northern thirty-five to thirty-seven miles of Vietnam from the DMZ south and from the South China Sea over to Laos. The province capital was Quan Tre. We had Dong Ha, Khe Sanh, and we opened up Khe Sanh for a couple of months while I was there. So we had all the police work outside the combat bases down in the cities themselves and down on the firebases. Unfortunately, about the only kind of crime we'd get involved with then were crimes of violence from one GI against another on the firebases. That was all too common. You've heard of fragging incidents and things of this nature. I'm assuming it happens in all wars but with the electronic media we had, this was widely disseminated.

I remember a first sergeant on one of the firebases was murdered by his own men—very difficult cases to solve. The first sergeant was of the E & D, Explosives and Demolition—the people who defuse bombs. He was blown up by one of his own people. Not only did they know how to take bombs apart, they knew how to put them together.

Two majors, a battalion executive officer and the operations officer in one of the armored battalions were killed one night by the company cooks. Now these were indeed apprehended. They had gone into their colonel's hooch and left—it was at night. The cooks were making a lot of noise and the majors walked in the front door, told them to keep it quiet, and walked out the rear door and were shot in the back, killed. I'm assuming this happened in other wars. It is a violent time. Everybody has weapons. So people do things…

The heroin traffic was a tremendous problem. It was ninety to ninety-five percent pure heroin. They smoked it or snorted it—put a few grains in a cigarette, most commonly the menthol cigarettes: Salems and Newports. It was unbelievably cheap. You could get it for a carton of cigarettes. You could track it in '70, '71—the usage rates just went higher and higher. I shared a military police station with the Quan Tre city police. I also had a police station at Dong Ha combat base. It was like putting your fingers in a dike—it just didn't work.

I had four people out making buys and arresting people. Whatever drug usage rate was reported back home, it was much, much worse—very difficult to deal with. I'm sure there were M.P.s who were using too—couldn't catch them. A lot of marijuana use. They called me up one day because they picked up a warrant officer, a pilot, and he had a gunnysack full of marijuana. It technically took an officer to arrest a fellow officer, so I went up and placed him under apprehension. He tried to tell me he wasn't going to sell that—it was for his personal consumption. Well, it would have taken him a whole tour of duty to smoke it."

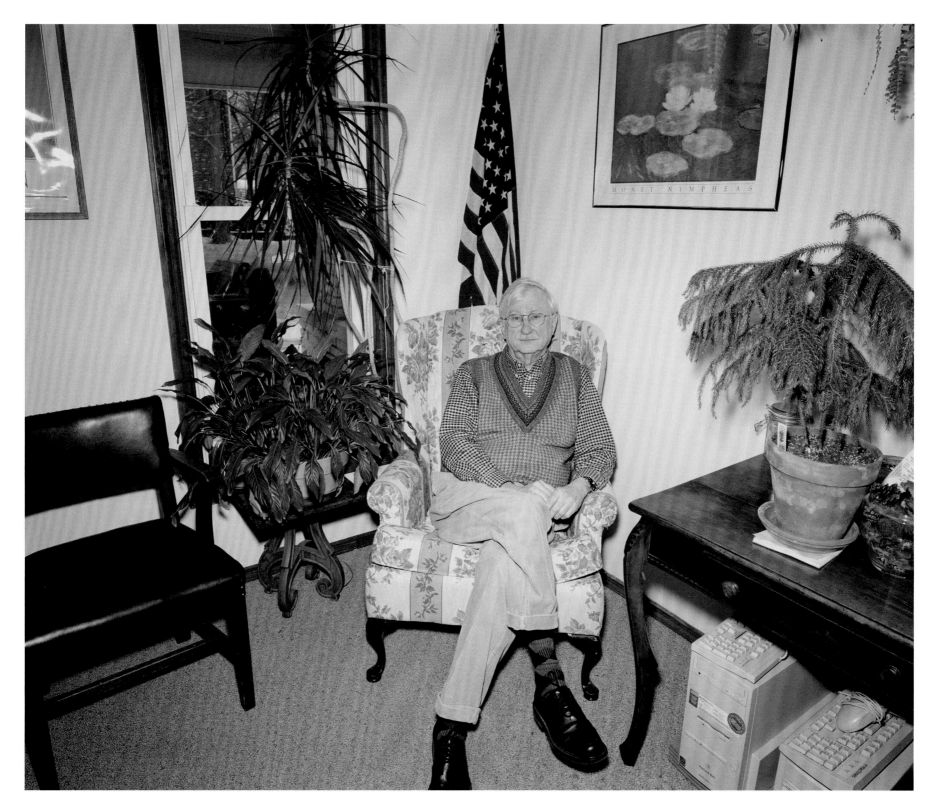

: Thomas Sherman

[**U.S. Air Force Colonel** | January 1965–January 1966; September 1972–February 1973]

"WE BOMBED HANOI WITH B-52S for the first time in December 1972. It was called *Operation Linebacker II* and it was eleven days of bombing. I led the third attack. A lot of people, me included, think that's what basically ended the war because up until then the North Vietnamese and the South Vietnamese were dragging their feet.

The conventional wisdom at the time was that if we got too tough on North Vietnam, the Chinese would come in. We didn't want that. We didn't want to get into a Korean-style war with China. Nixon and Kissinger opened the doors to China and the best I can tell, they got tacit approval from Mao Tse Tung that the Chinese wouldn't react if we beat up on North Vietnam. They had been arguing in Paris over the size of the table and all this kind of crap, but a few days into the bombing of Hanoi, North Vietnam finally agreed to get together and talk…

We took off from Guam after the usual pre-takeoff briefings. You're loaded with fuel, loaded with bombs. You're at max gross weight. These were all World War II bombs, stuff the guys hadn't dropped on Berlin. They were 500—and 1,000—pound bombs. During the eleven days of *Operation Linebacker II* we ran out of the 500 pounders.

After takeoff we formed up into three-ship cells. The cells were separated by a few miles and each cell had a title: cobalt, orange, etc. So when you called cobalt, you'd be talking to the commander of that cell. We flew about four hours to just off the coast of Vietnam. The 'D' models had to refuel because they weren't as fuel efficient as the 'G' models. So those guys had to hit the tanks.

We went northwest up through South Vietnam off into Laos until we were due west of Hanoi, then we cut east and ran down Thud Ridge. From the time we took off from Guam until we were over Hanoi was about five hours. I started off from Guam with maybe thirty B-52s, and I picked up twenty more based in Thailand after the refueling off the coast of Vietnam. So by the time we got up to Hanoi we had fifty-some birds, plus fighter support and such like. As Airborne Commander I was in charge of all that.

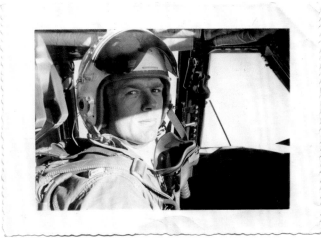

It was a night mission. It was black—all you could see were a few lights on the ground. I'm talking to the cell commanders, the fighters. There was an airborne early warning control plane too. And there were Navy ships also in the command and control business out in the Gulf of Tonkin. So I was yakking with all kinds of people—I had more damn radios than you can believe. Trying to keep track of all that was going on kept you kind of busy.

We came in at 35,000 feet. There was a hell of a tail wind. We were going lickity-split down Thud Ridge into downtown Hanoi then releasing and making a hard right, turning southwest into Laos. We believed that Hanoi was the best-defended city in the world at that time.

We weren't sure how many MiG fighters were going to be attacking and how many were measuring our altitude. We were doing a good job jamming the command and control of the surface-to-air missiles. Normally SAMs have a proximity fuse so when the warhead goes by at a certain distance, it's programmed to go off—it has its own radar. But we had them jammed so they didn't go off. Then the North Vietnamese set them to go off at a certain altitude. I counted thirty of these SAMs fired just at our cell. They were coming up all over the place. The idea was to be in the lethal SAM ring for the minimum amount of time. A lot of guys would get hit in that post-target turn. I lost one B-52 on my mission. We lost a total of thirteen or fifteen B-52s during *Linebacker II*.

Our targets were railroads, military installations like army bases, radar sites, airfields and so forth. The enemy was running out of SAMs. By the last night of the eleven-night operation it was damn near a milk run.

After eleven days of this, the North Vietnamese told the U.S. they wanted to resume the peace negotiations. *Linebacker II* gave everybody a good excuse to restart the talks. It was obvious that Hanoi was on its knees militarily. After the third or fourth night things were looking pretty good for us. One of our guys called the B-52, 'God's avenging dump truck.' I think it's a pretty good label."

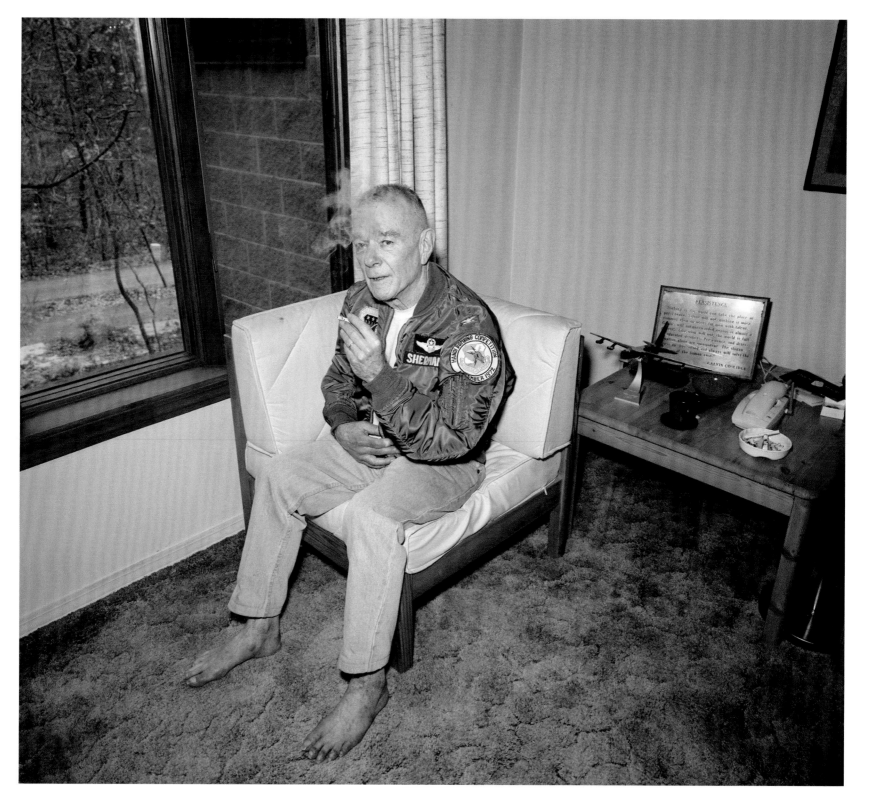

: Thomas Vernon

[**U.S. Marine Corps Sergeant** | **August 1965–August 1966**]

"ON OCTOBER 30, 1965, early in the morning, those gooks down in the village had set up a 75mm French recoilless rifle. On the hill we had a tank and an Ontos, which looked sort of like a tank but had six 106mm recoilless rifles mounted on it—a pretty deadly weapon. Those gooks had already zeroed in on the tank and that Ontos, and the first two rounds out of that seventy-five knocked them both out, knocked the track off the tank. They couldn't maneuver to fire down the hill. Anyway, all hell broke loose. We estimated there were about 200 VC. They came up the hill and actually overran our position. They blew up the command post and got into our ammo bunker and got grenades and ammo, rockets and mortars. And it was pretty much hand-to-hand combat for probably an hour before we could push them back off the hill.

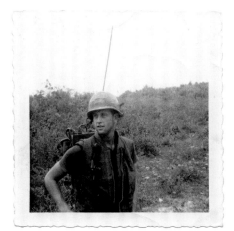

There were about 120 Marines there, a pretty full rifle company, which is three platoons. Of course, the Viet Cong had the element of surprise. It was raining like hell anyway. They approached, cut the wire, came right on up through the hill there. We were set up in a perimeter on this hill, which was about three acres on top. It was twenty-two feet elevation, so it wasn't that high. They came up on the side of the hill opposite to where I was at and, normally, when you're in a defensive position like that, you are firing outward. But they were coming up to our backside and anyone who was standing up in the middle of the perimeter was fair game—you just turned around and fired into them. You could hardly see anything—it was very dark and raining. About 2:30 a.m. that night we had medevacs flying in and out. We had nineteen Marines killed and forty-seven wounded, so it damned near cleaned out half the company. I thought, 'Hell, man. I've got forty more weeks to serve in country—what's that going to be like?'

The next morning what was left of us did a sweep around the perimeter of this hill—we got forty-three Viet Cong KIA. We gathered them up and had a tank come in with a blade on the front and dug a ditch and threw those VC in the ditch and covered them over. I went out around the hill, and I was looking at the different kinds of ammo lying on the ground there from the previous assault. They had a lot of old French weapons left over from when the French were there in '53. They had the old grease guns with the big banana clips on them. They had some old M-1 rifles they had collected that the U.S. government gave to the Vietnamese in the '40s to fight the Japanese; mostly automatic assault weapons, a lot of different weapons—whatever they could pick up here and there.

We stayed on that hill for about another week. Like I say, we had the hell shot out of us up there. The VC were a pretty well-organized fighting force and they were pretty damn formidable, too. Those guys came down there to kick our ass and they did kick our ass pretty good…

When I came back from Vietnam, the students were having a demonstration over on the Indiana University campus and they had these jerks out there in Dunn Meadow running around with North Vietnamese flags. I parked my motorcycle, ran down the bank, and cracked a few heads. Off they took me to jail for disorderly conduct. That's when I was still pumped up about the war being the right thing in 1966. After a while the war seemed to be so useless and futile. I kind of changed and I lost track of the war. I didn't read about it and I didn't watch the news. I felt like we should never have been there to begin with. What the hell for? Were we going to save the Philippines from Communism?…

I was lucky to get back without any physical injuries. I started having problems with PTSD about ten years after I got out of Vietnam and then about 10 years after that was when I really started having some problems with flashbacks. I was having nightmares about Vietnam. The VA diagnosed me with Post-Traumatic Stress Disorder related to combat trauma. In World War II they called it 'shell shock.' You don't ever really outlive that—it's baggage you carry with you your whole life.

I've scared the hell out of my wife more than once when I wake up screaming in bed. One nightmare I have more than others is, we're on patrol and somehow I get either left behind or I lose my way, and the patrol leaves and goes on without me and I'm left there by myself knowing full well the enemy is right around there someplace. The next thing, I'm hiding beneath this big bush and I hear Viet Cong coming down the trail and then they stop right in front of where I'm hiding and raise the branches up, and there I am. And it just scares the shit out of me. That's when I start screaming. I have that dream frequently. I probably have nightmares four, five times a month.

When I look across this field at home here today and I see that tree line over there—that's the things you look for while you're on patrol. You scan those tree lines for snipers or any kind of activity. You just deal with it the best you can—take your medication. It helps some with the nightmares and helps you sleep. We're going to see people coming back from Iraq with these same problems. It can't be helped. It's just so frightening to be in a situation you have no control over, where you can die at any moment."

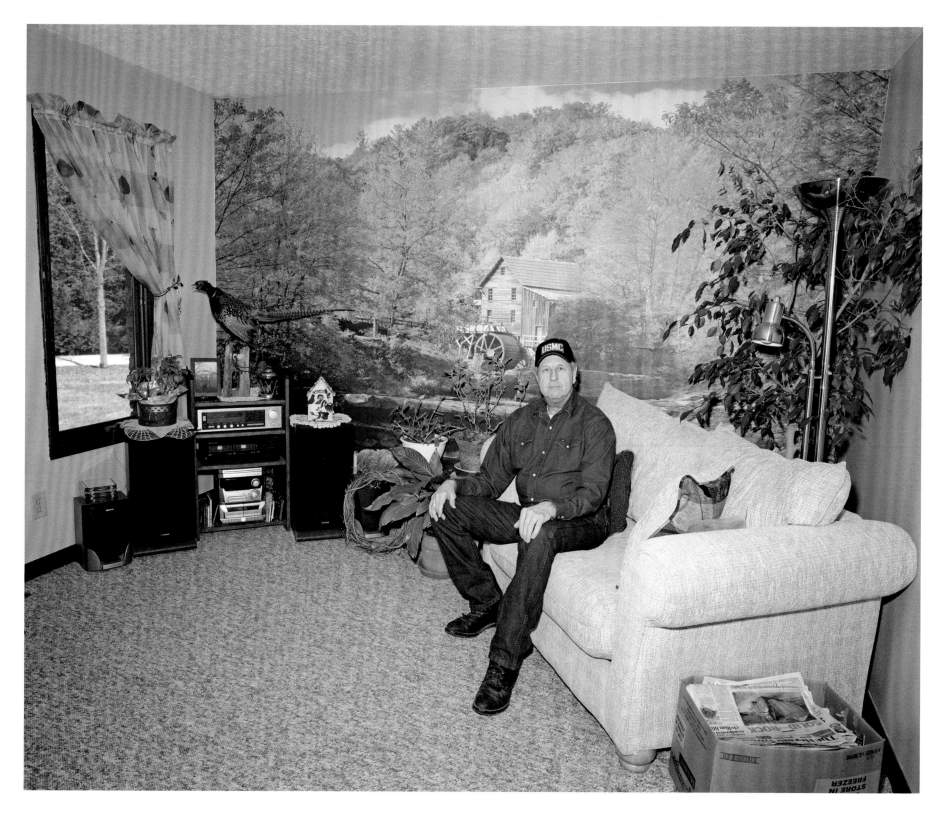

: Gordon Nakagawa

[U.S. Navy Lieutenant Commander | October 1967–June 1968;
September 1968–June 1969; September 1972–March 1972]

"DURING THE *LINEBACKER II* OPERATION of December 1972, there was an emphasis upon minimizing collateral damage; they wanted to hit just military targets. Our target was a small shipyard in Haiphong Harbor, the major port city of North Vietnam. As we were approaching the target, since we had discovered a malfunction in our computer the technique would be for the bomber/navigator to have a reference point that he could give you a command to drop the bombs at the proper time. He said, 'Ready, ready, hack!' And just as he said, 'Hack!', I pushed the button and nothing happened. We had a malfunction in our ordnance system. We had prepared for that.

I knew the heading for our alternate target, which was the airfield southwest of Haiphong. We were on manual attack for that target and just as we were approaching release point, there was a big thump and a bright light. As I was pulling away the flames started shooting out of the starboard engine. We did our best to follow our exit point. We climbed to about 4,000 feet and exited with the fire coming out. Various systems began to degrade. We lost our right generator, which meant we lost our radar.

We flew all of our missions in the Navy with the understanding that there would be no rescue attempt if you were in North Vietnam. If you got shot down over there, you had a free ticket to the Hanoi Hilton. The only way you could expect rescue was if you made it to the Tonkin Gulf.

We headed to the gulf and were descending to 2,000 feet so we could observe the beach, then we'd wait about thirty seconds and leave the aircraft. But our plans didn't work. I tried pulling up on the nose but nothing happened—the aircraft wasn't responding. We leveled off a little below 1,000 feet. We didn't have any control over where we were going but it was heading in the right direction. As we got close to the beach, the aircraft started to roll over on its back. The B/N punched out and I went out right after him.

I ended up in a rice paddy less than a mile from the gulf. I started off through the rice paddy and didn't realize what a muddy wake I left. The nearby villagers mobilized a search. I could hear the loudspeakers in the village. Hundreds of people spread out in a long line and walked through the rice paddies. I evaded for about an hour. It was a quiet night, no wind. You could hear voices carrying over the water.

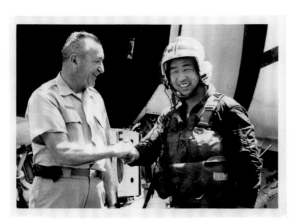

I could hear them walking through the water, and before long I could see them. Because of the wake of muddy water I left, it was pretty easy for them to locate me. Three or four militiamen, upon finding my location, stepped forward and surrounded me. I didn't want them to shoot me on the spot, so I raised my hands high and tried to stand up.

I was taken to the Hanoi Hilton, the old French Hoa Lo prison, used by the North Vietnamese for U.S. prisoners, mostly aviators. In order to establish the best environment for interrogation and indoctrination, they kept the new captives isolated. So the December 1972 *Linebacker II* shootdowns were pretty much kept isolated from everybody else until after the peace treaty was signed.

I was in solitary for about a week and then they put me in with another Japanese American aviator named Jim Nagahiro, a senior B-52 aircraft commander, and Lou Bernusconi, a senior officer captured during *Linebacker II*. They kept the three of us isolated until they moved us down to a different camp in the southern part of Hanoi where 108 P.O.W.s captured from 1970 on were kept.

We knew at the end of *Linebacker II* that the bombing had stopped, and they moved us to the new camp, which had some bomb damage, to remove the rubble. On January 28, there was a lot of gunfire, like they were celebrating. The next day they took us into a theatre and made the announcement that they signed the Paris Peace Accords. A provision of the treaty was that all detainees would be returned within sixty days. They lied about that too. I came home on the sixty-first day…

In 1942, when I was seven years old, my family was relocated to Tule Lake internment camp for Japanese Americans in northern California. In a way the experience wasn't nearly as traumatic as it could have been. Our parents took it in stride. They didn't moan and complain or bellyache or say, 'This is not the right thing to do.' They didn't say, 'This is good,' either. But they didn't make a big issue of it. We were there until April 1943, at which time they extended work releases to Japanese Americans they felt were trustworthy.

Our parents tried not to worry us. They protected us from the trauma that might have been associated with the experience. I had two uncles who volunteered out of those prison camps for military service in Europe in the 442nd Regiment, which became the most highly decorated unit in the war. One uncle was wounded twice. Since they did that, it was pretty easy for me to volunteer to serve in the military and especially because I'd hoped to get an opportunity to fly. In World War II, the U.S. Navy would not accept any Japanese. I became the first Japanese American fighter pilot in the Navy. I don't know that I was trying to prove myself as a Japanese necessarily, though that was part of it…"

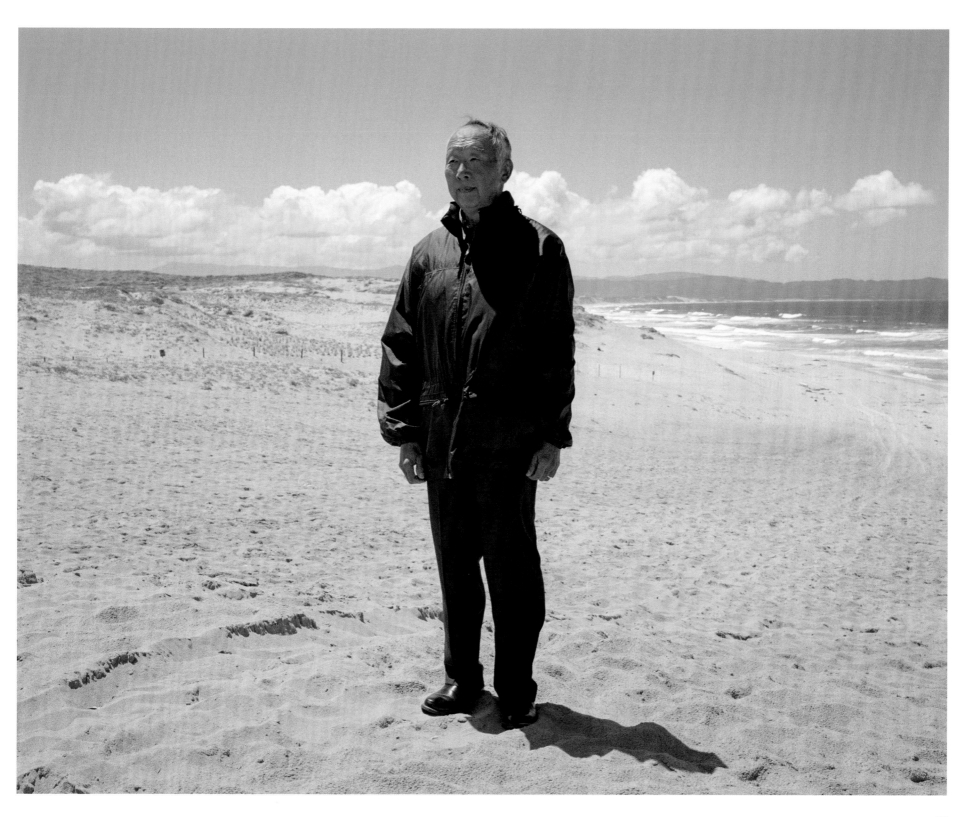

: Timothy Bagwell

[**U.S. Marine Corps Private First Class** | **January 1969–July 1969**]

THE FIRST OPERATION I WAS ON was called *Dewey Canyon*; significantly and ironically, the last operation I was on was called *Dewey Canyon III*. The first was in the A Shau Valley where the Ho Chi Minh trail entered South Vietnam; the last, *Dewey Canyon III*, was in Washington, D.C., and was under the banners of the Vietnam Veterans Against the War. To this day, I am prouder of the last operation than I ever will be of the first.

A Shau

I was a grunt, a lowly ammo humper on an M-60 machine gun team with Bravo, 1/9 (B Company, 1st Marine Battalion, 9th Marine Regiment). Because of our heavy casualties earlier at Con Thien, 1/9 was nicknamed 'The Walking Dead.' When Dewey Canyon kicked off, I had been in country about fourteen days—just long enough to get my combat gear at Quang Tri, catch a helicopter to Camp Vandergrift and be assigned to a gun team.

I don't have many heroic stories. I never felt that we were particularly heroic—other than my iconic memory of a lone dude standing bare-headed on a hot LZ, bringing in Army helicopters as we were desperately trying to leave the valley. Yes, we were in the A Shau for months. Yes, I had clothes rot off my back. Yes, we ran out of food on at least two occasions when the birds couldn't get to us because of monsoon weather; once we went without food for at least a week. I remember digging a C-rat cracker out of the mud, toasting it dry over an artillery increment, and then savoring it slowly. I still remember how great it tasted. Yes, we crossed into Laos in hot pursuit of an NVA unit and then stayed there illegally for three days, running patrols. Yes, we carried our dead when they could not be medevaced.

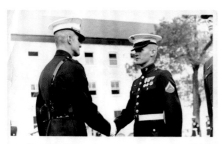

Corporal Bagwell: Congratulations on a well deserved Promotion! I am expecting excellent performance from you. Keep up the good work. [signature] Major USMC

But I also remember the wounded NVA soldier we captured early in the operation. He was interrogated throughout the night. He died before daybreak from his unattended wounds. Now, he lives in my memory. I remember the self-inflicted wounds of others—one grunt shot himself in the foot, another had his friends shatter his arm with a large rock—both in order to permanently escape the bush and, hopefully, Vietnam.

I had a very negative reaction to combat. I was not brought up in a violent environment and, to put it simply, I found combat to be a singularly shitty way of being human. I enlisted at seventeen because I intuitively sensed Vietnam would be *the event* of my generation. I wanted to experience it. I was a wide-eyed innocent searching for an identity that could give my life meaning. But the brutishness and brutality—in both attitude and behavior—of being an American in a combat zone was overwhelming to me. I returned home angry and confused and traumatized.

The other predominant feeling that I brought back from Vietnam was the beginning of a radicalization, of saying that I just won't be lied to again by my government. I really thought I was uncovering the truth about war. As an adolescent, I had glorified what war would be like; as a participant, I found nothing glorious whatsoever; combat is irredeemably grotesque and lacks all conscience.

Washington, D.C.

Without doubt, the proudest thing I ever did while a Marine was—as a card-carrying member of Vietnam Veterans Against the War—throw my medals back on the west steps of the U.S. Capitol at the concluding event of Dewey Canyon III. It was the morning of Friday, April 23, 1971, and, although I had applied for a discharge as a conscientious objector, I was still on active duty. Just a few months earlier, I had been removed as the Orderly to the Chairman of the Joint Chiefs of Staff (then Navy Admiral Thomas Moorer) because the Defense Intelligence Agency believed I had become a risk.

I came home from Vietnam with two years remaining on my enlistment and had been selected for duty at 8th and I—Marine Corps Headquarters—in Washington. We did weekly ceremonial parades at both 8th and I, and the Iwo Jima Monument. I was there about half a year before being selected Moorer's orderly at the Pentagon, across the Potomac River.

When the murders at Kent State occurred in May 1970, I seriously debated going to Canada, but the final point of my radicalization, the moment I committed completely to being fully and angrily against the war and the government, was when Moorer returned from a 'fact-finding' trip to Vietnam and began making public pronouncements on how the war was winnable. No longer could I wear the uniform—I had to get out.

For me, the giving back of my medals was where I took my personal stand. This was an act that I knew in my heart was totally unambiguous, one that could never be misconstrued, misinterpreted, or rationalized away. I was choosing to take my country's symbols of valor and say, 'No, this is unacceptable. I refuse to stand silent.' That is what it meant to me then and it still does today.

My long hair and my long beard are a result of Vietnam. I don't want people to think that I'm normal—I'm not. There is much about American culture that I reject, and the roots of that rejection were laid in Vietnam. I do not apologize for that. That is why the point of honor, for me, was giving back those damned and bloody medals.

My spiritual journey—begun painfully in Vietnam—has continued over the intervening years and my beliefs have morphed from the left-wing Christianity I believed in when I was honorably discharged in 1971, to the active atheism I happily and contentedly embrace now. What has never changed is my vociferous opposition to war as a valid option of human interaction."

: Simba Wiley Roberts

[**U.S. Army Specialist E-5** | **July 1968–July 1969**]

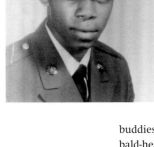

"**E**VERYBODY WAS REAL TIGHT IN MY PLATOON—we were like a brother-hood in the field. There were a lot of dudes we called the 'blue-eyed souls'. They realized, 'Hey we're all over here together. We should be sticking together.' These were the white guys who didn't mind walking with the brothers because the brothers got together over there. The only racial problems were back in the rear with the punks with the gear. We'd come in from the field to the base at Pleiku. They wanted us to give up our guns so we stayed in the motor pool with our tanks—told them we were part of the 'quick reaction force.'

I remember this one particular time, me and a bunch of the guys walked into a bar on the base. There were these guys sitting there in new fatigues and shined boots and looked like they ain't never been out in the sun. And it was generally like that. The majority of the guys in the rear with the gear were white. And one of them said, 'Here come a bunch of them damn boonie rats.' Another said, 'Yeah, boonie rats, niggers. It's the same.' You know, stuff like that. We just walked by.

It was an enlisted-men's club. I would roll up my sleeves so my E-5 rank would not show and I could go in with my buddies, because the majority of my buddies were E-4 and below. And I didn't like going into those clubs where they only played country western. Plus this club had the best entertainment: Philippine girls singing like Diana Ross: 'Stop in the name of love.' Everybody was going, 'Yeah! Sounds like Diana.'

But we was in there, and I'll never forget that night because those guys were throwing beer cans at us. About ten beer cans came flying over from them chumps, and we still said, 'Hey, man, let it go.' Everybody got a frag grenade in their pocket. It kept going and eventually the place started to close so everybody was talking and I said, 'Hey, man, let's just go out and deal with this right now.' I'm thinking my buddies heard me. So I walk out of the club all bad and this little short guy, kind of bald-headed, said, 'Yeah, that's right, nigger!'

And man, I punched him upside his face and was working him over. I picked him up; I had him down. I felt kicks in the back of my head—apparently my boys didn't hear the word; it was just me out there on the ground. All of a sudden it felt like an earthquake, like a stampede and then the fight really broke out—those crazy dudes from the tanks were ready. They were tearing up folk, man. And I remember grabbing that little guy by his leg and dragging him out of the mess so I could work him over some more. That was funny, man. I hope that guy's doing OK today.

The MPs came and we all started running. We didn't know our way around base camp. I remember falling in these drainage ditches because there was so much rain up there in the Central Highlands in the monsoons. And man, I remember falling into ditch after ditch. Nobody got caught; we all got back. We laughed about it…

After I got home to East Texas, me and Ray, a Vietnam vet buddy of mine, went to pick up the money the Army owed us. We were so happy. We'd been all over the world. I was based in Germany, man. I didn't go out on the town for a year. I couldn't. When people asked me, I said, 'No, man. Where I come from, you don't do that with white folks.' For a whole year me and the Playboy bunnies had an intimate relationship. But after going home to Texas on Christmas leave and finding my first love in the arms of another man—after I had been so true to her for a whole year—I was numb. So I finally went downtown in Erlangen, Germany; I was making up for lost time. I met a woman named Heidi, which was a blessing. Then I was in Vietnam for a year. There was a thing among African Americans: my father and every generation going back fought for our country in whatever war was going on.

Anyway, me and Ray drove over to Fort Polk, Louisiana, to get our money. There was a little club on the way back where we wanted to stop and have a beer. We walked in this place and the guy said, 'We don't serve niggers here.' I looked at Ray and he looked at me. He said, 'Did he say what I thought he said?' I said, 'Yeah, he did, Ray.' He said, 'All right, let's go.' Can you imagine? I'd been all over the world and everywhere I was a man except when I came back to America."

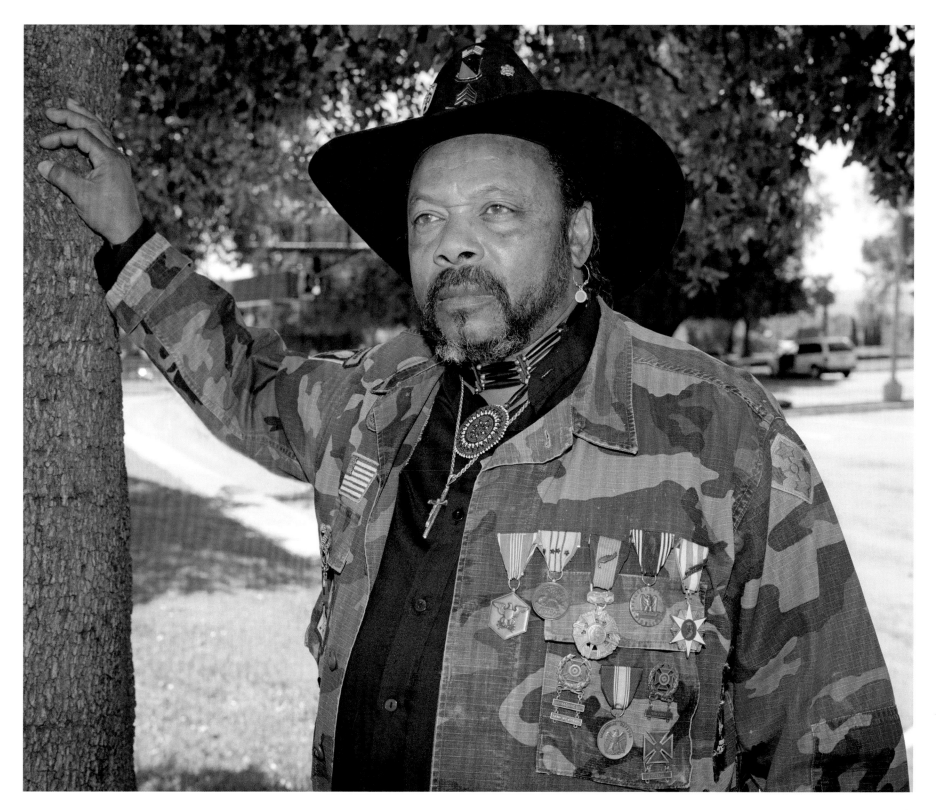

: Larry Heinemann

[**U.S. Army Specialist E-5** | **March 1967–March 1968**]

"ON NEW YEAR'S EVE we started getting radio messages from LPs in the woods—three-man listening posts: 'Something's happening! Something's happening! Something's happening!' The fighting started about 11 o'clock at night and went steady, on and off, until the next morning, until it got light enough to see—then it stopped. I will never forget this. I know I didn't dream it. I haven't imagined it. The sun came up and the smoke cleared and the dew burned off. There was meat all over everything. All around the perimeter it was meat. And the wood line, which was maybe fifteen or twenty meters away looked like ruined drapes. It was a mess.

One thing that Oliver Stone, who described this battle in *Platoon*, got right—at the end of the firefight in the film, the planes come in and drop napalm, which didn't happen; they didn't drop anything on us—the next morning when the kid wakes up there's white powder all over everything. Everything sort of looked antique—I remember that distinctly. It was dust and junk all over everything. Everybody was covered with dust and sweat. And the bodies and the body parts, the meat, looked antique. Not fun. I never want to go through something like that ever again.

One of the things I did at the beginning of the battle: my track had been on the perimeter and then they moved us to a new spot on the perimeter. I parked the track in such a way that the gas tank was as far away from a direct shot as possible. There were some tracks that got blown up and burned to the ground. The gasoline fire melted the metal armor—around a couple of the tracks you'd have this huge puddle of aluminum alloy. One of the tracks in our platoon got hit and burned and the driver's body was simply incinerated. All we found of him was a bit of his backbone, his pelvis and his skull.

As drivers we were sitting in the track from the neck down so you can see; everyone else is sitting on top. If an RPG hit the track, the driver has the gas tank right behind, and the drivers always got fucked. If I ever meet the bonehead who sent gasoline powered Armored Personnel Carriers to Vietnam instead of diesel, which is less flammable, he and I are going to have a real serious conversation. I would gladly do time in prison for the privilege of beating the shit out of the guy…

It's a true fact if ever there was: I became a writer because of the war and not the other way around. It's one of the great ironies of my life and it's an irony I share with a number of writers who came out of Vietnam. Bruce Weigl would be working in a mill around Lorain, Ohio. Probably the only writer I know who would have been a writer regardless of the war is Robert Olen Butler.

My old man drove a bus and had four sons. Word in the house was: finish high school and get a job. I'm the only one of the brothers who finished college. Becoming a writer was the farthest thing from my mind. I came back from Vietnam in early spring of 1968. Three weeks later Martin Luther King was murdered. Then in June, Bobby Kennedy was murdered. I got a job that summer driving a Chicago city bus and literally drove through the big doings at the Democratic National Convention in August. I thought the war had followed me home.

I wanted to go back to school. I took a writing class because I thought it was going to be a snap 'A' and I wouldn't have to work. I got fooled. The second night of class, the teacher comes up to me and says, 'If you want to write war stories, here, read these two books.' And he hands me *The Iliad* and *War and Peace*; it took a year to read those books. The *Iliad* is a paradigm for a lot of things but it's a war story, so it's a paradigm for war stories.

I became a writer because I had a story that would not be denied. I was talking about this the other day with my editor and I said, 'For thirty-five years I've been thinking about the war every day.' The war had a tremendous impact on my life. When my kids were old enough, I had to teach them not to come up behind me and give me a hug around my throat. Don't make a loud, sudden noise behind me. I've always had a kind of tic and I went to the VA and the shrink said it was some kind of seizure. It's a flashback. It only lasts an instant but you get a full image of an event.

As a writer, Vietnam is my subject. Faulkner had Yoknapatawpha County and he had that in his head all his life. All he had to do was dip in this story or that story and the characters were all right there. Garrison Keillor had Lake Wobegon—what a remarkable discovery! I used to be embarrassed to write about the war—not so much now. I've been blessed with a source. I know for a fact that as a writer, I can reach around and touch the war and always find a story. The war really did give me something that I love—writing is a craft that I love."

[Larry Heinemann received the National Book Award for Fiction for Paco's Story, *based on his Vietnam War experiences.]*

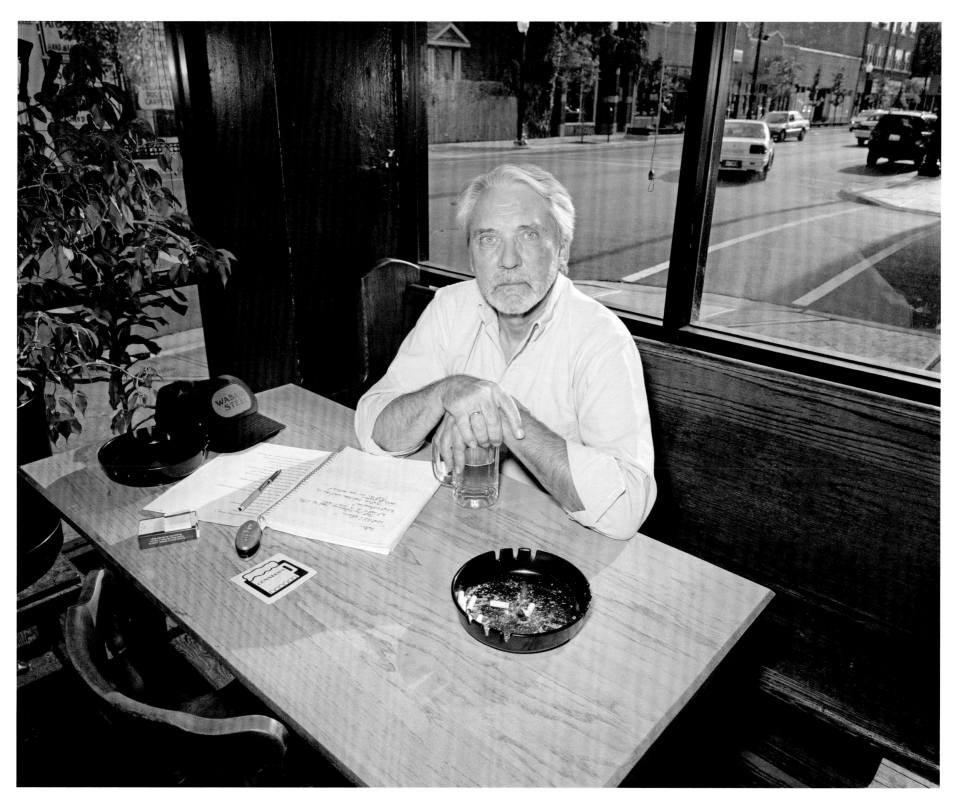

: Laurence Friese

[**U.S. Marine Corps Captain** | **June 1967–March 1973**]

"**I**WAS SHOT DOWN about seventeen miles west of Hanoi on the 24th of February during my 138th mission. After evading capture for four days—traveling at night, hiding by day—I was caught, blindfolded, and tied up. They took me to the old French prison we call the Hanoi Hilton.

At a long table is the interrogator called the 'Bug.' I'm on my knees, hands tied behind my back, on bricks. He says, 'What kind of an aircraft were you in?' I say, 'That's not information I have to give you.' 'What kind of aircraft were you in?' 'I'm only supposed to give you name, rank, serial number, and date of birth.' 'What type of aircraft were you flying?' Hey, I have more time than this guy does, right? 'But that's not part of name, rank, serial number, date of birth.' Bam! I'm being hit in the face and knocked into the corner. The Bug yells, 'Get back on your knees! What kind of aircraft were you in?' So we go through it again. Bam! I'm back in the corner. Then the Bug gets up and says, 'You're very stupid, Friese. You were the Bomber/Navigator on a Marine A6 flying with Major Marvel.' Then he leaves the room. The Bug gives me three chairs to sleep on; it's worse than the floor. He gives me something to read about how to handle interrogations. I don't know who wrote it; I assume it was an earlier shootdown (I was about the 314th guy to get shot down).

Another time he says, 'You can't take the punishment. We will do permanent physical damage to you. You're going to have to tell us more than name, rank, serial number, date of birth.' I study his eyes and I believe him. What the Bug says agrees with what I've read—the North Vietnamese are not abiding by the Geneva Convention Accords of 1956. The name of the game is do what you have to so you wind up doing the least for the enemy. I would constantly try to figure out what I could get away with regarding lies. I wanted to keep a low profile. The Bug himself beat me in the face during a follow-up session, trying to get me to tell him the frequency of the radar in the A-6 Intruder. There were no hit men or Army guards in the room with him at the time, so I screamed at him with blood in my teeth as though I was going animalistic and he backed off.

They are exceedingly sensitive to humiliation. In one session, the Bug had me down on my knees with my hands tied behind my back, pressuring me to write something. He finally asked, 'Do you refuse?' I looked him eye-to-eye and said, 'Sir, I don't think I should use that word.' He backed off, disgusted, and stopped pressuring me. He reeked of wanting me to say, 'I refuse,' so he would have the procedural right and patriotic obligation to make me his next piñata. He would have gotten even for his whole Fatherland for the dirty words Lyndon Johnson said on the floor of the Senate, describing the Vietnamese as 'yellow dwarves with pocket knives.'

Certain interrogators seemed to have to get political statements out of us: bad-mouthing the war, telling our president or troops in the South to get out of Vietnam. One interrogated me to make a tape recording to the GI's in the South. I told him I just wanted to be treated according to the Geneva agreements for POWs. 'Tell them to lay down their arms.' I said, 'Don't make me do that. Please, I don't want to do that.' (Again, I've got more time than this guy does.) He looked at his watch; he's probably under pressure to get a tape from some prisoner. I'm wasting his time. Good. He finally said, 'I could force you to make this tape easily.' I looked him right in the eye and said, 'Yes sir, you probably could, but if you torture me to make a tape, it wouldn't be a heroic thing for your government to do.' He looked at me, and told a soldier to take me back to my cell.

Time inched along; Johnson's term was coming to a close. Richard Milhous Nixon (RMN) spent his first term trying to navigate between finding an honorable solution to the Vietnam War and trying to restore domestic tranquility on streets in the United States. During the campaign between RMN and George McGovern in 1972, I sat in my cell and listened to camp radio, which was, to put it mildly, biased to the left. It sounded like a McGovern promotion. It was 1972 on the other side of the world, and this little country had a clear and definite stake in the American elections. My immediate thought when word was passed about Watergate was, 'Congratulations, Tricky Dick, you too are wondering whether McGovern's campaign is being financed out of the Kremlin.' But, in spite of Watergate, Nixon scored the biggest landslide victory ever in a Presidential election. The message was loud and clear in Hanoi—four more years of Nixon. *Linebacker II* was a 1972 version of American solidarity spirit of the type that hung in the air throughout our country after 9/11.

At this time I was a thirty-year-old United States Marine with almost five years in a Communist detention camp. A typical Class A personality, macho fighter pilot guy, but not on the night of December 18, 1972. I was afraid. My heart was pounding and all four of my extremities were shaking like a sheep shitting a pinecone. Why? Start by combining every Fourth of July fireworks display that ever occurred since 1776, and add to it every train wreck, airplane crash, thunderstorm, tornado, hurricane, typhoon, volcano, earthquake, and tsunami that ever happened, throw in the horror of the shower scene in *Psycho*, the worst turbulence you've experienced on an airline flight, and whatever else has ever made your heart tremble at its maximum. It went on and on in the dark. But not only did our bombs falling rattle the earth, the North Vietnamese SAMs did too, their anti-aircraft artillery shells corking off rattled the earth, small arms fire near and far added a minor amount of excitement.

Within weeks, the Vietnamese had our whole camp in the courtyard and announced that we were going home. The sick and wounded first, then by shoot-down date. March 14, 1974, was my turn. We were given civilian clothes and taken to Gia Lam airport in Hanoi on buses. I was standing in formation under a solid overcast wondering when I was going to wake up from this dream I had had so many times. I was gazing at the bottom of the clouds and saw the prettiest thing of my life: a United States Air Force C-141 Starlifter. There were about 107 guys on that flight all with roughly five years of captivity—more than five man-centuries of confinement rolling toward lift-off. When the wheels of that C-141 came off that piece of dirt called North Vietnam, we were free, and it was our turn to sing, 'When Johnny comes marching home again, hurrah, hurrah.' With it all was a feeling of gratitude that has never waned, and a taste of freedom that forever will be particularly sweet."

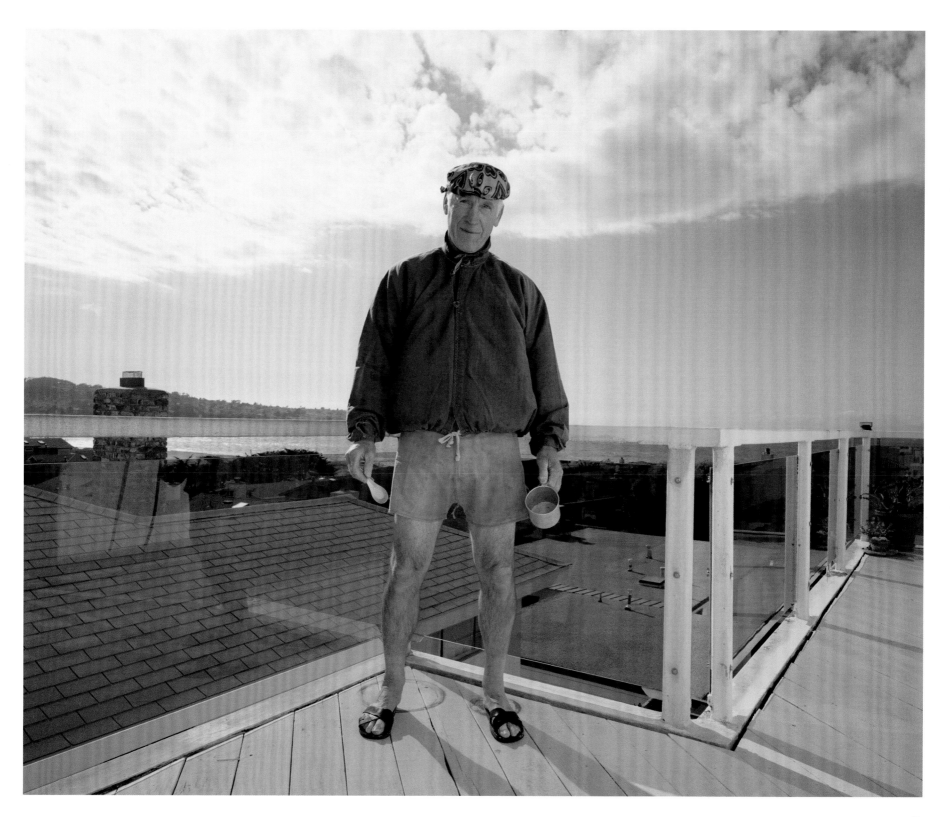

: James Claude Arnold

[U.S. Navy E-4 | July 1966–February 1968]

"I AM PROUD TO HAVE SERVED my country in Vietnam and the twenty years, three months and nine days that I served in the military. I'm proud to have been a little part of attempting to give an entire country its freedom because while we were there they did have elections and there was more than one person on the ballot. So they did get a little taste of democracy. And through aid we did build schools, hospitals, orphanages—there was a lot of good done, at least we were attempting to. And if the politicians would have let the military run the war, I think it would have been a different world today. We could have won if our hands hadn't been tied.

Americans have always been one step away from doing what's supposed to be done and they're doing it right now. I'm not going to compare Iraq to Vietnam. I'm going to compare the politics. Americans are always, 'We don't want to do that because we're going to hurt somebody.' What the hell is war? That little town over there in Iraq that's giving us all that trouble, Fallujah—let's just go in one side and when we get to the other side there's nobody left. I mean, nobody left.

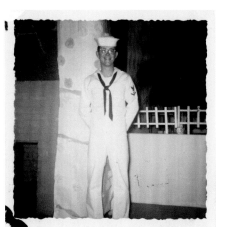

Do you know what General Pershing did in the Philippines? He took a few Muslims and killed them; put them in a hole in the ground. Cut up two pigs, poured blood all over the corpses, put the pigs on top, and buried them. He never had any more trouble because in the Muslim religion you can't meet Allah if you've been in contact with pork without purification…

A lot of us, including myself, came back from Vietnam as alcoholics. This may be hard to believe but in the time period I was over there, I don't remember one person taking drugs. That was later in the '70s. Our problem was alcohol.

You know when it's 110 degrees in the shade you've got to have some kind of liquid. Our water there was treated with bleach. It tasted exactly the way it smelled—I'll guarantee it. So you could drink this water that smells like bleach or you could have beer. We would get beer in by the pallets. This was American beer they brought us when I was stationed on the island of Phu Quac off the coast of Cambodia. After you've been there for a while you learn not to drink anything cold. That puts your body in shock. We drank warm beer. By the time I got back home, I wanted cold beer. I also drank Jim Beam and scotch.

After Vietnam, I was sent to Korea. I was spending my entire military paycheck at the NCO club, plus maximum credit. I had one pair of civilian pants, one pair of civilian shoes, one civilian shirt. Everything else was military. I mean I was drinking everything. One day my first sergeant came in and told me he was going to put me in the stockade if I didn't straighten up. This was in Chun Chon, eight minutes from the DMZ—I went from one combat situation right into the next one. Plus I had transferred from the Navy to the Army. I decided that I had to do something because I knew I wanted a military career.

People realize today that alcoholism is a problem with all the homeless Vietnam veterans. They couldn't lick it. But I can tell you how I did: my late wife helped me. When I met her in Korea—we got married in 1969—she helped me out by offering companionship, and by asking, 'Do you really need that drink right now? Let me get you a Coke instead.' And by substituting beer for the hard liquor; plus I wanted to quit. I stopped drinking completely. Maybe on New Year's Eve we'd pop the cork on a bottle of champagne and have one glass. Other than that, I don't drink. If I hadn't stopped then, professionally I was finished. If I had gone to the stockade, I was out. That first sergeant did me a favor. His name was A. D. Pridgen and if I knew where he was today I'd hug him and kiss him. I'll never forget him as long as I live.

Anyone with a drinking problem, they've got to want to do something about it. You can't force someone to do something they don't want to do. If I see someone at a bar that's got a drinking problem, I don't try to put my views upon him. That's one thing that everybody has fought for in this country—the right to make choices in your own life. You may not be right in what you want to do, but you've got the freedom to do it."

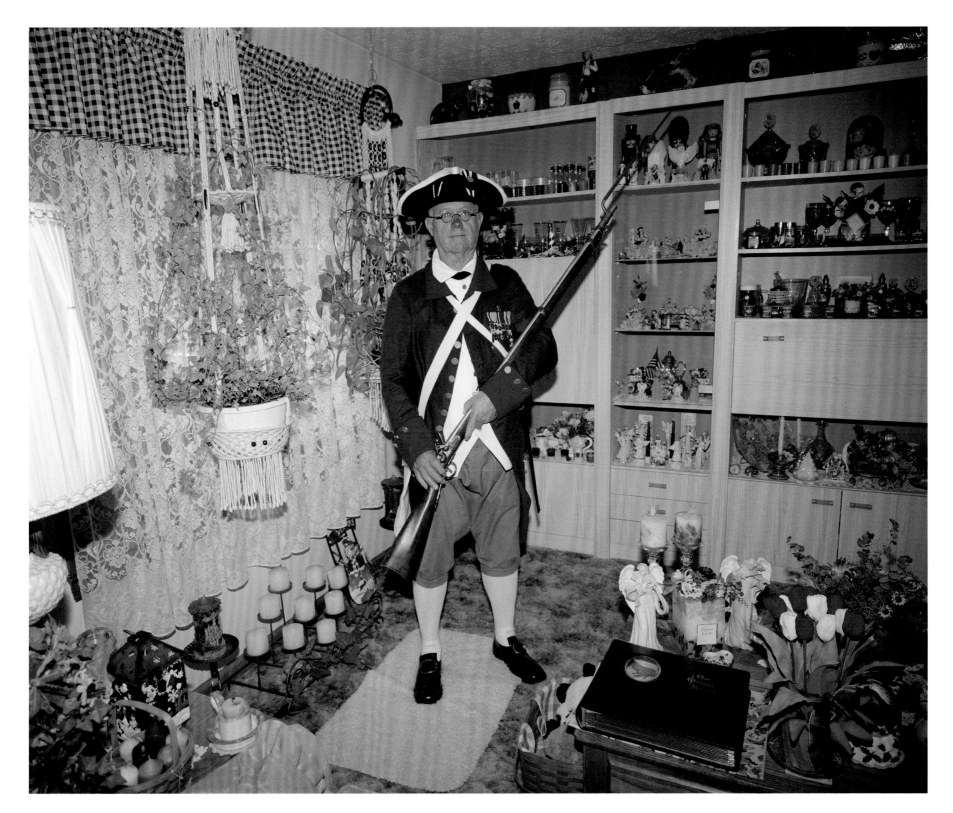

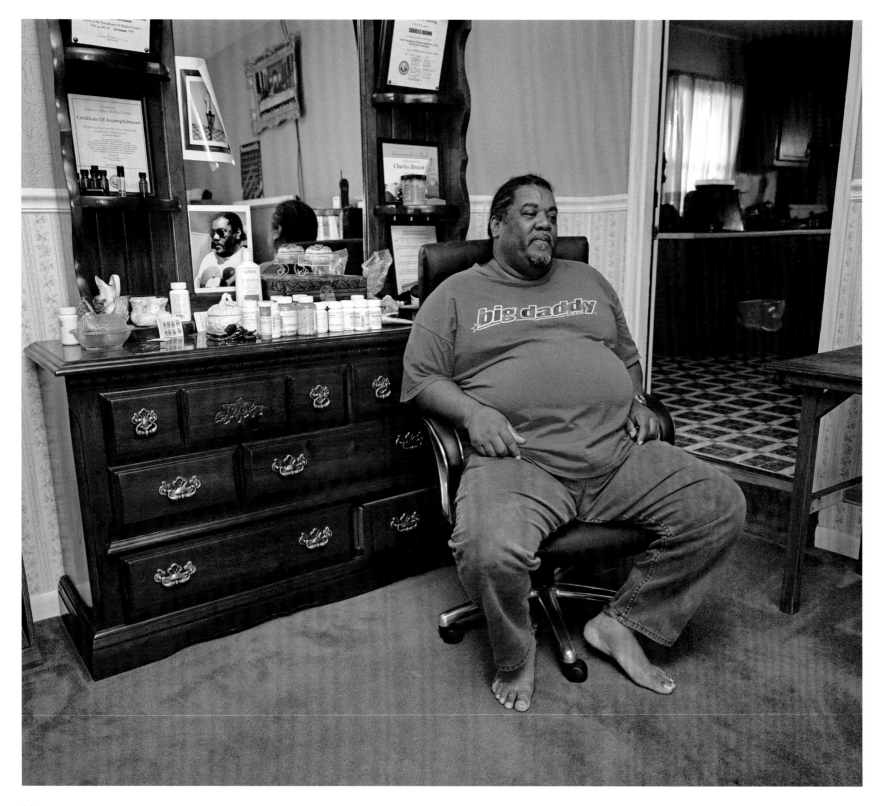

: Charles Brown

[U.S. Army Specialist E-4 | May 1970–April 1971]

"WE TOOK MAI, OUR MONTAGNARD SCOUT, and as soon as we hit the area, I knew something was wrong. I dropped back to fourth in the squad and everything went quiet. In the jungle there's something wrong when there's nothing chirping or chipping. We stopped and I'm looking and I don't hear anything. All of a sudden an AK goes off and I see three people drop. Mai, who was next to me, caught a slug in his chest, toppled over backwards. So I'm hitting the ground with my M-60 but before I could get down they set off one of their mines—a big old can with glass and feces and everything. When that blew, it blew me straight up in the air. I was bleeding. My fatigue was blown off; blood is all over the place—it tore my shit all up. The LT was lying on the ground. He caught a big old chunk of stuff in his neck.

The other squads had to come from other directions to get to us. I was still trying to fight. I was trying to find something to fight with. It seemed like everything I picked up was blown to hell. I couldn't even get the damned grenade launcher to work. I hated to be there bleeding. I didn't feel it; my adrenaline was so high.

They medevaced me out. I woke up. Guess what? The LT is lying right next to me. Colonel comes in, salutes us. He tells us we uncovered a large cache of weapons. He presented us with Purple Hearts. Mai, my friend, was dead. Me, I stayed in Vietnam until I went home in April.

We Vietnam veterans are unique. We're the only vets that's been tossed eggs at and spit at, the only war veterans that have been treated like a piece of shit. For what reason? We don't know. We were just doing what we were supposed to do.

I would rather deal with veterans because nobody else could ever understand us. I can get along with just about any veteran. It's the other people I can't deal with, who I haven't been able to deal with these past thirty years. I don't have one civilian friend. I try not to think about my war experiences. I've got enough medicine to keep me that way.

I am the finished product of a war gone bad. All my whole life has been about a war and I'm just now coming to terms with it and I'm over fifty years old. I just pity these guys coming back from Iraq now. They're in a lesser war than we had, but I wonder if they are going to end up like us."

: Christopher Stack

[U.S. Navy Lieutenant Junior Grade | November 1965–May 1966]

"IN EARLY '66, THE NAVY PEOPLE started thinking about how they can get Navy personnel more involved in the land war. The issue came up particularly down south in the Mekong Delta; there are all these rivers and streams and the Viet Cong were using them as transport and as safe havens. So that's when the boat stuff started, the stuff that John Kerry wound up with, the Swift Boats. They all began when I was over there. They were training people for the so-called 'brown water' Navy.

At that point the higher-ups in underwater demolition and Seal teams, an off-shoot of underwater demolition, were teaching frogmen to go inland and raid things, kill people or capture things or just sit and watch and report back—to basically get us out of the water. This one operation was the first attempt by the higher-ups to use UDT for ambush, guerrilla land-war types of operations.

It was a fiasco that turned out ok. And it was my opinion and the opinion of nearly everybody that participated that it was really screwed up. We had about 100 people divided up into three-man teams. We went up the river in the delta; it was this hazardous area. They were going to land some Marines one place and the Viet Cong would all flee. We'd be in a blocking position, sort of a hammer and anvil, and we were the anvil. So we were on the far bank of this river and the thought was as the VC fled, the Marines would come toward us and we'd get them all.

They put us in three-man teams about 200 meters apart in a mangrove swamp, dense, dense stuff. You couldn't move in it. Depending upon the tide you were either sitting in a branch or up to your waist in water. We were put there in broad daylight, which is a violation of technique. Anybody who was watching could have seen where this boat dropped us.

So we were sitting in the mangrove swamp for four to five hours before anything happened. It got dark and then we started to hear noises, started to see tracer rounds. The tide had gone out and so these VC were slogging through the mud, and there were quite a few of them. I was in a team that didn't happen to see anything—we just sat there. There were rounds going over our heads but we didn't see anything to shoot at. A sampan came down the river when the tide was high and they shot that up and apparently killed a few people and found some weapons.

And then the sun came up and we were expecting to be picked up. None of our radios worked. Then they came back in and nosed into the location they thought we were and there was a guy with a bullhorn booming, 'Team Seven—we'll be back to pick you up in an hour.' It was an administrative mess. If you had been an enemy watching you'd have said, 'Well, I suppose that's where they are.' The whole thing was a fiasco. We weren't really trained for this operation. We didn't know what we were doing. We were underwater demolition experts. We were misused…

For me, Vietnam was the beginning of my disillusionment with the American government. Not that I'm a radical—I'm not advocating overthrow. I remember growing up the Feds were the good guys. I grew up in Chicago and police corruption in the '40s and '50s was rampant. State government had scandals. In that era you glamorized the FBI and Secret Service. They were the good guys. If something came out of Washington, it was going to be true—you could bank on that.

But that ten-year period from 1965 when I served in Vietnam, to 1975 watching the end of the war and Nixon and Watergate, that was the end of my faith in American government. Not that I think there's anything better out there. I just don't believe what government officials say anymore. Vietnam was this colossal mistake that our government made that cost 58,000 American lives and to this day remains this divisive thing. It was a new experience for Americans to lose a war…

I was always interested in how things turned out in Vietnam. I did a lot of reading and it sort of bugged me, the whole thing. And I guess it bugged me because a few months after I got out, a good friend was killed. And after that I stayed in the reserves for three or four years and I'd go back to Coronado in the summertime for two weeks of frogman refresher training. And you'd hear about lots of guys getting killed. I knew a lot of people that got killed over there. It made a big impression on me.

There was an organization of surgeons called Orthopedics Overseas, which I joined. They started a program in Vietnam so I volunteered in 1993. You pay your own way and you go there and you give some lectures and you operate on patients. We mostly stayed in Ho Chi Minh City. There was a lot of war-related tourism. There's a war museum in Saigon of American atrocities and propaganda. Well, they won, so they can build their museums. It had captured tanks and rusted-out hulks. But I was glad I went because I came away with the feeling that they were a very good people. They were doing OK. I did not think the war wrecked their psyche—it wrecked our psyche as a nation, not theirs. Everything I've read suggests they are more comfortable with the war than we are."

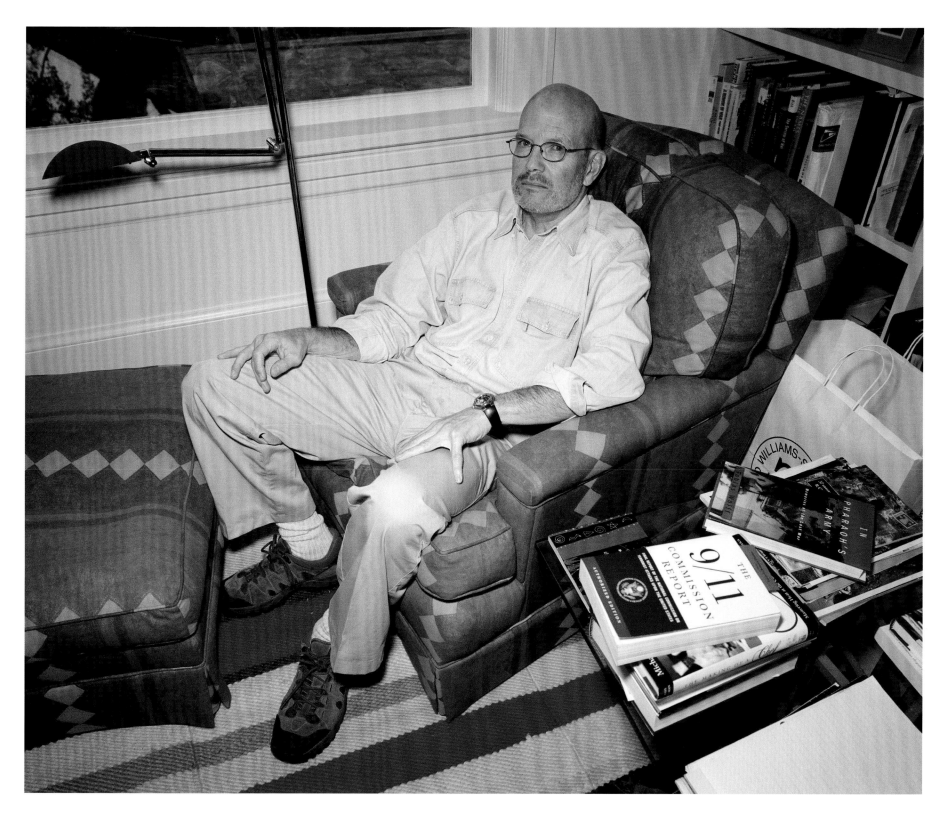

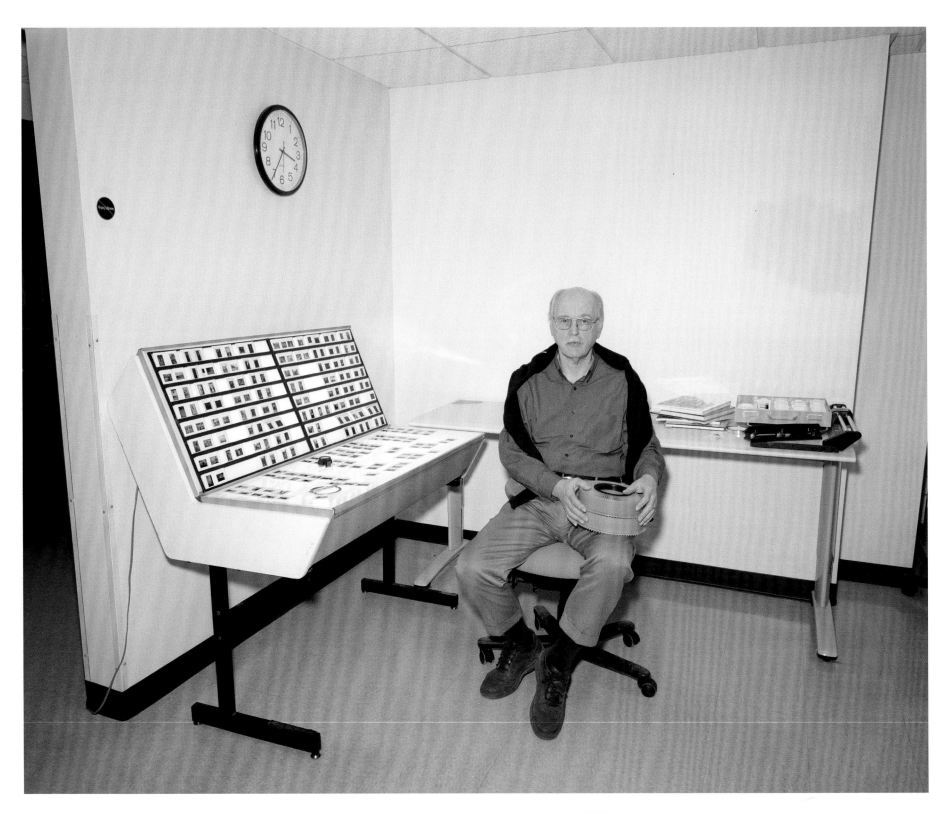

A LOT OF MY COLLEGE FRIENDS either went to Canada or arranged to stay in school and did various other things to keep from serving. I respected that, although I didn't have a lot of political consciousness at that point and I didn't see the war as an issue. But I probably enlisted for absolutely the worst reason and that was because I thought it would be 'interesting.' I had read a lot of Hemingway and Steinbeck in college and other people who wrote about war experiences and at that time I entertained notions of writing fiction, being a novelist. I thought Vietnam would show me part of the human experience at its extreme, which in fact it did. I don't have any regrets at all about spending two years and ten months and two weeks and three days of my life in the military, and I certainly don't regret having spent a year in Vietnam. I don't know that it's the most important experience of my life but it was one of the major formative experiences…

Up until the Tet Offensive, General Westmoreland and Defense Secretary McNamara with the body counts were telling everyone: 'The war's almost over.' 'We can see the light at the end of the tunnel.' 'Just give us a few thousand more troops and we'll have this all wrapped up.' And on and on. And this well-coordinated attack all across the country caught the military by surprise. They had a really good ruse: The North Vietnamese laid siege to Khe Sanh and a lot of people thought Khe Sanh was going to be another Dien Bien Phu. Many of the military people thought that was where the action was going to be, but that appeared to be a cover for this concerted attack all across South Vietnam. It caught everybody by surprise. We had our perimeter secured. We had guard towers, concertina wire, bunkers, everything like that, but we were not expecting an attack.

You know, whenever the Army loses a war, they have a great rationalization for it. In this particular case it's blamed on the media and on bad reporting by the media because the die-hard military types continue to say, 'Well, we won the Tet Offensive because we beat them. They never were able to hold anything that they captured. We beat them back and we killed so many more of them than they killed of us,' and so forth. But that misses the point. War is a battle of ideas. It's a psychological battle as well. It demands support on the home front. To see the claims of Westmoreland and McNamara and President Johnson proved false, it wasn't that the media hyped this out of proportion—it just reported it. Up until then, actually, much of the media was pro-war, but Tet really was the turning point in the area of public opinion. And I didn't know or understand any of that at the time. If you are in a war or a battle zone, you have a very small, very limited perspective; it's very hard to see the big picture.

We did see *Stars and Stripes*, which was a military newspaper, and I remember in the spring reading about the assassination of Martin Luther King and about the riots in the big cities that followed. Then a little bit later I remember reading about the assassination of Bobby Kennedy. Again, I wasn't terribly political but I knew there was something probably just as important or more so going on in the United States than was going on in Vietnam.

When I left my company to come home, I was essentially out of contact with the world and any kind of news for three or four days. I got discharged in Seattle and flew back to Chicago. I got into O'Hare and I saw all these hippies walking around the airport, and I started to look at the newspapers. I saw all these stories on the front pages—I had gotten into O'Hare the morning after the Democratic National Convention ended, with all the police attacks on the protesters and everything else. I saw people at O'Hare with their arms in casts, bandages on their heads; folks who had been hit by Mayor Daly's police and it was all over

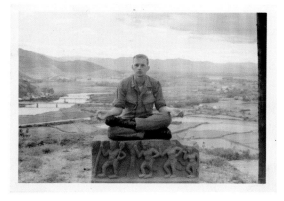

the front pages of the newspapers, and I thought, 'What have I come back to?' It struck me that things were perhaps as bad off, as violent, in the U.S. as they had been in Vietnam."

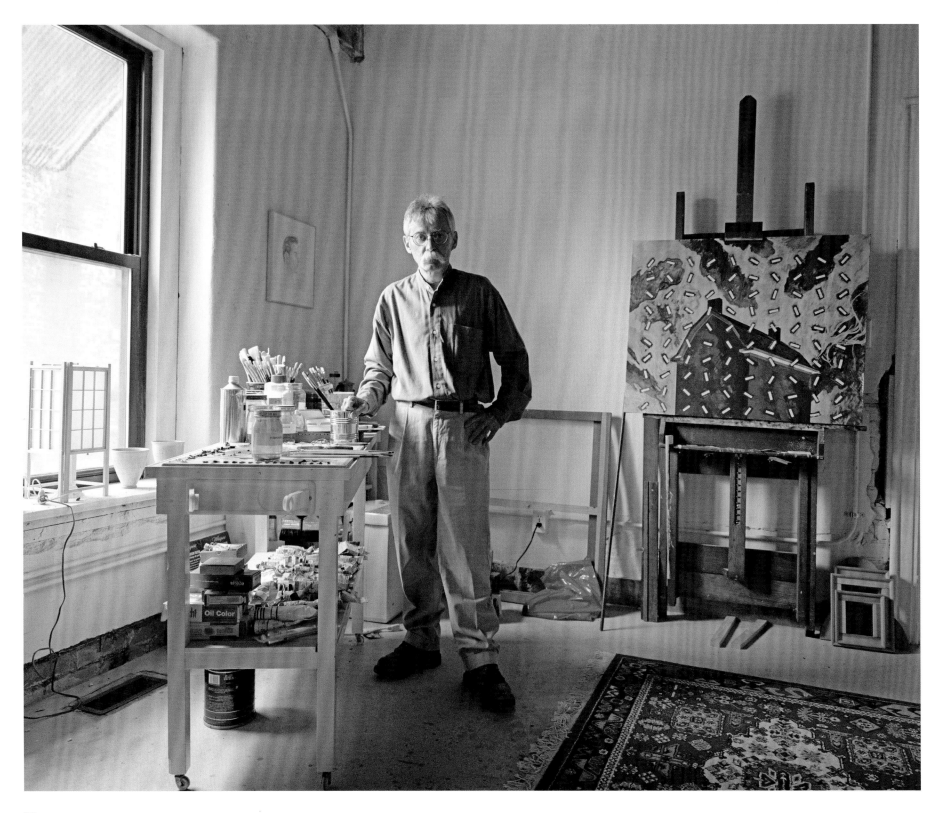

: Richard Emery Nickolson

[U.S. Army Specialist E-4 Assigned to the Office, Chief of Military History and the
United States Army Combat Artist Team XI | October 1970–February 1971]

"GROWING UP IN WASHINGTON, D.C., I had always known about the great war artists and photographers including ones from the American Civil War: William Henry Jackson, Matthew Brady, and Alexander Gardner. I had seen shows of their work from Antietam and Gettysburg at the Smithsonian. I thought in the back of my mind since childhood that if I ever got drafted, I would volunteer for this program. There was a woman in the Special Services Headquarters at the time, Eugenia C. Nowland, who had organized the United States Army Combat Artist Program at the beginning of the Vietnam War. They would select four or five artists each year and one civilian advisor to do documentary work. Its purpose was to be 'morale-boosting.'

I was drafted in 1969, at the end of my first year in graduate school at Indiana University in Bloomington. I went through basic training at Fort Bragg, North Carolina, and advanced training at Fort Ord, California. In the meantime I would go to the Post Special Services Center once a week for a life drawing class and one week I saw an announcement to submit portfolios for the next Combat Artist Team sponsored by Special Services and the Center for Military History in Washington. I kept this little sketchbook in my field jacket and drew an assortment of trucks and jeeps and guys standing in line. I also had some photos I had taken around the base and I went into the darkroom and printed some of those. I sent them in and I thought, 'Well, that's my shot.' I didn't hear for a long time and then I got these orders back: I had been accepted for the United States Army Combat Artist Team XI. They came directly to me from the Pentagon and from the Center for Military History. I had two weeks to get to the Oakland Naval Air Station where everyone was shipped out. That was one of the scariest things because you knew when you got your orders to report to Oakland, you were doomed.

We were to document military and civilian life in Southeast Asia at that time. The local commanders didn't know exactly what to do with us. We had these orders and could go anywhere. And by then, 1970, the American ground forces were trying to pull out, the North Vietnamese were pouring down through the Ho Chi Minh Trail into Laos and Cambodia, and major air bases had been established just west of the Mekong River to provide around the clock bombing and air cover. The war had literally spread to all of Southeast Asia. We weren't to do anything that went against our consciences as artists. The work had to be suitable to become part of the annals of military history. If we had an idea to go someplace, we could. Mostly we were around air bases, because that was the main focus of the war at that time, but we did witness local activities, historical monuments and various other camps and bases.

We visited a temple that was built by the same people who built Angkor Wat—a little temple at Pi Mai, very beautiful. I did some portraits of the local people who worked on the bases, the house girls and the people in the markets. My favorite drawing was of a marketplace. It was big, two feet square, and I did it all in one sitting. I sat on a curb and drew bags of rice, little food stands, bamboo roofs and the people who were gathered there. I wanted a more direct medium so I used bamboo pens and brushes and India ink. I thought that was the best way to connect with the subject matter and it forced me to draw in a different, more spontaneous way. My work started to have an Asian graphic influence.

When my tour was completed I flew straight back from Bangkok to Bloomington to find a place to live for the fall semester and my second year of graduate school. Everybody said the best thing to do was to pick up exactly where you left off. So I flew to Bloomington, still going military standby, still in uniform. I shared a taxi from the tiny regional airport with four other graduate students at Indiana University. I had completely forgotten what the Midwest looked like. From up on the hills I could see this structure off in the distance. We would drive down a hill and around a cornfield and come back up, and I would see this thing again. It was the grain elevator downtown. It would disappear and then reappear. I thought, 'This is really amazing!' That was to be my last year in graduate school and I decided to make that my thesis.

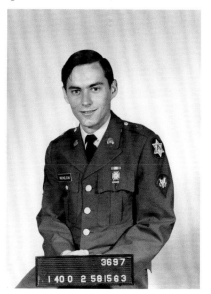

The first couple of paintings were awful, really bad, all landscapes. I returned to Indiana University, the seedbed of figure painting in America at the time, and never painted another figure. The other students didn't know what to make of me so I didn't talk much that year. Mostly people were not welcoming toward soldiers returning from Vietnam in 1971. I thought that the grain elevator was the thing that I identified with most as a monument to my feeling that I had returned home. I decided for my thesis show to do a series of paintings of just this one image. It was like a temple to me, like a monument that allowed me to feel home again. So I decided to paint the grain elevator from every different angle—there were eighteen paintings in all.

I knew what kind of artist I was going to be in the army: I was not going to just paint jet fighters, helicopters, and tanks—someone else from our group would cover that. I made drawings of the cities, people in the marketplaces, and at the Buddhist temples. I felt that the best thing I could do was to show the life and culture of Southeast Asia. I wanted to find something that would somehow symbolize or capture that culture. Afterwards, the grain elevator back in Bloomington worked in that very same way for me. Over the years, that grain elevator has been destroyed. However, the temple at Pi Mai is still standing and being restored."

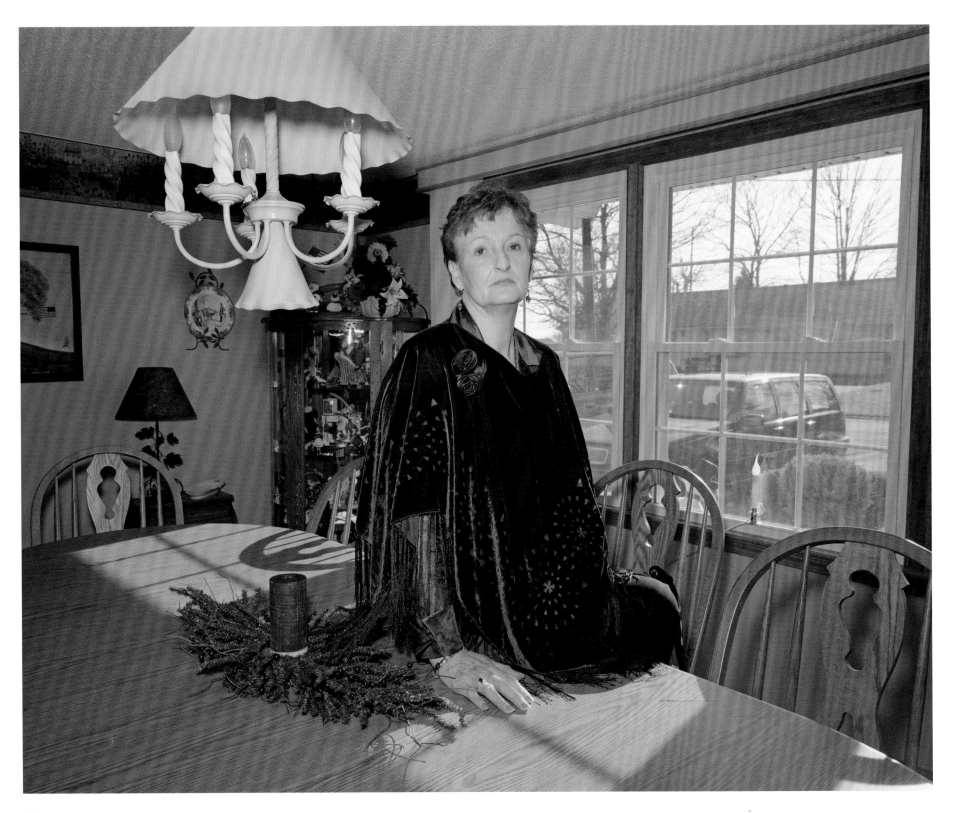

: Jeanne Urbin Markle

[**U.S. Army Nurse 1ˢᵗ Lieutenant** | **December 1966–August 1967**]

"IN VIETNAM, ALL WOUNDS WERE CONSIDERED DIRTY — they were gunshot wounds. The wounds had shrapnel, lead, dirt and anything else in them. Everything was filthy. The wounded were taken from the helicopter and triaged and then on to the surgical ward. When they arrived at Post-Op II, the ward I worked in, they came straight from recovery and their wound repairs were left open—no sutures. No matter how invasive, no matter how deep the wound, no matter where it was on their body, it was open. If the wounds had been sutured or closed immediately, the dirt would have been left inside to fester or abscess. After the medical team saved them, no one was about to let them die from infection. So we used what was known as DPC or delayed primary closure. What that meant was that the soldiers had open wounds for seven days and they had to have dressing changes every two hours in most cases. On the seventh day, if there were no signs of infection, the soldier was taken back to surgery where the wound(s) were sutured closed. They returned to the ward, we did the paperwork and they were discharged out, usually in twenty-four hours' time.

There were several destinations for soldiers leaving the 24th Evacuation Hospital. The lightly wounded, who were going to be able to return to their units, could stay longer on the ward or go to an ambulatory ward until healed completely. For most, the next stop was Japan. A few would need a few more weeks to heal and then find themselves on a plane back to join their unit and live to fight another day. The majority of soldiers sent to Japan were triaged for treatment destinations back to the States—they were hurt too badly.

At twenty-three, it was very hard, physically and mentally. Looking back I am not sure how I or anyone else did it. We just put one foot in front of the other and kept on going. I kept my sanity by maintaining my focus—don't get involved with the wound, get involved with the boy. 'It's okay. We're taking good care of you.' 'I'm sorry we're hurting you.' Deal with the boy. They were eighteen, twenty years old. They were scared. I was scared. I couldn't cry in front of them. 'Hey Chip, you're going to be fine. Guess what? Your girl is waiting for you back in Georgia or West Virginia or California. You've got your whole life ahead of you.' Stay upbeat, up, upbeat. Don't break down until you get away from the ward.

I am a woman with a perspective of war. The doctors, you understand, did not take care of the soldiers. They performed the surgery, they saved the lives, and they wrote the orders for treatment that we nurses followed. They cared, but they came and went. It was we nurses who were there all the time. We changed shifts every twelve hours but they all became 'our boys.' We cried with them, we wrote letters to their moms and girlfriends. We were there to be proud like sisters or moms when their commanders came in and awarded them their Purple Heart. We are the nurturers and if left to us, there would be no wars.

The saddest part was having the soldiers that came in who told you they were almost ready to go on R & R. We had a captain admitted. I think it was just a leg injury, nothing that was going to kill him. He was to leave the next week to meet his fiancée in Hawaii to get married, so we were all excited for him. That kind of thing cheered the whole ward. He'd been picked up south of Saigon. The unit was under attack and the Huey medevac helicopter knew where he was; they just couldn't get to him because of the continuing battle. They also didn't want to miss and therefore broadcast his position to the enemy. So he lay there for over twenty-four hours. He was a joy—so much kidding and fun with all the guys. Going to get married in a leg cast and on crutches, but who cared. Get through the seven days; go back to surgery to be sutured and then on a plane to Hawaii to meet his girl. I was working the night shift a few days later when he began to struggle to breathe. The next thing I know is that we are coding him. Get the doc quick. Tell him who it is. He's special, hurry. Hang in there, Cap, we're going to fix this. Chest compressions, we have a heartbeat, a blood pressure. Oh no, here we go again. Five times he quit breathing, five times we coded him. We knew he was gone the fourth time. Doc was crying, I was crying, the medics were crying. Middle of the night, the ward was awake. Every boy on every cot was holding his breath. I could hear the sounds of rosary beads coming from somewhere. It's no use; he's gone. One more time. Just do it one more time. For us, for the boys, for the bride who was supposed to be in Hawaii in a few days.

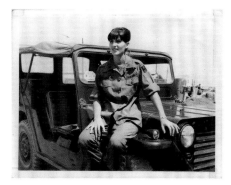

One time I received special permission to leave Long Binh and visit Saigon. I must have thought I had on ruby red shoes. People everywhere, on bikes, scooters, and little buses. Girls walking together in groups, pointing and smiling. I thought, 'Hey where is the war?'

We had only a few hours free in a place that looked untouched by destruction. As we approached the Presidential Palace we could see a commotion a block away. It was a monk in white, enveloped in flames—I saw him fall. He had set himself on fire in protest. Just a small black pile with gray smoke curls drifting upwards as we passed the corner. To this day, it remains one of the worst experiences of my life. I was there to preserve life. I couldn't understand someone making that kind of statement. My mind couldn't get around it at all. It still can't. I have never been able to explain why anyone would ever want to do that.

Today I find myself questioning the same actions in a different country and war. I doubt if anyone but me remembers that monk burning or his reasons for doing so. The world has not been at peace because of that monk's actions that day. We have young boys and girls strapping bombs on their bodies and blowing themselves up because some men ask them to. Where are their mothers? Why can these men have such mind control over the children? Why cannot the mothers teach their sons and daughters to say, 'Okay, but you go first, and show me how it's done.'

Years from now, who will remember they once were young boys and girls, full of promise with sons and daughters of their own. Only their mothers who will yearn for what might have been until the day they die. Maybe it is time for the women, the nurturers, to be in charge of the world."

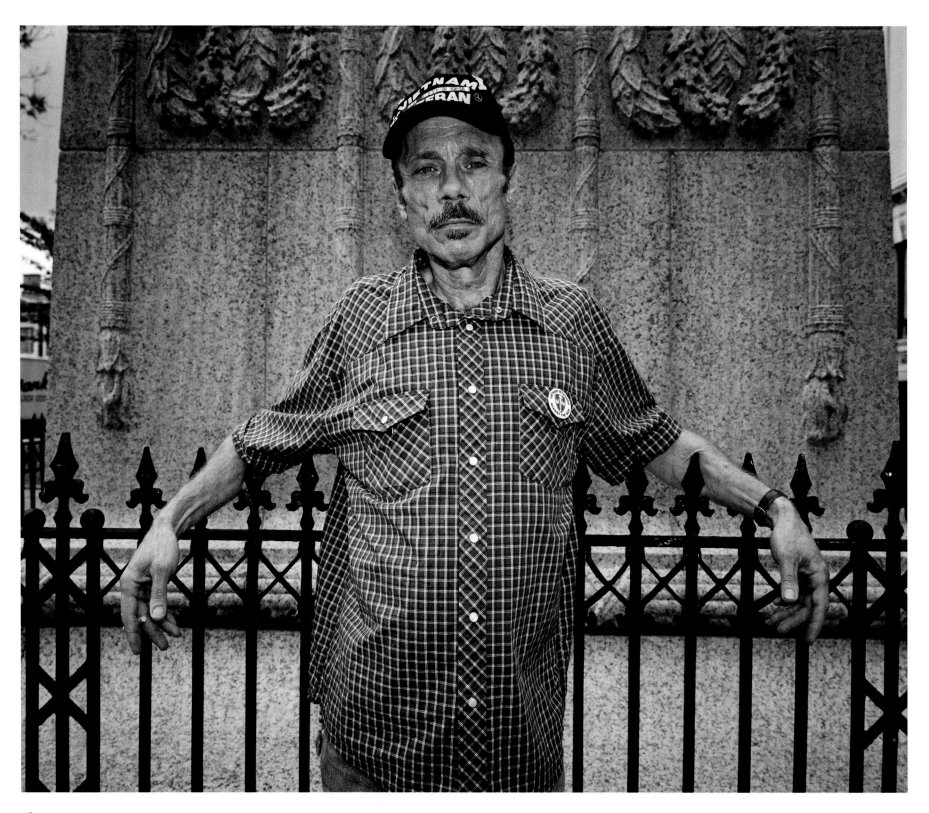

: David Cline

[**U.S. Army Specialist E-3** | **August 1967–January 1968**]

"**I** REMEMBER BEFORE we went to Bo Tuc they had us set up for about a week in an area near the Cambodia border. We set up a battalion-size perimeter and we put out barbed wire and rigged up the whole perimeter with Claymore mines. They never attacked us there because they saw us setting all this up. They waited until the next night when we went to Bo Tuc and that night, at two in the morning, we got overrun by North Vietnamese.

Mortar rounds started coming in. I was in a foxhole with two other guys, black guys, one named Jameson and the other named Walker. We'd sleep three in a hole. We were supposed to be a reserve support position, not a line position, and being in a reserve position we were able to all three of us sleep. So the mortar attack woke us up and all of a sudden we could hear someone about thirty meters in front of us yelling orders in Vietnamese. They were attacking the position next to us. They overran that position and one of them started running toward our hole. It was two in the morning so you couldn't tell if he was an American or Vietnamese.

I was sitting cross-legged with my rifle pointed up at the entrance to the hole. We always put a sand bag cover on our foxholes so if we got mortared, we'd have some protection from the shrapnel. All of a sudden this guy came up behind my hole and he stuck in his rifle. I saw the front side of an AK-47 and then a muzzle flash and I pulled my trigger. The bullet hit me in the knee and I blacked out from the impact. When I came to a few minutes later, my weapon was jammed and my knee was shattered. Walker—who we used to call 'Thump' because he had the M-79 grenade launcher and that's the sound it made—started shooting and Jameson pulled me out of the hole and lifted me on his back. We pulled back to the platoon CP which was a hole even further back and they stuck me in the foxhole with a bottle of Darvons and I lay there eating them Darvons all night to kill the pain.

That night the NVA overran a lot of our positions. We had flown in artillery and they overran the artillery, set the artillery rounds on fire. So they were blowing up and they'd cook off—a dull thud-type of explosion. It was the only night in Vietnam I thought I was dead for sure because the Vietnamese were all over the place charging, and at night you couldn't tell who was who. The fight went on all night. They were not able to kill us all and take over our positions so they withdrew before the sun came up. We took a lot of casualties. I'm sure they took a lot of casualties, too.

In the morning they took me out of the foxhole and put me on a stretcher to medevac me out. They carried me over to my position and the guy who had shot me was dead. He was sitting up against a tree stump and he had his AK-47 across his lap and a couple of bullet holes up his chest. The sergeant started patting me on the shoulder. 'Here's this gook you killed. You did a good job.'

They used to have a big thing—first off it was a racial thing: they weren't people; they were 'gooks'. How you get people to kill people, you dehumanize them, make them less than human. They also used to have a big thing in my unit about Individual Confirmed Kills. You know, a lot of times we'd get into a firefight and everyone would start shooting and then you'd find some bodies later and you weren't sure who individually shot them—you all did. But if you had an Individual Confirmed Kill and the person you killed was carrying an automatic weapon—not a semi-automatic—you would get a three-day in-country pass.

Sounds bizarre when you think about it. Sounds like hunting. But when we were fighting the Vietnamese, they were putting a high priority on capturing AKs. So this sergeant is telling me, 'Here's the gook you killed.' I looked at this guy; he was about my age and I started thinking, 'Why is he dead and I'm alive?' It was pure luck that I had my rifle aimed at his chest while his was aimed at my knee—not anything to do with being a better soldier or fighting for a better cause.

Then I started thinking, 'I wonder if he had a girlfriend? How will his mother find out her son is dead?' What I didn't realize at the time, but did later, was that I was refusing to give up on his humanity. And that's what a lot of war is about: denying your enemy's humanity. That's where a lot of guys came back and still had a lot of hatred and anger. That was the point at which I felt I had to do more than go back home and try to pretend I wasn't in the war zone. The senselessness of the whole thing was right in front of me. And if you asked me about what I thought about at that moment I would have said, 'Old men send young men to wars, so why doesn't Lyndon Johnson and Ho Chi Minh fight it out and let us all go home?'"

: Jerry Kykisz

[**U.S. Army 1st Lieutenant** | **May 1968–May 1969**]

"**O**UR JOB AT CHEO REO WAS TO TRAIN THE LOCAL POPULATION into forming a defense force. The hamlets we were responsible for were a little removed from province headquarters and they were victimized by the Viet Cong at night, and sometimes subject to reprisals from the government forces during the day for collaborating with the enemy. So we were there primarily to take whatever was available from the local population to form into the regional popular forces platoons.

We formed two platoons of Montagnards. We had an attached platoon of South Vietnamese and we patrolled, built a little fortification at the conjunction of a couple of hillsides, and started teaching them everything from basic infantry tactics, to using the new weapons we were supplying them with. The Montagnards got the World War II-vintage weapons—carbines, M-1's. The Montagnards are indigenous people like American Indian tribes here—the South Vietnamese had no respect for them at all. They were considered savages. Most of my time was spent with the Montagnards rather than the South Vietnamese…

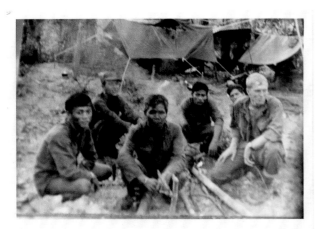

The best night I ever spent in Vietnam was when we had just finished two months training with these people and we were going to go on our first mission with the squad leaders of the two platoons. One platoon was the old, old guys, and they basically provided security for the compound itself. The other platoon, the able-bodied one, did the patrolling. So we had twelve Montagnards, myself and Sgt. Porter. He was a career soldier, E-6 at the time. We went out and the mission was to set up a night ambush patrol outside the hamlet that had recently been picked on by the VC.

We set up, and we were sitting there, and it gets dark and suddenly we see people coming down the trail. Night ambush is simple: anybody out after curfew is dead meat. My Montagnard interpreter said, "No. Don't shoot,' and he calls out to these guys and they call back. Sgt. Porter and I look at each other and I think, 'Oh, fuck! We're dead.'

Anyway these people kept walking by and pretty soon another group came by and in the interim my interpreter is trying to get me and Sgt. Porter to go to the village with them—follow the groups in. Sgt. Porter refused, 'I'm not going. There's no way. I'll head off into the bush.' I, on the other hand, knew there was no place to hide, so I said, 'I'll go with them.' So I left Sgt. Porter my M-79 grenade launcher and I put a hand grenade in my pocket and a .45 in back of my belt, and I took off with the interpreter and half the squad. The other half stayed with Sgt. Porter.

When we got to the village they were having a party—there were a lot of people. There was a line of dancers. The village was lit by torchlight. They had hors d'oeuvres cooking on open coals. They sat me down, got me some wine and passed around a pipe. I was still gawking at what was going on and I remember looking over and I could see people looking at me from behind huts.

Then this little old lady came up to me and took me by the hand and pulled me up and into this line of dancers. We made a couple of passes around the hut, sat back down, had a little more wine, passed around another pipe.

I was set to go out dancing again, but you can't dance with a hand grenade bouncing against your leg and a .45 up against your back. So I gave those to the interpreter and commenced to party. And then the next thing that I remember was that I was down to a loincloth—otherwise I was bare-assed. It's the end of the party, fires are dying down, people are going off, and I remember looking up thinking, 'Where the hell am I? Where is this? When is this?' I tried to reorient myself.

Whether it was that moment of trying to come back to reality and reorient myself, trying to figure out, 'What year is this?' (I couldn't remember the year—a lot of things were missing, especially numbers and even for a long time after that I had a hard time saying, 'That's an M-79 or that's an M-16') my first realization hit me: Well it doesn't matter where you are and it doesn't matter what year it is. This could be 2000 B.C., and this is what people have been doing since then.

The next question was, 'What was the party for? What was the event?' The party was a celebration of being alive. And that kind of broke my paranoia, my being afraid. It was an acceptance of things and a transition to getting on to experiencing things and not worrying what was going to happen. So that was the highlight of my Vietnam tour—celebrating being alive."

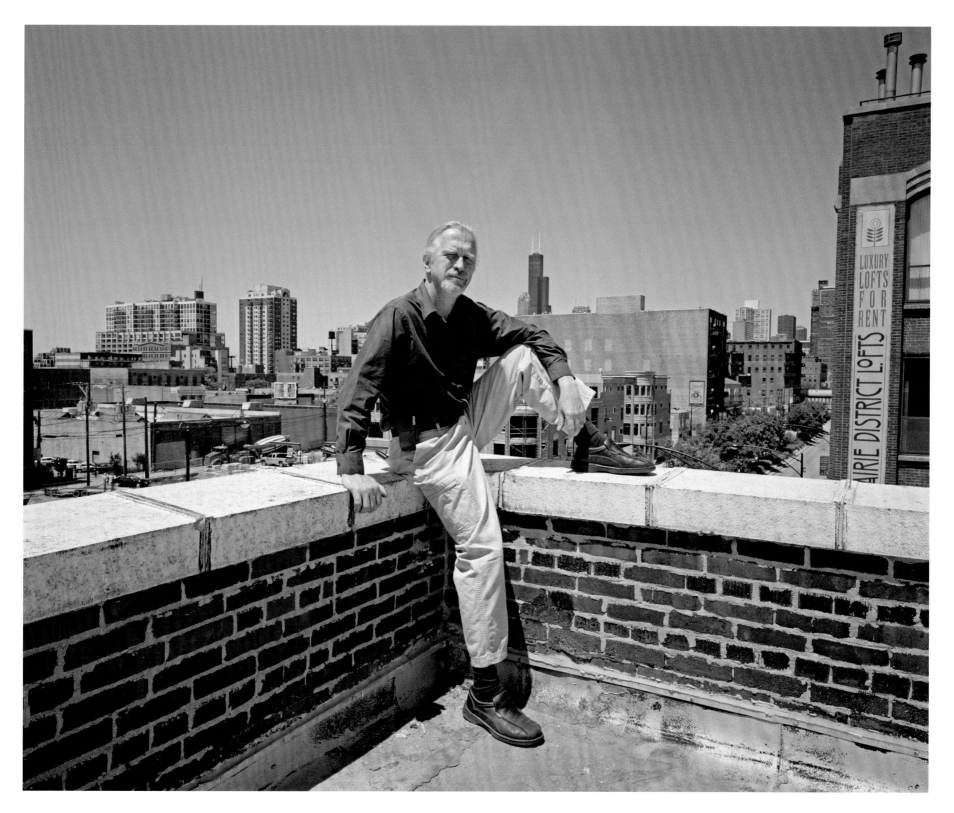

"**WE DOCS HAD A LOT OF RESENTMENT** being taken to a war we didn't believe in, but the saving grace for us was that we weren't going to fight or kill anyone—we were going to treat sick people. Time has taught us that physicians who take part in a war are much better surgeons and physicians because you learn to react instantaneously without scratching your head. That kind of training is invaluable. You could forget about the war because your concentration was on patients, until those times when the fighting stopped, until you went into periods where you had to deal with the guys falling apart emotionally.

Vietnam was a war with no front. The front was underneath you; it was behind you; it was beside you. The method of survival in Vietnam was for the Vietnamese to be dedicated to the U.S. troops during the day because we were fighting North Vietnam, but the Viet Cong were so embedded in the country that the South Vietnamese were so threatened that many who worked for us also worked for the VC at night.

We had an instance where a couple of Vietnamese nurses who worked for us burrowed into one of our bunker hospitals one night and opened fire, killing all twenty-six patients who they'd been treating that day plus three of the corpsmen. One of these was a brilliant surgical nurse. She was captured by the Marines the next day. It was discovered what she had done and so the Marines tied her to two helicopters that took off and pulled her body apart.

It was hideous conceptually, and it was deplorable, but when you were fresh from what just happened, it was difficult to admit that you almost had a feeling that that was 'OK.' Once you got some distance from it, you knew what pressure she was under so that you got the guilts for 'participating.' We've all heard the stories about My Lai and Lt. Calley and about Abu Ghraib in Iraq. Unless you've actually been in that situation, it's hard to imagine man's inhumanity to man. When you're in the middle of it, sadly, it doesn't somehow seem so heinous, so inhuman. It's only upon reflection that you then absorb part of the guilt of what I think this whole nation has, for what we did to Vietnam.

One of the things that was most difficult to deal with was the number of guys who had self-inflicted wounds trying to stay out of the field. We had a kid come in—it was back on the hospital ship. He was probably only seventeen, underage for the military. He was going to be sent up the Cua Viet River into a situation where he was guaranteed, being so low on the totem pole, to be killed. And he was so terrified about it that he decided to shoot himself. What he wanted to do was simply shoot his toe off but he missed and got his ankle instead. They brought him in on a chopper in the middle of the night. He said, 'I'm not going to go up that river. Don't cut my fucking foot off!'

I said to him, 'It's already off.' And he said, 'I won't stay here any longer. I did it myself.' I tried to rationalize with him, 'Whatever the shot was that did this, your foot is not there.' Finally, one of the corpsmen raised his bootless leg up and showed him his foot was gone. Then the stunned kid turned his story around and said he stepped on a mine—he would be court-martialed if he shot it off himself. I tried to never find out how that was dealt with by the authorities.

It happened frequently. Guys would stab themselves in the hand or refuse to soak their feet in the saltwater baths so their jungle rot would get really bad—anything to stay out of the field. The guys would confide in you because they didn't look at us as 'military'—it was a doctor/patient relationship. They knew I wasn't going to report them. I was very against what was going on and I wasn't about to turn a kid in who was so desperate that he would do something like that to himself. What human being would?

As a doctor you had to commit to two years of military service. If your first year was in Vietnam, you could choose anyplace in the U.S. for your second year. I'd always wanted to live in New England, so I was assigned to the Fargo Building, the Marine Corps Brig in Boston. I lived in a little village, Newton Upper Falls above Wellesley—beautiful countryside. I chose it because it would show all four seasons and maybe that would let me have a year of purging everything.

The first time I drove to work—I had a new VW Squareback and I was in uniform—I took a shortcut to go through Harvard Yard. I'd never been to Harvard and I wanted to see what it looked like. When the students saw my uniform on campus, they pulled me out and beat me up. I somehow got back to the car and drove to my station. I ran into the commanding officer. I didn't look very good and I told him what happened. He said, 'Never wear your uniform off base.' And I said, 'With all due respect, I'm not going to wear my uniform this year at all.' So I didn't.

And you know, now, with a little bit of hindsight and a lot of time passing, I can understand that it wasn't me being attacked, it was the idea of the uniform and people being against the war. They had no idea that I was a doctor. I represented the ugly other that everybody hated. So that's what they were beating up. They weren't beating up Grady, a doctor, who had been in Vietnam basically as a civilian. But it made all of us who'd been through the war have a really different outlook on protesters. Even though I protested the war, I fell victim to what protesters can do and that's emotionally intolerable."

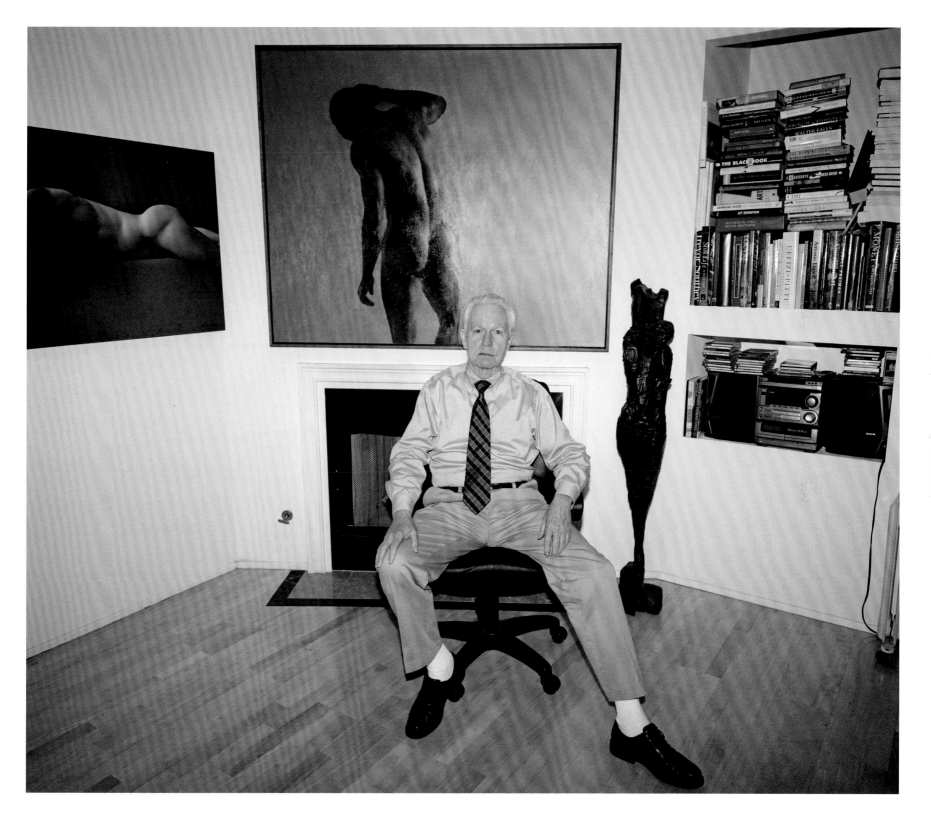

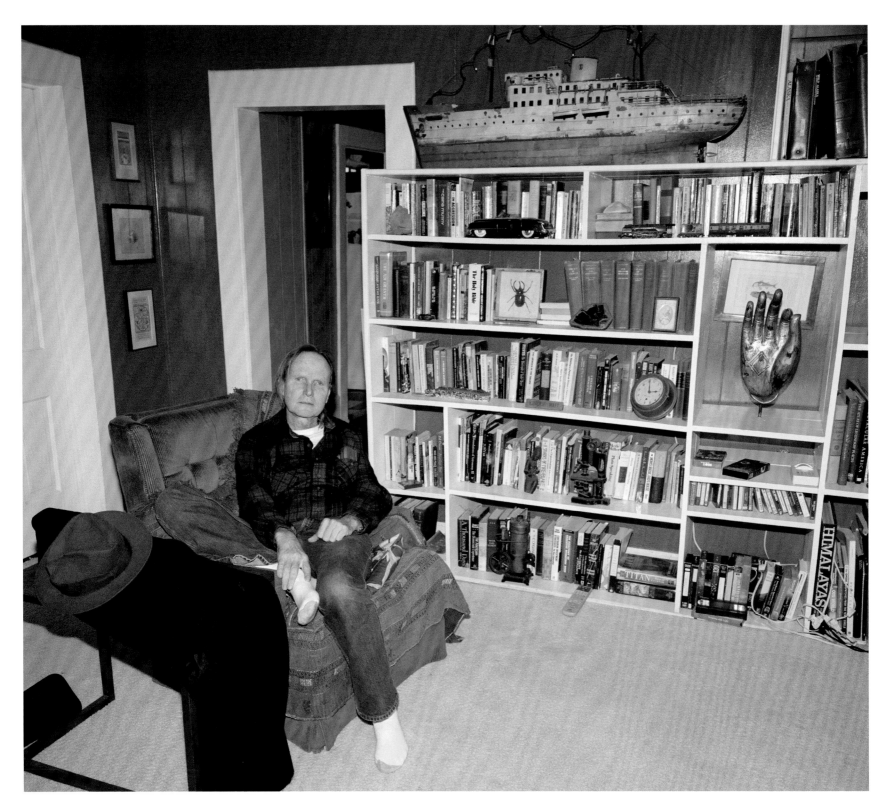

"**E**VERYBODY WAS NERVOUS. We knew there was a possibility of getting hit unlike being back at some base camp. They woke me up for guard duty and there was a Hispanic kid on the Armored Cavalry Assault Vehicle, and I said, 'How's it going?' and he said, 'Quiet. Everything's quiet.' I said, 'OK. I'm coming up.' I go up on the front of the ACAV and he opened up. I have no idea why. He wasn't angry at me—it was not that kind of situation. Actually, we were friends. I don't know if his finger slipped. I have no explanation—it's just crazy. It blew me backwards and I was unconscious. I woke up and the pain was unspeakable. I'd go off and come back, off and back.

A lot of things happened in that period of time. The most important was that I thought, 'You can't put it off any longer. Do you believe in God? It's not an academic question.' And I thought about it: No, I didn't believe. Nothing has been revealed to me, so I'm not going to go out crawling, and I'm not going to go out lying. There are people I love and I believe in that. That's as much as I've got.

A lot of people have said the same thing: that you get to a point and there's a decision about whether you want to live or not. First off, you're scared shitless because you exist, and then you're not going to exist—scary. But then you get to a point where you're not fearful at all. Maybe you live, and maybe you don't live, but everything is fine. It really is fine. Then it's just a matter of whether you did what you had to, or didn't. And I just had this feeling that I hadn't had a child, hadn't had a son. A son! I didn't even have a girlfriend. I just went, 'Can't die yet.' So everything flowed from that moment, I believe.

Then there's this other Hispanic guy and he didn't say a word. Just held my hand and that was what I needed, because that was truth—he felt for me and I knew it. And then they loaded me on the chopper.

I got to this field hospital and they were doing this, that, and the other to me and there was a nurse there and a doctor who had no experience. I was like his first case or something—you could just tell. It was scary because you want him to know what's going on. They put a tube in my back to drain this stuff out, and every once in a while they'd have to roll me over, and I can't tell you how much that hurt. And I yelled, 'Oh, Jesus Christ!' And this nurse said, 'Watch your language. Can't you control yourself?' And they'd roll me back and I screamed, 'Oh God! Jesus Christ!' And then the nurse says to the doctor, 'Doctor, can't you make him stop saying those words?' And the doctor says to me, 'You're in the presence of a lady!' It was the craziest thing I ever heard. When I look at the scar, it's slipshod and it looks like they cut it open with a garden shears but it was enough. It got me through. I've got no hard feelings…

Twenty years later, I did go back to Vietnam and I got a chance to experience the country and the people from an utterly different perspective. For me it was not any kind of pilgrimage. I just travel a lot. I love Southeast Asia. You can rent a car with other veterans and share the expenses and have a driver—it's the best way to see the country.

We went up the coast and met a guy who was a Vietnam veteran. I could tell there was something quite extraordinary about the scene because the guy was sitting there—he had screwed-up arms, screwed-up legs. He'd hit a mine or something—he was in bad shape. But he was surrounded by these Vietnamese people and it was almost palpable—you could feel the love. It was just coming in on this guy. He had a little kid on his lap; girls were sitting around; old guys sitting there. You could tell they loved this guy. I started talking to him and he said, 'I got home and I was bitter, angry, and for years and years and years I was just pissed off all the time. I've come back here and now I'm working on this project where we're putting solar energy in this hospital in My Lai. And I feel at peace here.' And he said, 'Look, I don't know if it's doing any good really.'

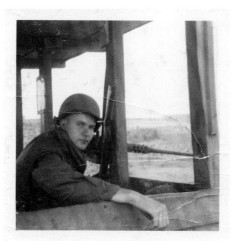

But I thought, 'Man, I don't know if you're making any electricity, but you are doing the job; you are binding up the wounds. You're a hero because I can smell that you are bringing people back together. You replaced hate with love.' And we talked and talked and talked through the night and finally the thing was breaking up and he said, 'Where are you going tomorrow?' And I said, 'We're going up north to the DMZ.' He said, 'I got one suggestion: Go to My Lai.'

The next day we were driving in the van. There's really only one good road that goes up the spine of Vietnam. There was a dirt road that teed off and our driver stopped and said, 'My Lai is down that way about twenty klicks.' And there were five of us, and two said they wanted to go, and two said they didn't want to go, and so I was it—I was the deciding vote. I don't go for old battle sites—I don't have enough imagination or something so I know I wouldn't have gone, but I respected that fellow's opinion. So I said, 'Yeah, let's go.'

So we drove there and got to the place and we walked in through this arch and the whole area was covered with flowers someone had planted. It was just a field of flowers. And I didn't even know I had all that sadness in me because I broke down, uncontrollably, just seeing all those flowers. I really didn't think I needed any resolution but I guess I must have and I was glad for that. And whoever planted those flowers, I salute them, because that's what you have to do."

: Afterword

In 2002, I traveled across Indiana to initiate the Veterans History Project and begin documenting the stories of Hoosier veterans. The Library of Congress first proposed this project to all members of Congress because the histories of the average GI, the men and women who carried the burden of protecting our freedom, are sorely lacking. With shelves of information about Generals Patton and Eisenhower, Admirals Halsey and Spruance, our national history is in desperate need of these kinds of remarkable, honest, and deeply affecting stories told in this book by Vietnam veterans.

Drawing from my own time in the Navy, I understand the life-changing experiences that occur in the military. I vividly remember my time working in the Pentagon, briefing Admiral Arleigh Burke. I am very proud to have worked with the Admiral; he was a true leader in uncertain times. He taught me the importance of leading well and also taught me how to use the proper tools to accomplish my goals. Similar to my experience, many Hoosiers have answered the call to duty throughout our great history, fighting in battles from the Civil War to our current war on terror. These brave men and women have a story that should be shared so that future generations can come to understand the many sacrifices made on behalf of freedom.

Each story shared as part of the Veterans History Project provides a window into the life and service of our veterans. In Indiana alone, we have a generation of Vietnam veterans that served with honor and distinction during a trying time in our history. I hope the photographic images captured by Jeff Wolin will allow all Americans to understand the service and sacrifices of the veterans featured in this incredible collection.

Jeff Wolin of Indiana University, along with many partners across the state of Indiana, has helped to collect the memories of over 6,200 Hoosiers for our national history at the Library of Congress. Our history is much richer for the stories we have, and are continuing to collect. I am pleased to be part of this statewide effort to recognize our veterans for all they have done, and all they continue to do for the United States of America.

Senator Richard G. Lugar
United States Senator for Indiana

: Acknowledgments

I would like to thank the following people for their help with the exhibition and book:

Rod Slemmons, Director of the Museum of Contemporary Photography, Chicago

Stephanie Conaway, Karen Irvine, Natasha Egan and Corinne Rose of the Museum of Contemporary Photography, Chicago

The Museum Council of the Museum of Contemporary Photography, Columbia College, Chicago

Catherine Edelman, Catherine Edelman Gallery, Chicago

Nan Richardson, Umbrage Editions, New York

Paul Carlos, Book Designer, Pure+Applied, New York

My wife, Betsy Stirratt and my two sons, Ben and Andrew Wolin

Ruth N. Halls Foundation

James Nakagawa, Ian Whitmore, Jordan Tate and Michelle Given, Indiana University School of Fine Arts

Jeffrey Alberts and Michael McRobbie, Office of the Vice President for Research, Indiana University

New Frontiers Program for support of Arts & Humanities

Senator Richard Lugar and the Veterans History Project of the Library of Congress

Monica Kozlowski and Emmy Huffman from Senator Lugar's Office

Jerry Kykisz, General Manager, National Vietnam Veterans Art Museum, Chicago, and a participant in the project who introduced me to other vets in Chicago and around the country

Bud Lynch and Marc Levy, highly decorated Vietnam War Veterans, who agreed to work with me and to help me locate other vets at critical times in the project

All the Vietnam War Veterans in this book who shared their war stories and friendship with me. I'm eternally grateful for their help and support.

: Index